L. RON HUBBARD

presents

writers of the future

the FIRST 25 YEARS

Galaxy Press, LLC
7051 Hollywood Blvd.
Hollywood, California 90028

ISBN 978-1-59212-848-8 hardcover edition
ISBN 978-1-59212-849-5 paperback edition

Library of Congress Control Number: 2010929792

L. RON HUBBARD

presents

writers of the future

the FIRST 25 YEARS

with
kevin j. anderson, *executive editor*

the most enduring and influential contest in the history of SF and fantasy

GALAXY

contents

l. ron hubbard · 9

the contest · 15

the judges · 27

the workshop · 65

the experience · 81

the awards event · 87

the anthology · 93

the winners · 97

"A culture is as rich and as capable of

surviving as it has imaginative artists. . . .

It is with this in mind that I initiated a

means for new and budding writers to

have a chance for their creative efforts to

be seen and acknowledged."

— L. Ron Hubbard

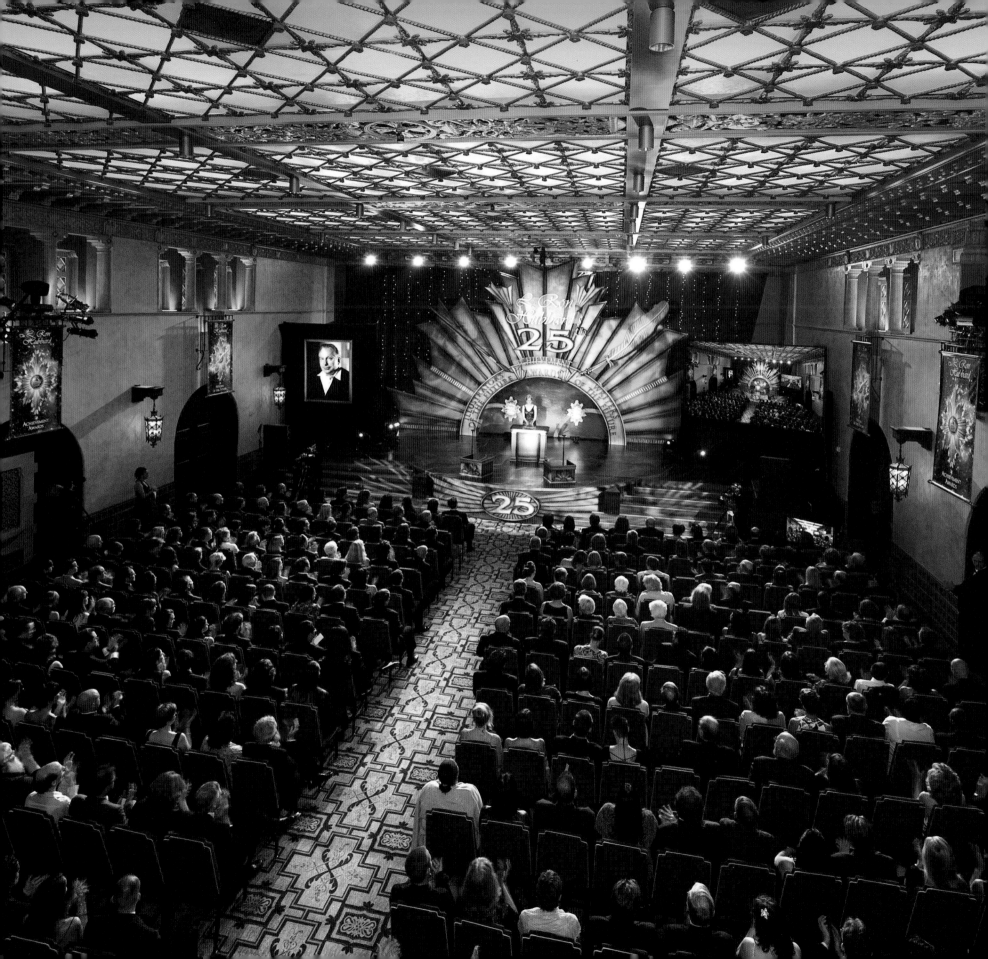

introduction:
a level playing field for new writers

Kevin J. Anderson

"What a wonderful idea—one of science fiction's all-time giants opening the way for a new generation of exciting talent! For these brilliant stories, and the careers that will grow from them, we all stand indebted to L. Ron Hubbard." — Robert Silverberg

In 1984, a year before my very first professional short story sale, I had already linked up with other serious-minded "soon to be successful" authors, and we routinely exchanged information about markets and opportunities. It's how writers help one another.

That year, the announcement of a new contest generated a lot of buzz among my fellow aspiring authors. The L. Ron Hubbard Writers of the Future Contest seemed like a good deal indeed, with big prize money, guaranteed publication in an anthology, and *no entry fee*. Best of all, it was open only to new writers. No longer did I have to compete against the demigods of the genre for a slot in the monthly magazines. The Writers of the Future Contest (WotF) offered a level playing field; I would be up against other unknowns. The list of judges alone was stunning: Gregory Benford, Algis Budrys, C. L. Moore, Robert Silverberg, Theodore Sturgeon, Jack Williamson, Roger Zelazny and others. In the second year, they were joined by Frank Herbert, Larry Niven, Anne McCaffrey and Frederik Pohl.

I submitted to the Contest and, when I didn't win, I submitted the next quarter. And the next. Though I accumulated some Honorable Mention and Finalist certificates, I never managed to place in

Left The Blossom Room at the Roosevelt Hotel in Hollywood, California, was the venue for the 25th anniversary celebration of Writers and Illustrators of the Future.

the top three for each quarter. Then I published my first professional short story in *The Magazine of Fantasy & Science Fiction*—and the Contest clock started ticking, because once I had three professional publications, I was no longer considered a "new" writer. (On the other hand, at that point I *would be able to* join the Science Fiction Writers of America as a full member, so becoming successful wasn't a total loss.)

The following year, when Algis Budrys put on his first prototype workshop in Taos, New Mexico, as a test run for what he wanted to do with Writers of the Future, he invited some of my close writer friends to attend, and I was extremely jealous. This sounded like the best thing in the world: New writers spending an intensive week being taught by some of the biggest names in the genre—Algis, Gene Wolfe, Frederik Pohl and Jack Williamson. In 1986, that workshop became an integral part of the Writers of the Future prize, and in my mind, that intensive week was a far more valuable trophy than the award sculpture or the prize check. The workshop curriculum was practical, no-nonsense, nuts-and-bolts advice built around a series of how-to writing articles that Hubbard had written in the 1930s and 1940s. Those articles are still widely available today, and their advice is just as valid as it ever was.

By this time, through attending numerous science fiction conventions, I had gotten to know many of the people involved in the Contest, including Algis ("AJ" as we all called him). Then, alas, I sold

another professional story and then a novel to Signet Books. Saddened that I hadn't managed to win one of the WotF prizes before it was too late, I mentioned to AJ that I wouldn't be entering anymore. But AJ had been a silent cheerleader all along (although entries in the contest were strictly confidential and anonymous); he looked at the fine print of the rules and came back to me. "No, Kevin. You can

 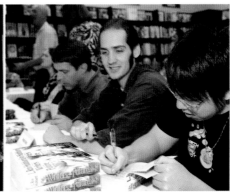

keep submitting until your novel is actually *published*." Well, that was at least three quarters away! So I fired off my best possible story before each deadline.

I entered the Contest a total of twelve times before I no longer qualified as an "amateur." Having a published novel in my hands and on the bookshelves, however, was no small consolation prize. Nevertheless, I still regretted not being able to attend that marvelous workshop.

After I had published more than a dozen novels—six of which were *New York Times* bestsellers—I was asked to become a Contest judge in which capacity I would present an award at the event and be a guest speaker at the workshop. At last, I could attend the workshop, even if it was on the opposite side of the instructor's table. I jumped at the chance.

In the past fifteen years, I have attended nearly every event, served as guest lecturer many times, proudly handed awards to exuberant winners, and spent a lot of casual time answering the questions of eager and determined students. During that time, I have formed very close

relationships with some of the other judges and prize winners, and I see many of them at science fiction gatherings.

That is how I've begun to see how extensive the influence of the Contest truly is.

For instance, at a Nebula Awards ceremony in Chicago several years ago, I made a point to meet highly successful SF author Eric Flint, who had worked with one of my friends on a novel. When I shook his hand, he responded with a strange smile. "Don't you remember? You were one of my instructors at Writers of the Future in 1993." I hadn't realized that was where Eric got his start.

Last year, at the Rocky Mountain Book Festival, I was signing books with my friend and fellow author Dave Wolverton (one of the early WotF Grand Prize winners), along with a man who had just published his first hardcover fantasy novel from Tor Books, John Brown. When I introduced myself, he said, "We've met before. You were one of my instructors at Writers of the Future in 1997."

Along with my wife Rebecca Moesta, bestselling author and fellow WotF judge, I recently did an extensive book-signing tour throughout Australia and New Zealand. Years ago, one of the students who attended our WotF workshop lecture was Sean Williams, a Contest winner who has since gone on to become Australia's bestselling SF author. We have remained in touch and become good friends. During a book-signing appearance in Adelaide, Sean stopped by the bookstore to say hello to Rebecca and me. A few minutes later, one of the fans in line handed me his book for an autograph, then leaned forward to say in an awed whisper, "Wow, Sean Williams *knows* you!"

Looking back through twenty-five years of WotF anthologies, I am astonished to see all of those familiar names, bestselling and award-winning authors who got their start from the Contest. In compiling this retrospective, we were even more gratified to discover that the Contest had helped launch careers not only in science fiction or fantasy, but also of bestselling romance authors, horror authors, comic writers, young adult authors,

children's fiction authors, computer game writers and developers, even a well-known political commentator.

By our best estimate, Contest winners have published more than 700 novels and 3,000 short stories. Many have appeared on the *New York Times* bestseller list, even reaching the #1 slot; winners have garnered nearly seventy nominations for the Hugo or Nebula Awards, the highest honors given in science fiction. Others have won the Newbery, the National Book Award, the Pushcart Prize and many other awards.

The list of judges over the past quarter century is a veritable Mount Olympus of the greatest names in science fiction, past and present.

Five years following the announcement of the Writers of the Future Contest, and two years after L. Ron Hubbard's passing, a companion contest was launched, the Illustrators of the Future, which intended to do for new illustrators what the Writers Contest had done for new writers—discover and acknowledge new artistic talent, bring them to the attention of publishers and help launch their professional careers. While the two Contests are closely connected, the focus of this book is primarily on the Writers Contest. A forthcoming sister volume will feature the scope and success of the Illustrators of the Future.

At the inception of the Contest, famed SF writer Theodore Sturgeon declared his enthusiasm for the idea, predicting that it would "introduce and encourage thousands of new writers" and might well continue for twenty years. Well, WotF has surpassed that expectation by five years already and is still going strong; Writers of the Future ranks in importance with the Hugos and Nebulas for the science fiction genre.

Please join us in celebrating twenty-five years of shaping and encouraging the next generation of writers in science fiction, fantasy and horror.

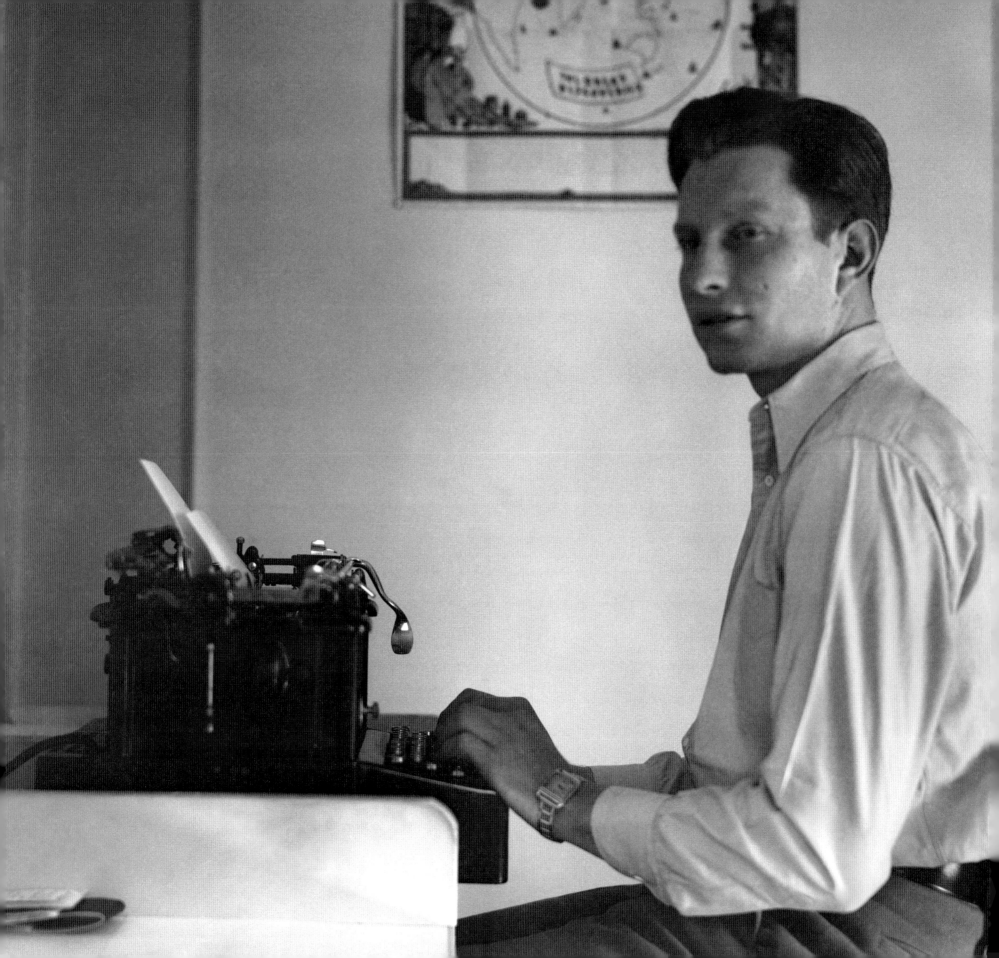

L. ron hubbard:
living the life and
paying it forward

> "My salvation is . . . to write, write and write some more. To hammer keys until I am finger worn to the second joint and then to hammer keys some more. To pile up copy, stack up stories, roll the wordage and generally conduct my life along the one line of success I have ever had. I write."
> — L. Ron Hubbard

In the 1930s and 1940s, through the heyday of pulp magazines that filled newsstands with countless pages of adventure in all genres, one especially prolific and accomplished writer set the bar high for his peers and aspiring authors alike, a man whose fiction has since sold more than fifty million copies and is one of today's most widely read authors.

L. Ron Hubbard all but defined what it means to be a successful writer, and throughout his career he freely passed along his knowledge of the craft. His creation and endowment of the Writers of the Future Contest in the final years of his life is a natural extension of many years of "paying it forward."

Hubbard's literary output was legendary—simultaneously the envy of his peers and a blessing to his fans. For years, he regularly penned about 100,000 words every month (the equivalent of a typical modern novel). From 1934 to 1940, he published an average of three stories every four weeks—more than 138 short stories, novellas and novels in seven years.

"There used to be articles in the writers' magazines about the incredible speed with which L. Ron Hubbard wrote," a science fiction editor and historian once remarked. "And in those days an

Left L. Ron Hubbard, early in his writing career.

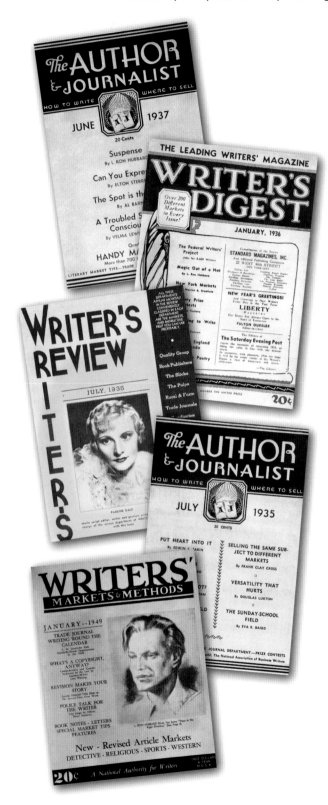

electric typewriter was a novelty. Very few writers had one. And the very fact that L. Ron Hubbard had bought an electric typewriter so he could write faster was considered quite newsworthy."

Science fiction Grand Master Jack Williamson recalled: "He was using an electric typewriter—the first one I ever heard about—and he was able to write two thousand words an hour, and he generally would sell them on first draft, I think. It was something that very few of the rest of us could do."

Hubbard explained his own secret to his extraordinary productivity—namely, *"To write, write and then write some more. And never to allow weariness, lack of time, noise, or any other thing to throw me off my course."*

As a consequence of his popularity and prodigious output, novice writers who hoped to learn Hubbard's storytelling skills often consulted him for advice. He was always willing to offer suggestions and, in fact, provided lengthy responses to queries on where a writer should live, how much research one should do and which type of fiction to write. In a somewhat wide-eyed reply, one such aspiring author informed him: "Received your very generous letter in answer to my query. I feel I cannot let it pass without letting you know how much I appreciate the trouble you took to inform me about things I couldn't have known otherwise, or without wasting a good deal of time, effort and perhaps money."

Hubbard further shared his hard-earned experience with creative writing students at Harvard and George Washington University. (As he tells it, students went "positively apoplectic" when told that the only way to become a writer was to *write*.) To help young writers accomplish just that, Hubbard authored a series of how-to articles that appeared in writing magazines through the 1930s and 1940s. Offering

above Hubbard was elected the youngest-ever president of the New York chapter of the American Fiction Guild, shown here in 1935 (center, back row).

left Just a few of the covers of journals from the 1930s and 1940s that contained Hubbard's writing advice.

guidance to help new writers navigate the rough waters they were likely to encounter, these articles are classics in their own right:

"When you first started to write, if you were wise, you wrote anything and everything for everybody and sent it all out. If your quantity was large and your variety wide, then you probably made three or four sales." ("The Manuscript Factory," 1935)

As Jack Williamson explained, "I used to read Hubbard's articles in *Writer's Digest* and *Author and Journalist* and so forth about how to write and be successful. Writers' magazines wanted to fill up their pages with inspirational articles and ideas and he was their prolific source of such material—and a natural for them."

Shortly after publishing "The Manuscript Factory," Hubbard became elected the youngest-ever president of the New York chapter of the American Fiction Guild and immediately set out to remake that organization into a truly practical and professional guild. By way of example, in order to promote more

accurate use of factual detail in detective and mystery fiction, he invited a New York City coroner to join Guild members over lunch, whereupon all were regaled with the man's professional expertise on strange forms of murder. ("They would go away from the luncheon or something like that the weirdest shades of green," Hubbard recounted afterward.) He extended similar invitations for other experts, including the city's police commissioner. Likewise, as Guild president—and this expressly on behalf of the neophyte writer—he allowed newcomers to join under a new category of "novice."

In 1940, as a feature on a radio program Hubbard hosted while in Ketchikan, Alaska (where he paused on one of his several expeditions under the famed Explorers Club flag) he offered not only practical advice for beginning writers, but also initiated the "Golden Pen Award." It was designed to encourage listeners of station KGBU to pen short stories, and the best of them were submitted to a professional New York publisher. In that respect, Hubbard's Golden Pen Award was a direct precursor to his contest of today.

More than four decades later, in 1983, L. Ron Hubbard created and endowed the Writers of the Future Contest as a means to discover and nurture new talent in science fiction. The Contest is very much an extension of a well-established and demonstrated philosophy of "paying it forward" to help new generations of writers.

center
A sampling of some of the titles representing Hubbard's more than twenty million words of fiction.

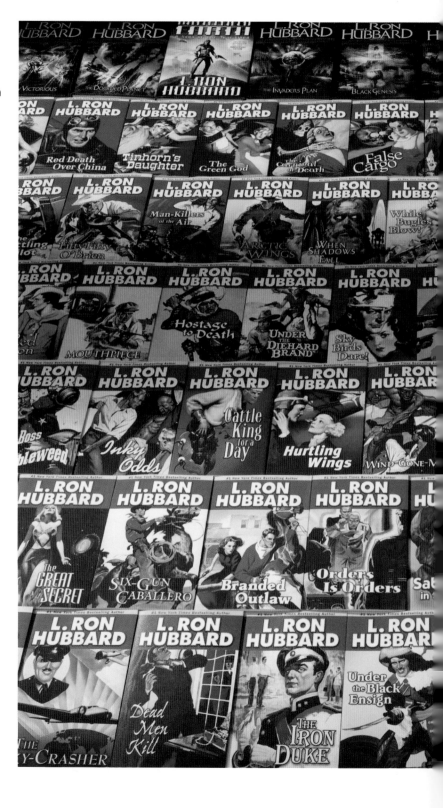

12

The following is excerpted from Hubbard's introduction to the first volume of Writers of the Future winners:

"A culture is as rich and as capable of surviving as it has imaginative artists. The artist is looked upon to start things. The artist injects the spirit of life into a culture. And through his creative endeavors, the writer works continually to give tomorrow a new form.

"In these modern times, there are many communication lines for works of art. Because a few works of art can be shown so easily to so many, there may even be fewer artists. The competition is very keen and even dagger sharp.

"It is with this in mind that I initiated a means for new and budding writers to have a chance for their creative efforts to be seen and acknowledged. With the advent of the Writers of the Future competition came an avalanche of new material from all over the country. . . .

"Judging the winners for this book could not have been an easy task, and I am sincerely grateful to those professionals and top-flight veterans of the profession for their hard work and final selections which made this book possible.

"And my heartiest congratulations to those they selected for this first volume.

"Good luck to all other writers of the future.

"And good reading."

— L. Ron Hubbard (1985)

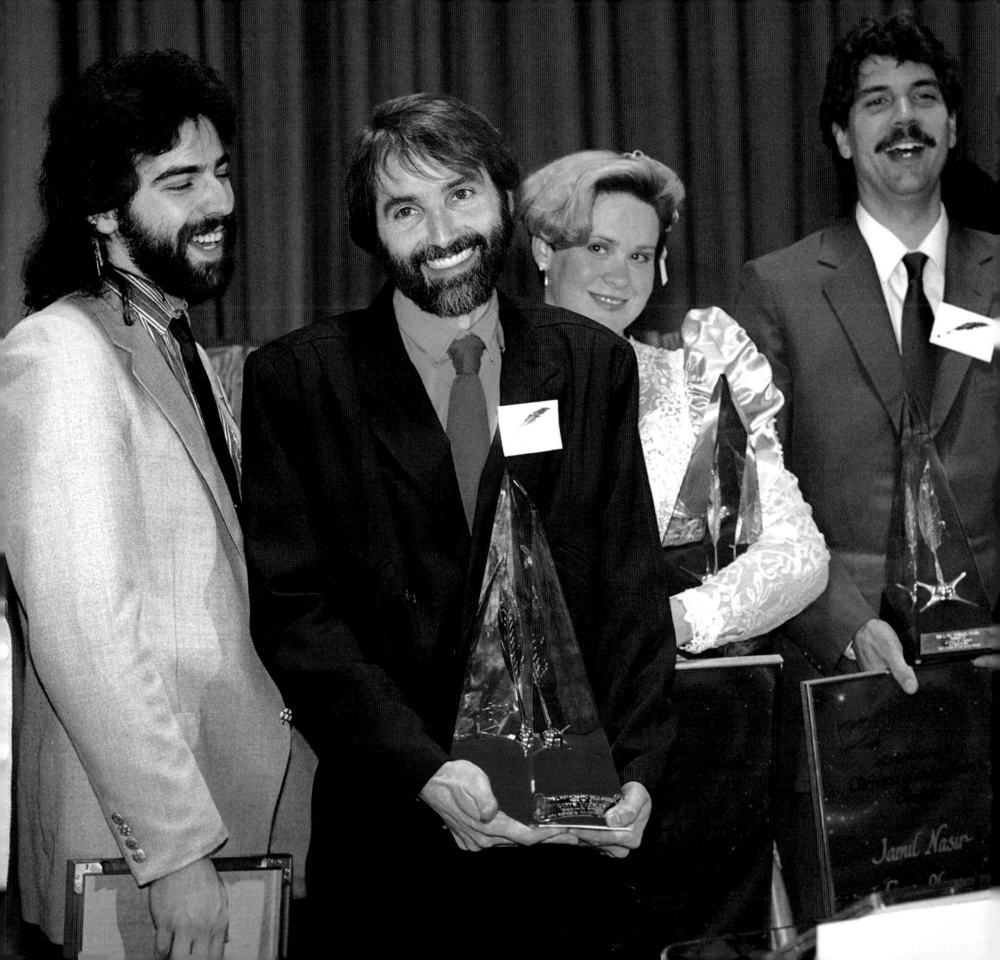

the contest

> "I feel this is the most important thing I could be doing with all the things I've learned in my life." — Algis Budrys

In 1983, in recognition of the difficult road to success that new writers had to face in an ever-tightening publishing environment, L. Ron Hubbard "initiated a means for new and budding writers to have a chance for their creative efforts to be seen and acknowledged." This was the Writers of the Future Contest, endowed with significant prize money, administered and judged by giants of the field of science fiction.

This came about after surveys at several SF conventions showed that almost 25% of attending fans harbored a secret dream to become writers themselves. L. Ron Hubbard had a long track record of helping young writers, having carried on lengthy personal fan mail correspondence, writing numerous how-to articles in writers' magazines, even forming and directing a small amateur writer contest earlier in his career.

Hubbard himself had dealt with many of the same obstacles when he was first learning not only how to direct his own talent as a wordsmith but to bring it to the attention of editors and publishers. He also knew that beginning writers often lacked for practical support—money, sound advice and

Left Gary Shockley receives the 1989 Gold Award in the WotF ceremonies at the United Nations in New York. Also pictured (L to R), Alan Wexelblat, Virginia Baker and Jamil Nasir.

meaningful encouragement from their predecessors in the writing trade. Such things have no effect on innate talent, but everything to do with the freedom for such talent to develop.

K. D. Wentworth, the current Coordinating Judge of WotF, wrote, "Only another writer can know how very hard it is to persuade oneself to set out on that long winding road to publication with all its back alleys

and notorious dead-end streets. You not only have to convince the publishing world that your work is worthy of seeing print, you have to defeat your own self-doubt which is at least as hard, if not even harder."

above Algis Budrys instructs WotF winners in the workshop at George Washington University, 1992.

With the initial announcement, the new Contest caused quite a stir among aspiring authors. There was no entry fee. The prizes were outstanding: $1,000 for first place, $750 for second, $500 for third, and publication (not to mention separate pay—and a very high pay) in a professional and widely distributed anthology. The judges were some of the most famous science fiction authors alive.

Entries poured in by the hundreds, then the thousands.

Algis Budrys, the first Coordinating Judge of the Contest, described the process of how manuscripts are received, evaluated and distributed to the judges.

"The Contest Administration sends the entrant a notice that the entry has been received, carefully records the author's name and address and story title, and safeguards the information in records none

of the Contest judges see. Then the Administrator checks to be sure no trace of the author's name appears on the manuscript itself, and forwards the now-anonymous work to me, the Coordinating Judge, in a plain, numbered envelope. I see all the eligible entries, each handled in the manner described. Then, every three months, on the quarterly schedule given in the rules, I select all the

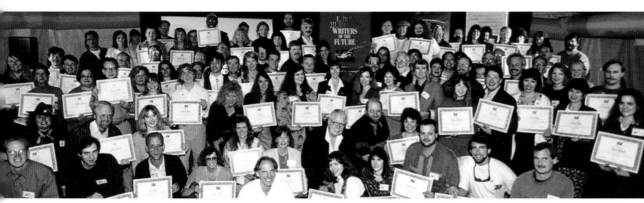

above left For the tenth anniversary of the Contest in 1994, the workshop was opened to a larger pool of aspiring writers.

above right Tim Powers teaches the 2007 workshop in Pasadena.

stories I judge to be publishable speculative fiction, and pass those on to a group of Finalist judges chosen from our panel of the world's top-flight creators of SF in the English language.

"Each quarter, the Finalist judges select three winners. The quarterly winners are contacted as soon as the judging results come in and are tabulated. Their personal reactions are as varied as their stories: stunned silence, disbelief, yelling, crying, laughing . . . you name it and we've probably heard it.

"The only criterion for winning is a good SF story, of whatever kind is published in the field or could be published to SF readers. We don't know who the authors are, we don't know their age, sex, race, or their circumstances in life, and we can only guess at their hopes and fears because we can assume they are the same as ours were. The readers read, and thus encourage the writers. The writers make sure there's something new for the whole family to read. And WotF provides a specific, effective channel for getting that done.

"Without aspiration for the future, there is nothing."

In the second year of the Contest, L. Ron Hubbard instituted a $4,000 Grand Prize award for the top story among the four First Prize winners, in addition to the $1,000 they already receive for First Prize. Thus, each year one lucky winner of both First Prize and Grand Prize will go from being a complete newcomer to receiving $5,000 for a short story, plus the money he or she would earn from publication and reprint rights.

No other science fiction prize comes close to this.

Dave Wolverton, who succeeded Budrys as WotF Coordinating Judge in 1991, described his process.

"I read thousands of stories each year, trying to find promising new writers, and I began to notice a trend. I would start out the year in something of a cold panic. When those first few crates of stories started hitting my doorstep, I would pull them open and cross my fingers, hoping that in them I would find the next Heinlein or Orson Scott Card or Anne Rice or Andre Norton.

"That's the dream, to discover someone really marvelous. And if I can't find someone who is of that quality, then at least I want to find some stories that are exceptional—stories that we can laugh with, or cry with, or which hold some rare beauty or simply astonish us. Always as I read through the boxes of manuscripts, I found many, many stories that didn't measure up. Then the cold sweat would get colder. But every quarter I found a handful of stories that did measure up. At that point, I'd give a sigh of relief at the very least. I have even been known to jump up and down if I found something really exceptional.

"Some of the stories in each anthology were more polished or accomplished than others. Some were from authors who chose, for whatever reason, to create perhaps only one or two works in this genre and then moved on to other things.

Left The "passing of the quill"—In 1991 Algis Budrys welcomed former Contest winner and protégé Dave Wolverton as Coordinating Judge for WotF. Budrys remained heavily involved with the Contest, workshop and anthology for many years until his death in 2008.

right Frank Kelly Freas and Ray Bradbury at the inauguration of the Illustrators of the Future Contest.

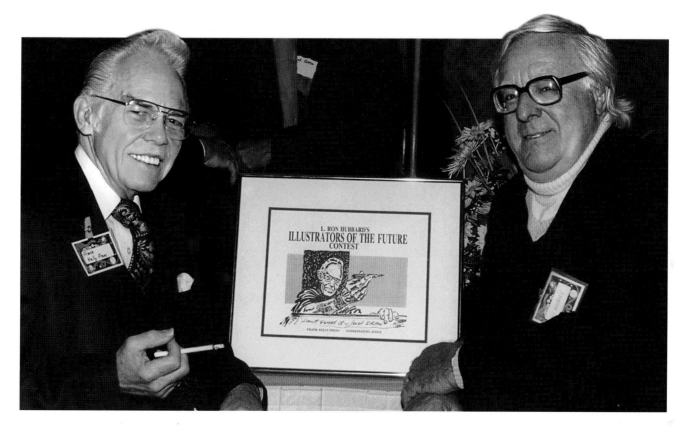

"But some of the authors I helped discover went on to become recognizable names in later years. Of that, I am sure. And over the course of the volumes I edited, I have to say that I'm pretty proud of the work that we've published. After each year, I finished the job knowing that there never was any reason to break out into that cold sweat. It never failed. Good new authors kept coming."

Though L. Ron Hubbard passed away in 1986, his literary agency, Author Services, Inc., continues to administer the Writers of the Future program, which has thrived for a full quarter century.

Three years after the first Writers of the Future Awards ceremonies, in 1988, a parallel contest for novice illustrators was launched. The Illustrators of the Future Contest boasted science fiction legend Frank Kelly Freas as its Coordinating Judge. The Illustrators of the Future Contest has likewise had a long and successful run in training and encouraging many of the brightest stars in science fiction illustration, with a veritable hall of fame of judges, including Frank Frazetta,

Frank Kelly Freas, Will Eisner, Paul Lehr, Ron Lindahn, Val Lakey Lindahn, Bob Eggleton, Vincent Di Fate, Edd Cartier, Diane and Leo Dillon, Laura Brodian Freas, Stephen Hickman, Shun Kijima, Jack Kirby, Stephan Martiniere, Judith Miller, Moebius, Cliff Nielsen, Sergey Poyarkov, Alex Schomburg, H. R. Van Dongen, William R. Warren, Jr. and Stephen Youll.

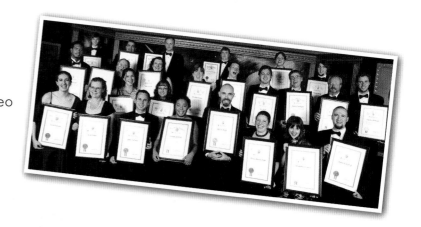

Twenty-five years later, many of the writers who were first published in *Writers of the Future* volumes are now appearing regularly in magazines and in bookstores; other major publishers in the field seek them out. A gratifying percentage of Contest winners have already been contenders for top awards on an equal footing with long-established SF authors; some have even become judges for the Contest. No other field of popular literature offers its novices such an opportunity for lifelong success.

Over the first quarter of a century of its existence, the Writers of the Future Contest has produced three hundred winners, enthusiastic and dedicated new writers from the United States, Canada, Australia, England, France, Zimbabwe, Sweden, Ireland, Scotland and the Netherlands. The total prize money awarded amounts to $325,000.

Publishers Weekly acknowledged the Contest as "the most enduring forum to showcase new talent in the genre." In 2005, *Library Journal* presented the Contests its

above The winners of 2008 received an official certificate of congratulations from the Mayor of Los Angeles.

Left Dylan Otto Krider receives the Gold Award in 2002.

Award of Excellence in recognition of "discovering, fostering and nurturing writers and illustrators of speculative fiction and successfully infusing new talent into the fields of literary and visual arts."

The important thing about the design for the program is that it reflects a profound grasp of how creativity works—that it must be supported but left unfettered. At its core, the program primarily does two things: it encourages talent with measured and practical rewards with no strings attached, and it imposes no form of "editorial policy" on the winning stories or on the future work of its authors.

As Algis Budrys wrote, "To me the impressive thing is not so much that L. Ron Hubbard chose this way to impart a lasting, fruitful legacy to the field in which he had done so much significant work. It is that he did it so well."

above A small selection of the proclamations and awards the Writers and Illustrators of the Future Contests have received.

The following is excerpted from Robert Silverberg's celebratory article in the 25th volume of
L. Ron Hubbard Presents Writers of the Future *anthology.*

retrospective:
writers of the future

Robert Silverberg

As I wrote in the first *Writers of the Future* **anthology,** "We were all new writers once—even Sophocles, even Homer, even Jack Williamson." (That great, much beloved and long-lived SF writer who, I sometimes thought, began his career only shortly after Homer's or Sophocles' and was still turning out award-winning fiction in his nineties, just a few years ago.)

Or, as I said in the tenth volume, after compiling a list of some of the best-known writers who had emerged from the Contest, "All of them were amateurs ten years ago, when this Contest began. But you see their names regularly in print these days. Like you (and like Robert A. Heinlein, Arthur C. Clarke, Ray Bradbury, Isaac Asimov and, yes, Robert Silverberg) they wanted very, very much to be published writers and, because they had the talent, the will and the perseverance, they made it happen."

Or, to quote my essay in the *twentieth* annual anthology, "Hubbard too had been a young, struggling writer once, in the pulp-magazine days of the 1930s. He loved science fiction and he wanted to ease the way for talented and deserving beginners who could bring new visions to the field. His idea was to call for stories from writers who had never published any science fiction—gifted writers standing at the threshold of their careers—and to assemble a group of top-ranking science fiction writers to serve as the judges who would select the best of those stories. The authors of the winning stories

Left Gold Award winners in 1991, writer James C. Glass (left) and artist Sergey Poyarkov.

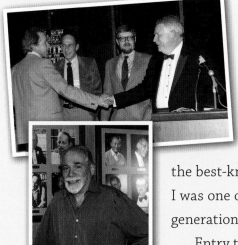

would receive significant cash prizes and a powerful publicity spotlight would be focused on them at an annual awards ceremony."

I quote myself three times here because I've been part of this project for the entire twenty-five years of its existence, and so, from time to time, I'm asked to write little commemorative essays to mark another milestone in its remarkable history. Back there in 1983 calls went out to many of the best-known SF writers of the day, asking them to serve as judges in the Contest. I was one of them. My old friend Algis Budrys—we had once been part of the same generation of new writers ourselves, back in the 1950s—would be in charge.

Entry to the Contest was limited to writers who had never had a novel or a novella professionally published and no more than three short stories. Algis would winnow the entries down to six or eight, from which the judges would choose the three best. As I said the last time I told this story—I will have to keep quoting myself, because I have been involved in this enterprise for so long—"I didn't hesitate. I was a new writer once myself, after all, back in the Pleistocene. A very young one, who was adopted as a sort of mascot by the established pros along the eastern seaboard where I lived then, taken under this wing and that one, and treated very well."

It was quite a crowd: names to conjure within the science fiction world, people like Frederik Pohl, Isaac Asimov, Lester del Rey, Algis Budrys, Cyril M. Kornbluth, Robert Sheckley. They all knew how hard it was for a new writer to break in—for they had been new writers once, too—and they offered me every sort of help. Some of them introduced me to the big New York editors, from John W. Campbell, Jr., and Horace Gold on down. Some of them gave me tips about what I had done wrong in a particular story that was getting rejected all over the place. Some of them offered me advice about things I was doing wrong in my published stories, showing me that even though I had found some editor silly enough to buy them, I had begun them in the wrong place, or failed to squeeze all the juice out of a good idea, or used eleven words where three would have sufficed. And some, for whom I feel nothing but love, spoke roughly to me—very roughly indeed—about my early willingness to take the easy path to short-range gain at the price of long-range benefit, and what that was going to do to my career if I continued to go that route.

above top First-year judges take the stage: Robert Silverberg, Roger Zelazny, Dr. Gregory Benford and Algis Budrys.

right Carla Montgomery receives her Second Place Award from Dr. Jerry Pournelle, 1998.

23

I learned my lessons well, back there fifty years ago, and I went on to have the big career as a science fiction writer that I had daydreamed about when I was just a star-struck boy. And because those older writers had so kindly helped me along my path, I have always felt an obligation to do the same for the writers who came into science fiction after me. It's an eternal cycle of repayment. (The great SF writer Cyril Kornbluth, who was one of those who was willing to teach me some tough lessons in the 1950s, put it that way explicitly: others had helped him break in when he was a kid, he felt that it behooved him to do the same for newcomers like me, and he hoped that I would follow suit in my turn.)

And so I have, working with young writers in one fashion or another over the decades, as Cyril (who has been dead for nearly half a century now) told me to do long ago. I wasn't the only big-name author who recognized what a great idea the Writers of the Future Contest was. Among the other original judges were two writers who had been stars of the field even before I was born—Jack Williamson and C. L. Moore—and another—Theodore Sturgeon—who had established himself in the top rank when I was still a young reader. The other three members of the original group were Gregory Benford, Roger Zelazny and Stephen Goldin. So the panel spanned three or four generations of science fiction history, from the early Hugo Gernsback days on, and covered the whole literary spectrum of the field from flamboyant fantasy to nuts-and-bolts hard science.

I have the first of the twenty-five Writers of the Future anthologies of prize winners on my desk now. Five of the writers included in it have gone on to establish solid professional careers—Karen Joy Fowler, David Zindell, Dean Wesley Smith, Leonard Carpenter and Nina Kiriki Hoffman. (Hoffman, in fact, has become a Contest judge herself, the first of several Contest entrants to undergo that transformation in the course of the past quarter of a century.) Most of the others in that first book have scarcely been heard from again at all: but five discoveries in a single year's batch of amateur writers is a pretty good percentage.

The second year's volume—in which Frank Herbert, Gene Wolfe, Anne McCaffrey, Larry Niven and Frederik Pohl added their luster to the board

above top Hal Clement, Robert Silverberg, Frederik Pohl, Dr. Jerry Pournelle.

above bottom Robert Silverberg presents the Second Place certificate to Mary Frances Zambreno, 1985.

left Karawynn Long with her Gold Award, 1993.

of judges—brought us stories by such future stars as Robert Reed (writing then as "Robert Touzalin"), Howard V. Hendrix and Marina Fitch. The third year saw Jerry Pournelle joining the panel of judges, and among the winning writers whose stories are reprinted in that year's anthology are M. Shayne Bell, Martha Soukup, Dave Wolverton, J. R. Dunn and Carolyn Ives Gilman.

So it has gone, year after year. Stephen Baxter turns up in the fifth anthology with his third published story, along with K. D. Wentworth and Jamil Nasir. Jay Lake, Sean Williams, Eric Flint and Nancy Farmer enter the roster of winners in later years, along with dozens of others whose most significant achievements still lie ahead. Death has taken many of the early judges—Algis Budrys, Frank Herbert, Charles Sheffield, Andre Norton, Hal Clement, Theodore Sturgeon, Roger Zelazny, Jack Williamson, C. L. Moore and all too many others, but Gregory Benford and I still remain from the original panel of twenty-five years ago and such illustrious figures as Ben Bova, John Varley, Orson Scott Card, Tim Powers, Robert Sawyer and Ramsey Campbell became members of the list of judges later on.

An old pro like me can tell pretty easily, from reading just half a dozen sentences, whether their author has that mysterious innate storytelling magic that separates the pros from the amateurs. No doubt some of the writers whose Contest submissions have seemed to me lacking in that magic have gone on to achieve brilliant careers anyway, but then there are the other stories, the ones that immediately announce, "Here is a star." You know it right away, when you read one of those. You feel a certain electricity. And it's a wonderful feeling.

As I look back over the history of the Writers of the Future Contest, I feel great pride in what we have done to help the work of those writers gain prominence in the publishing world and I know that L. Ron Hubbard would feel that way himself. Thus the Contest, now entering the second quarter of a century of its existence, has served the purpose for which he brought it into being: to provide "a means for new and budding writers to have a chance for their creative efforts to be seen and acknowledged." And, as I said five years ago and hope to say again five years from now, the process continues. The amateurs of today are the Hugo and Nebula winners of tomorrow. The Writers of the Future Contest is helping to bring that about.

right Tobias S. Buckell with his First Place trophy, 2000.

the judges

"When new science fiction writers ask me what they ought to do first, I tell them to send their best work to the Writers of the Future. The Contest is one of the best things to happen to science fiction since the Golden Age." — Dr. Jerry Pournelle

The Writers of the Future Contest identifies and nurtures some of the best new talent in the genre. In doing so, it relies on what L. Ron Hubbard envisioned as *"a special blue ribbon panel"* —prominent, successful authors in the field—to read the entries and select the winning stories for each quarter. Many of the judges also give presentations and help teach the students at the annual workshop.

During the creation of the Contest, Algis Budrys began to assemble the core team of judges from the best of the best among his peers, and this blue ribbon panel has grown over the years.

Budrys wrote, "Each of us has a certain personal knowledge of how hard it is to hoe one's way toward success as a writer, and then to keep it going. Almost all of us owe something to the tutelage of older writers who took us under their wings when we were first breaking in. That's an old tradition in the arts, and particularly in SF, whose 'Good Old Days' weren't all that long ago.

left A gathering of WotF judges for the ceremonies at the Houston Space Center, 1996. Pictured (L to R): Dr. Doug Beason, Kevin J. Anderson, Dr. Jerry Pournelle, Larry Niven, Algis Budrys, Jack Williamson, Frederik Pohl, Tim Powers, Dr. Gregory Benford, Dave Wolverton.

right Algis Budrys launches the Awards ceremonies.

There were no academies, so there had to be masters and apprentices if our literature was going to live and evolve.

"All the competition judges represent top, multiple-award-winning talent from every generation since the pioneering days of SF on the newsstands. They serve virtually without recompense. Why do they do that? They do it because no one ever forgets what it was like to dream of acceptance and recognition, often in the long face of repeated discouragement. And they do it because historically in the SF field, beginning writers have never been regarded as potential competition; they are new comrades."

KEVIN J. ANDERSON

Kevin J. Anderson is the author of over a hundred books, nearly half of which have appeared on national or international bestseller lists; he has over twenty million copies in print in thirty languages. He has won or been nominated for the Nebula Award, Bram Stoker Award, the SFX Reader's Choice Award and *New York Times* Notable Book.

Anderson coauthored eleven books in the Dune saga with fellow WotF judge Brian Herbert, and eight high-tech thrillers with WotF judge Dr. Doug Beason. Anderson's epic Saga of Seven Suns and his Terra Incognita fantasy trilogy (including two crossover rock CDs) are his most ambitious works. He has written numerous novels based on *The X-Files*, Batman and Superman and *Star Wars* (particularly the Young Jedi Knights series with his wife, Rebecca Moesta, who is also a WotF judge). He has edited seven anthologies (three of which are the bestselling SF anthologies of all time).

Living in Colorado, Anderson is an avid hiker and mountain climber; he has scaled all fifty-four of the state's peaks higher than 14,000 feet and has walked more than 300 miles of the Colorado Trail.

As a new author, he was an early WotF contestant, entering many times before he became a professional author in his own right, and thus ineligible for further submissions. He became a guest instructor in 1993 and a judge in 1996.

above Rebecca Moesta and Kevin J. Anderson lecture at the WotF workshop in Hollywood, California.

"*Before the Writers of the Future Contest, the new writer had no marketplace where he competed only with his peers—other new writers. When I was starting out, the Contest gave me a goal to shoot for: prize money, trophy, recognition and most of all the chance to participate in a marvelous writing workshop. The quarterly deadlines gave me goals, and I improved so much that I started making sales. I am now honored to be one of the judges for the Contest, and I enjoy sharing my knowledge and experience with each year's winners.*

There is great satisfaction in helping to teach the winners every year, helping them forge their writing careers, and—often faster than it seems possible—welcoming them as professional colleagues.

— *Kevin J. Anderson*

DR. DOUG BEASON

Dr. Doug Beason is the author of fourteen books, eight with collaborator Kevin J. Anderson, including *Ignition* (film rights purchased by Universal Studios) and *Ill Wind*, as well as two nonfiction books and over one hundred short stories, journal articles and scientific papers. His novel *Assemblers of Infinity* (with Anderson) was a Nebula Award finalist, and his short fiction has appeared in numerous magazines and anthologies; he has written for publications as diverse as *Analog*, *Amazing Stories*, *Physical Review Letters*, *Physics of Fluids* and *Taking Sides: Clashing Views on Controversial Issues in Science, Technology, and Society*. He submitted to the Contest many times when he was an aspiring author, and though he didn't win, his career has done quite well.

above
Dr. Doug Beason
and Dr. Jerry
Pournelle.

A Fellow of the American Physical Society and PhD physicist, Dr. Beason has over thirty years of research and development experience; he has conducted basic research, directed applied-science programs and formulated national policy. He was recently an associate laboratory director at the Los Alamos National Laboratory, responsible for programs that reduced the global threat of weapons of mass destruction. Prior to that, he completed a career as a US Air Force officer, retiring as a colonel. He has worked on the White House staff for the President's Science Advisor under both the Clinton and Bush administrations. He currently serves as chief scientist for the USAF Space Command. He has lived in Canada, the Philippine Islands and Okinawa, as well as Washington DC, California, New Mexico and Colorado; he has been married for more than three decades and is the proud father of two daughters.

He became a Writers of the Future judge in 1996.

The Writers of the Future Contest is like the gift that keeps on giving. As a new writer, the skills, perseverance and attention to detail I learned while competing in the Writers of the Future Contest inspired me to write professionally. I still consider the friends I made as a contestant some of my closest confidants. And years later as a judge, the anticipation I feel helping to discover new talent provides me with a rush of joy and wonder each time I read a contestant's manuscript.

But those are selfish gifts, benefiting only myself. The Contest is much more than that. When one considers the enormous impact the contestants and winners are having in publishing, in winning awards, and even in shaping the field of science fiction, the Writers of the Future Contest will benefit generations to come: the gift that keeps on giving.

— *Dr. Doug Beason*

(Note: the views presented are those of the author and do not necessarily represent the views of the DOD or its components.)

DR. GREGORY BENFORD

At the beginning of his career, Dr. Gregory Benford entered and won Second Place in a *Magazine of Fantasy & Science Fiction* contest, so it is fitting that he has served as a judge for the Writers of the Future Contest for all twenty-five years of its history.

A PhD physicist, Dr. Benford is the author of such landmark SF novels as *Timescape, In the Ocean of Night, Heart of the Comet* (with David Brin), *Artifact* and *Eater*. He has been nominated for four Hugo Awards and twelve Nebula Awards (winning two).

Dr. Benford proposed the "Library of Life" project in a groundbreaking paper published in the *Proceedings of the National Academy of Sciences* and developed the proposal for conducting Arctic aerosol experiments to promote cooling. He is a professor of physics at the University of California, Irvine.

Who twenty-five years ago would have foreseen the impact of this program? The awards? The professional writers sent out to a welcoming world?

The Contest has made so many writers into professionals, a list too long to include here. In the end, the best thing to learn from the teaching and encounters is a good general rule: good writing is not about knowing words, grammar or Faulkner, but having that rare ability to tell the truth—an ability that education and sophistication often serve to suppress.

— *Dr. Gregory Benford*

BEN BOVA

Best known for his Grand Tour series and his Voyagers trilogy, Ben Bova writes realistic cutting-edge science fiction about humanity's expansion into the solar system. He succeeded the legendary John W. Campbell, Jr., as editor of *Analog* magazine and was vice-president and editorial director of *Omni* magazine.

Bova has published more than one hundred novels and nonfiction books and has served the SF and space community for most of his career. He is president emeritus of the National Space Society and served as president of the Science Fiction Writers of America. He has won six Hugo Awards and received the Lifetime Achievement Award of the Arthur C. Clarke Foundation in 2005 for fueling mankind's imagination regarding the wonders of outer space. He served as a Writers of the Future judge from 1990 to 1991.

John W. Campbell, Jr., the greatest editor ever, spent his life encouraging new writers and helping them to succeed in their craft. When John died and I was picked to be the new editor of Analog *magazine, I found that my greatest joy was discovering new stars for the science fiction firmament.*

The Writers of the Future Contest helps to perform this crucial function. The vitality of the field stems from developing new writers. The Writers of the Future Contest encourages writers—the best thing that anyone interested in the field of science fiction/fantasy can do.

— Ben Bova

ALGIS BUDRYS

Algis Budrys (1931–2008), known as "AJ" to his students and friends, was one of the most prominent forces behind the Writers of the Future Contest, workshop and anthology series. He was born in Königsberg, East Prussia, on January 9, 1931. He became interested in science fiction at the age of six, shortly after coming to America when a landlady slipped him a copy of the *New York Journal-American* Sunday funnies.

Algis began selling steadily to the top magazine markets at the age of twenty-one, while living in Great Neck, Long Island. He sold his first novel in 1953 and produced eight more novels, including *Who?*, *Rogue Moon*, *Michaelmas* and *Hard Landing*, and three short story collections. In addition to writing, he was renowned as an editor, serving as editor in chief of Regency Books, Playboy Press and all the titles at Woodall's Trailer Travel publications. He also edited *Tomorrow Speculative Fiction*, where he published numerous new authors (many of them his students at WotF).

In 1983, Algis was enlisted to help establish a new writing contest for aspiring writers. This was a request he took to heart. Not only did Algis assist with the judging, he used his well-known skills as editor for the annual anthology. He attended scores of science fiction conventions, speaking on panels during the day about the Writers of the Future, and again at night discussing the Contest with many of the top names in science fiction and fantasy, using his influence and charm to bring them on board as Contest judges.

In 2001 Algis Budrys received the L. Ron Hubbard Lifetime Achievement Award for Outstanding Contributions to the Arts. Algis believed in the Contest and in what it would do for the field of science fiction and fantasy. After more than a quarter of a century, Algis' faith has certainly proven itself.

We do not claim these writers would be unknown if it were not for us; we do claim that we found them and gave them a platform, in some cases years before anyone else would have. And we will continue to do so, finding new names, each year, to join with the old. That was L. Ron Hubbard's plan, and it is a good one. "The artist injects the spirit of life into a culture," he wrote. And "A culture is only as great as its dreams, and its dreams are dreamed by artists." He knew what he was talking about.

— *Algis Budrys*

RAMSEY CAMPBELL

The Oxford Companion to English Literature calls Ramsey Campbell "Britain's most respected living horror writer." Campbell's seminal work in the 1960s was based on H. P. Lovecraft's Cthulhu Mythos, and he has published numerous collections of his short stories.

His best-known horror novels range from the supernatural to the nonsupernatural, including the classics *The Face That Must Die, Incarnate, Midnight Sun* and *The Darkest Part of the Woods.*

Ramsey Campbell served as a Writers of the Future judge from 1987 to 1994.

ORSON SCOTT CARD

Orson Scott Card is the author of the SF novels *Ender's Game, Ender's Shadow* and *Speaker for the Dead,* which are widely read by both adults and younger readers and are increasingly used in schools. Card also writes contemporary fantasy, biblical novels, the American frontier fantasy series the Tales of Alvin Maker, poetry and many plays and scripts. He has won the John W. Campbell Award, the Nebula (twice), the Hugo (four times) and the 2008 Margaret A. Edwards Award for Young Adult Literature.

Card was born in Washington and grew up in California, Arizona and Utah. He recently began a long-term position as a professor of writing and literature at Southern Virginia University. Since 2001, he has run an annual "literary boot camp," an intensive critiquing workshop for aspiring writers; he has also written two books on writing.

Orson Scott Card has been a judge of the Writers of the Future Contest since 1994, having earlier served as a guest instructor at the writers' workshops, both at Sag Harbor, Long Island and at Pepperdine University in Los Angeles.

When people ask, "How do I get started writing science fiction and fantasy? How do I get published?" I tell them there is no secret to it. It's not who you know. A cover letter from me will get you the same

treatment as if you just send it in over the transom. Maybe worse, depending on how the editor feels about my work!

If you've got a good story and you have not yet been published, the first thing you do is submit it to the *Writers of the Future Contest*. I tell everybody that it's the only literary contest I've seen that is worth entering.

Part of that is simply because *Writers of the Future* responds within three months. That's a better response time

above Orson Scott Card with Jay Kay Klein.

than people can get from most of the magazines. You know whether the story is going to win. If not, then you can send it elsewhere. You're not tied up for a year waiting for the contest results.

But the most important reason I recommend *Writers of the Future* to new writers is the quality. You're going to be competing with the best. It's a truism in the science fiction field that you have to break in with a story that is better than average. Established writers can sell an average-quality story because their name on the cover helps sell issues. They've been around so long people say, "Oh, I know who she is," or "I liked his novel," so they pick up the magazine. But if nobody has ever heard of you, you'd better have an extraordinarily good story for it to have enough impact to launch a career.

The *Writers of the Future Contest* gets the best work of new writers with fresh ideas. Reading the winners is like the exhilaration of a brand-new thrill ride—you've never heard this voice before, never shared this vision. That's why the annual anthology is always so good.

In fact, the book is key to everything. If you win a contest and all you get is money or a press event or a nice line to add to your résumé, does that really make a difference? People still don't know anything about your work. But by putting out the best short fiction anthology today, *Writers of the Future* is able to give new writers a spectacular launch to their careers.

I won't even try to list the writers whom I saw first in the *WotF* anthology, who have gone on to become important writers in every branch of speculative fiction. Whether they stayed with short fiction for a while or moved quickly to novels, they began to build an audience—and the editors noticed them. If you can get into the *WotF* anthology, or even place in the Contest, you have instant credibility with the editors. They're part of the public conversation of science fiction.

Writers of the Future simply is the best way to launch a career. It's one of the forces that keep science fiction alive.

— *Orson Scott Card*

HAL CLEMENT

Hal Clement (1922–2003) was born Harry Clement Stubbs in 1922 and earned degrees in astronomy, chemistry and education. He was a multiengine pilot in World War II, and by that time, he was already publishing stories in *Astounding Science Fiction* with his own brand of "hard" SF: a combination of gripping story with meticulously worked-out scientific extrapolation of a totally alien environment.

He is best known for his novels *Mission of Gravity, Iceworld* and *Needle.* A lifelong science fiction enthusiast, Clement was a proud member of First Fandom.

He was named a Grand Master by the Science Fiction Writers of America in 1998 and became a WotF judge in 2001. Hal Clement passed away in 2003.

Writing a science fiction story is fun, not work . . . treat the whole thing as a game.

You are painting a word picture (or a series of them—the frames in a movie). Your pigment is your vocabulary, your brushes are the rules of grammar and your model is the universe—the known (and thinkable, if you're extrapolating) laws of Nature.

— *Hal Clement*

above Hal Clement with actress Denice Duff and 2002 First Place winner Ray Roberts.

below Kevin J. Anderson, Eric Flint and Dave Wolverton after teaching a writing seminar in Pasadena, 2010.

ERIC FLINT

Eric Flint is a prolific and successful author of military science fiction, alternate history and fantasy. He has written over fifty novels, both solo and in collaboration with K. D. Wentworth, David Drake, David Weber, Mercedes Lackey, Dave Freer and many others. He has edited numerous anthologies, particularly the Grantville Gazette series based on his 1632 universe, and was also the founder and editor of *Jim Baen's Universe* online magazine.

Flint has also worked as a longshoreman, truck driver, meatpacker, auto forge worker, glass blower and machinist's apprentice; he spent nearly a quarter of a century working as a machinist before deciding to turn his hand toward writing in 1992, at the age of 45. And he started off with a bang. Having taken First Place in the fourth quarter of 1993, Eric Flint joins Dave Wolverton, Nina Kiriki Hoffman, Sean Williams, Dean Wesley Smith and K. D. Wentworth as a WotF winner-turned-judge.

The Writers of the Future Contest played a very important role in launching my career as an author. So I'm delighted to be able to pay forward the favor by serving as a judge for the Contest myself.

— Eric Flint

STEPHEN GOLDIN

Stephen Goldin is the author of over thirty science fiction and fantasy books, including *The Eternity Brigade, Assault on the Gods,* the Arabian-Nights style Parsina Saga and the Agents of ISIS space opera series. In collaboration with his first wife, Kathleen Sky, he wrote the acclaimed nonfiction book *The Business of Being a Writer;* with his second wife, Mary Mason, he's written the series of novels, The Rehumanization of Jade Darcy. He spent three years as editor of the *SFWA Bulletin,* and served a term as the organization's western regional director.

From 1984 to 1987, he was the Contest's First Reader, sorting through the ever-increasing piles of manuscripts that came in from entrants. He remembers:

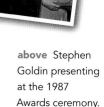

above Stephen Goldin presenting at the 1987 Awards ceremony.

I would go through the literally hundreds of submissions each quarter and winnow the entrants to the best couple of dozen for the judges to consider seriously. In other words, I never picked any of the actual winners.

I handled this responsibility every quarter for about three years. I read some that have stuck with me to this day. I'm proud of the work I did, and of the small part I played in helping start some truly outstanding careers in the field. My time involved with the Contest was one of the most positive things I've done in my life.

— Stephen Goldin

BRIAN HERBERT

Brian Herbert, the son of Frank Herbert, is the author of multiple *New York Times*–bestselling novels coauthored with Kevin J. Anderson. After his father passed away, Brian stood in for him at the second WotF Awards ceremony at Norwescon in Seattle-Tacoma in 1986. In 2003, he published *Dreamer of Dune,* the Hugo-Award-nominated biography of Frank Herbert; the same year, he himself became a Writers of the Future judge.

Brian Herbert is the winner of several literary honors and has been nominated for the highest awards in science fiction. His recent SF trilogy, the Timeweb Chronicles, was published by Five Star, and his earlier acclaimed novels include *Sidney's Comet; Sudanna, Sudanna; The Race for God* and *Man of Two Worlds* (written with Frank Herbert). With Anderson, he is currently writing an original SF trilogy, Hellhole.

The benefit of the Writers of the Future Contest is not only to individuals; it is to the community of SF writers as a whole, for such a program elevates the quality of SF writing by bringing on board talented future professionals. WotF, and SF writers as a whole, are a community of caring individuals.

Any new writer who has been helped by such a program or by an experienced writer in other (non-WotF) situations is likely to be a better, more generous person. He or she will keep the memory of being helped, and will in turn extend a helping hand to others.

— *Brian Herbert*

top Janet Herbert and Brian Herbert at the 2006 Awards banquet.

bottom Brian Herbert and Kevin J. Anderson working on a new Dune novel, 2006.

FRANK HERBERT

Frank Herbert (1920–1986) was a reporter and editor on a number of newspapers before becoming a full-time writer. Although he had been publishing short fiction in various SF magazines since 1952, he became an "overnight" success in 1956 with his first novel, *The Dragon in the Sea*, which was serialized as *Under Pressure* in John W. Campbell's *Astounding Science Fiction* magazine.

Frank Herbert's career took a major turn with the 1963 publication (also in *Astounding*) of the first Dune story. After that, the Dune series became world famous, sparking both a major motion picture adaptation by David Lynch and two miniseries on the Sci-Fi Channel. Other seminal works include *The Dosadi Experiment*, *The White Plague*, *Hellstrom's Hive* and *Destination: Void*.

Frank Herbert was an uncompromising advocate for the solid storytelling principles and rigorous research that are a core SF tradition. He served as a Writers of the Future judge from 1985 until his death. The last essay Frank Herbert ever wrote was for the Contest, with the clear purpose of fulfilling what he saw as a paramount obligation to his art and craft.

I'd like to say something about older hands helping newcomers. Like many other established writers, I teach students on frequent occasions and lecture to many other audiences anxious for advice on writing. I'm very happy to be able to lend my help to the Writers of the Future program. From time to time, though, people have come up to me and asked why I want to "create competition" by helping newcomers.

Talking about "competition" in that way is nonsense! The more good writers there are, the more good readers there will be. We'll all benefit—writers and readers alike!

So the other piece of advice I have for newcomers is: "Remember how you learned, and when your turn comes, teach."

— *Frank Herbert*

NINA KIRIKI HOFFMAN

Over the past twenty-some years, Nina Kiriki Hoffman has sold adult and young adult novels and more than 250 short stories. Her works have been finalists for the World Fantasy, Mythopoeic, Sturgeon, Philip K. Dick and Endeavour Awards. Her first novel, *The Thread That Binds the Bones,* won a Stoker Award, and her short story "Trophy Wives" won a Nebula Award in 2009. Her most recent novels are *Fall of Light* and *Thresholds.*

Nina does production work for the *Magazine of Fantasy & Science Fiction* and she also works with teen writers. She became a judge of the Writers of the Future Contest in 2000.

I was invited to judge the Contest some years ago, and I've really enjoyed having that opportunity. Each year the job gets harder, because the finalists chosen by K. D. Wentworth are more skillful; it's hard to choose among them. It's exciting to see what beginning writers are doing these days. They have access to so much more information than we did back in the eighties. I didn't get my first modem until 1990. Before that, I was limited to what my local writers' group knew or could find out at science fiction conventions, or by reading magazines and books. Today's connectivity gives writers more scope to learn and grow, and many of them are using that.

The Contest has continued to offer me the chance to make friends with new writers and reconnect with established writers at the Awards ceremonies every year. Writers and illustrators with exciting talents and new ideas show up every year, and it's fun to see them go on to even greater things.

— *Nina Kiriki Hoffman*

top Presenter Jim Meskimen and Nina Kiriki Hoffman with Third Place winner Fiona Lehn, 2009.

bottom Judges Dr. Yoji Kondo, Nina Kiriki Hoffman and Robert J. Sawyer with Finalist Andrew Gudgel.

DR. YOJI KONDO

Born in Japan, Dr. Yoji Kondo—who writes SF under the name Eric Kotani—holds his PhD in astronomy and astrophysics from the University of Pennsylvania and has been with NASA since 1965. At the time of the Apollo missions to the Moon, he was head of the Astrophysics Laboratory at the Johnson Space Center. He served as director of the International Ultraviolet Explorer satellite observatory at Goddard Space Flight Center and is now a coinvestigator of the Kepler Mission to detect Earth-sized planets within the habitable zone of their primary stars. He has taught at several major universities, served as president of two International Astronomical Union commissions, and is a recipient of the NASA Medal for Exceptional Scientific Achievement. He has published over 150 papers in refereed scientific journals and edited eight scientific books.

above Sean Astin with Dr. Yoji Kondo and Ursula Kondo.

In the science fiction realm, he has written several novels, some of them in collaboration with John Maddox Roberts. His Robert A. Heinlein retrospective, *Requiem,* was a national bestseller.

He became a Writers of the Future judge in 1998, but has been involved with the Contest since 1989, when he served as a panelist at a WotF-sponsored symposium at the United Nations.

"*It is indeed a pleasure for me to take part in L. Ron Hubbard's Writers of the Future Contest. The judges in the Contests and the instructors at the workshops for the winning writers and illustrators have always been of the highest professional caliber. The quality of the winners has been quite remarkable.*

However, it is not only all those things I mentioned that makes the Contest so amazing. It is also the way you carefully nurture the talents of the winners and promote their careers through effective public relations work even after the Contest.

I would like to commend the late L. Ron Hubbard for founding this wonderful Contest to discover and help new gifted writers and illustrators. Without new talents entering the field, surely no profession can sustain its vigor for long. In fact, one of the most important things that a successful professional can do in any field of human endeavor is to help train the next generation of workers, be they writers, artists, engineers or scientists.

— *Dr. Yoji Kondo*

ANNE MCCAFFREY

Anne McCaffrey is one of the most successful science fiction authors in the latter half of the twentieth century, and has been an enthusiastic Writers of the Future judge since 1985. Best known for her Dragonriders of Pern series (which she is now coauthoring with her son Todd McCaffrey), she has also written the Acorna series, the Brain & Brawn Ship series, the Crystal Singer series, the Dinosaur Planet series, the Doona series, the Freedom series and many other novels, both alone and in collaboration with other authors. She has won the Hugo and Nebula Awards. She lives in Ireland now, raising magnificent horses as well as writing wonderful fiction, but she returns as often as possible for the annual Writers and Illustrators of the Future ceremonies, whenever her health permits. (She has claimed that WotF is one of the only reasons she'll make the long trip, these days.)

Anne McCaffrey received the L. Ron Hubbard Lifetime Achievement Award for Outstanding Contributions to the the Arts in 2004. The Science Fiction Writers of America named her a Grand Master in 2005.

She sent the following words to celebrate the 25th Anniversary Awards event:

"First let me mention how very much I wish I were also there but, at eighty-three, even air travel is difficult and taxing. Occasionally I give way to "sensible" advice. But I miss the adventure of meeting new writers—and artists—of our special genre, especially when they are recipients of the generosity of L. Ron Hubbard, whose early career made him so aware of the problems of writing in general and of science fiction in particular that he set up the scheme of Writers— and Illustrators—of the Future to assist dreamers to realize their potentials. Not only are you here to learn more about your future, you are able to recognize the most important aspect. Becoming published! Lift your glasses and your hearts to the fact that

left
Anne McCaffrey and son Todd McCaffrey.

this is the twenty-fifth ceremonial dinner in the Contest, sponsored for folks like you by L. Ron Hubbard, who also wanted to be published and to give a helping hand, as well as solid advice, to other dreamers. It is a constant satisfaction to me to have been a judge in this wonderful scheme, especially as it has been joined by a similar contest for artists of the future.

WotF and its artistic counterpart have been sponsored by a visionary like L. Ron Hubbard who wanted to make it easier for all of us to be published, which has already been one of your successes this weekend. Now you must go forward with even more creative works. Mr. Hubbard has set the scene for you. Get on with it.

Do thou go forward in your efforts with thanks to the WotF and your mentors dining here tonight. Live long, and prosper.

— Anne McCaffrey

REBECCA MOESTA

Rebecca Moesta wanted to be an author since her early teens, but it wasn't until 1991 that she began writing in earnest. She has written or ghost written more than thirty books, including *Buffy the Vampire Slayer: Little Things* and three Star Wars: Junior Jedi Knights novels. With her husband, fellow WotF judge Kevin J. Anderson, she wrote two movie novelizations, a novel based on the StarCraft computer game and a Star Trek graphic novel, *The Gorn Crisis.* As a team, Moesta and Anderson are best known for their series of fourteen bestselling and award-winning young adult Star Wars novels, the Young Jedi Knights. Their original Crystal Doors fantasy trilogy was published by Little, Brown, and the pair penned the lyrics to two rock CDs. They are currently working on Star Challengers, a series of books to promote space and science education, in conjunction with the Challenger Learning Centers. Moesta, who earned an MS in Business Administration from Boston University in 1985, has taught every grade level from kindergarten through junior college.

She is CEO of WordFire, Inc., the company that she and Kevin J. Anderson own. In addition to her writing, she serves as final reader and copy editor on her husband's manuscripts. After being a guest lecturer at the WotF workshop for many years, she became a judge in 2007.

There is a good reason for the success of the Writers and Illustrators of the Future Contests. No one understood better than L. Ron Hubbard what it means to be a creative professional. He wanted to help up-and-coming talents, and fortunately, he knew exactly what they needed. In the spirit of late-night entertainers, here is my own "Top Ten" list of the most important things a new author needs:

above Rebecca Moesta with husband Kevin J. Anderson on the observation deck of the Space Needle, 2005.

Top 10 Ways to Help Beginning Writers & Illustrators

1. Inspire them—The Writers and Illustrators of the Future Contests give aspiring writers and artists a goal to strive toward.

2. Set a challenge—For WotF, writers have a quarterly deadline by which to submit a speculative fiction story whose merit will be judged "blind" (judges never see the name, gender, race, etc., of the entrants).

3. Reward a job well done—No comparable contest provides such a breadth of incentives: publication in a world-renowned series of books, an award that looks as impressive on the mantel as it does on a résumé, free instruction by experts in their field, a professional paycheck.

4. Publicly recognize their achievements—Each year, a magnificent event celebrates the winners of the contests and gives them a rare platform from which to thank those who have helped them along the way.

5. Instruct them in their craft—L. Ron Hubbard not only established the contests, he wrote a series of articles covering countless aspects of writing and creativity. The intensive workshop for Contest winners is one of the most broad-based and enlightening of its kind.

6. Educate them on their business—Every year, working writers, publishers, editors and illustrators offer the winners common-sense insights to expand the students' understanding of their business.

7. Encourage them—Contest winners are celebrated for their talent. In the week leading up to the Awards ceremony, they are given opportunities to meet and socialize with well-known authors and artists (many of whom were Contest winners themselves) and ask them for advice.

8. Lead by example—Like Hubbard, Contest judges are successful creative professionals, following the time-honored tradition of paying it forward to help the next generation.

9. Plan for the future—By endowing the Contests with secure financing, Hubbard provided for the future, so that WotF and IotF could continue to inspire new creative talent for decades to come.

10. Provide opportunities—The Contests open countless doors for the winners, such as introducing them to respected professionals in other specialties, inviting them to participate in autograph and media events and giving them a chance to network with experts and peers in their artistic fields.

As a judge, I've also shared in these benefits, and I am proud to be a part of the Writers of the Future Contest.

— Rebecca Moesta

C. L. MOORE

Catherine Moore (1911–1987) was a master of science fiction and fantasy, a pioneer in the field. Her first stories appeared in pulp magazines in the 1930s and '40s, particularly *Weird Tales* and *Astounding Science Fiction*. She married fellow Golden Age SF writer Henry Kuttner and collaborated with him on many stories under the pen name Lewis Padgett. One of her stories, "Mimsy Were the Borogroves," was the basis for the 2007 film *The Last Mimsy*.

C. L. Moore was also a founding member of the WotF judges' panel, serving with a pride and dedication that continued her years of assistance to new and aspiring writers, until her death in 1987.

The following is an excerpt from a letter she wrote to L. Ron Hubbard in 1937 as a relatively new author asking for advice:

I wouldn't hesitate to ask questions for fear of being thought inquisitive, of course. You seem to be at the place where I hope to reach in a few years—writing widely for the pulps, with a book or two out, beginning to cast glances into the greener pastures beyond. And any technical advice you can give me will be deeply appreciated. . . .

Anyhow, thanks a great deal for all the encouragement, and for liking my gilded-gingerbread style of writing.

— C. L. Moore

LARRY NIVEN

Larry Niven was working on his master's degree in mathematics when he dropped out to write science fiction. He broke into professional SF writing in 1964 and has been going strong ever since. Now a giant in the world of science fiction, he is best known for his Known Space future history, a still-growing series of more than thirty novels and stories. *Ringworld,* the most famous of these titles, won the Hugo, Nebula and Locus Awards. He later coauthored a series of novels with fellow judge Dr. Jerry Pournelle, including the celebrated national bestsellers *The Mote in God's Eye, Lucifer's Hammer* and *Footfall.*

Larry Niven received the L. Ron Hubbard Lifetime Achievement Award for Outstanding Contributions to the Arts in 2006. He has been a Writers of the Future judge since 1985.

I wish the Writers of the Future Contest had been a part of my early life. It's a wonderful opportunity, a powerful boost for a new writer: not just the money, but publication in an anthology that has garnered much prestige over the decades.

— *Larry Niven*

bottom Larry Niven and Robert J. Sawyer with Third Place winner Andrew Tisbert, 2004.

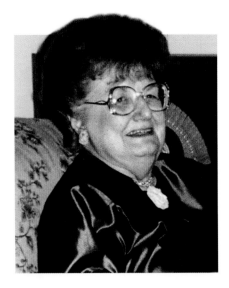

ANDRE NORTON

Science fiction and fantasy legend Andre Norton (1912–2005) wrote popular stories over a span of seventy years. Her given name actually was Alice, but as teenage boys were her main readers, she adopted the ambiguous name *Andre.* "I am very used to being 'Mr. Norton' and have stunned radio program directors when acting as guest-interviewee by appearing in skirts."

Called the "Grande Dame of Science Fiction and Fantasy," Andre Norton broke ground for women in the genre; she was the first woman to receive Grand Master awards from both the World

Science Fiction Society and the Science Fiction Writers of America. Her 1965 novel *Year of the Unicorn* was the first American fantasy novel with a female chief protagonist.

Generations of readers have grown up voraciously reading Andre Norton's work. Her novels featured a recurring theme of a journey to find one's full potential—and that more than anything speaks of her dedication to the new writers in the Writers of the Future Contest.

She became a judge in 1988 and served until her death in 2005.

L. Ron Hubbard believed that newcomers to the imaginative field should be encouraged and nourished. From this conviction was eventually born the Writers of the Future Contest, in which fledgling authors might receive experienced critical assessment of their efforts, and recognition, in the form of prizes and publication, for quality work.

The privilege and pleasure has been given me to serve as one of the judges for this competition. The many stories of high merit which have been placed in my hands have proven that Mr. Hubbard was emphatically correct in his estimation: that a cadre of leaders-to-be in the field of imaginative writing stands ready, willing and able to deliver its best when given the chance of a lifetime to do so offered by the Contest he established. To paraphrase Walt Kelly's Pogo, "We have met the Future—and it is They."

I think Mr. Hubbard, who was an excellent writer himself, would be most pleased could he know what is being done in his name.

— Andre Norton

FREDERIK POHL

A notable SF author since before World War II, Frederik Pohl has also been an editor of great influence, starting at *Astonishing* and *Super Science* magazines and going on to *Galaxy, IF* and others. He is the discoverer of R. A. Lafferty, Keith Laumer and Larry Niven, among scores of other well-known figures. He has also been a novel editor at several prestigious publishing houses and served as an instructor for writers' programs.

His own fiction includes "Day Million," *The Gold at Starbow's End, The Space Merchants* (with C. M. Kornbluth), *The Cool War* and

Man Plus. His novel *Gateway* won every major SF award the year of its publication. As editor, he also received numerous kudos. One year, *IF* won the Hugos in every eligible category.

The Science Fiction Writers of America named Frederik Pohl a Grand Master in 1993. In 2000, Pohl earned the L. Ron Hubbard Lifetime Achievement Award for Outstanding Contributions to the Arts. He has been a Writers of the Future judge since 1985 and was one of the instructors at the first prototype WotF workshop in Taos, New Mexico.

"When unpublished writers ask for advice about how to get their careers moving I always advise them to enter their stories in the WotF Contest. I'm very pleased with the results of the first twenty-five years and hope it goes on for another twenty-five years.

— *Frederik Pohl*

top Frederik Pohl with Elizabeth Anne Hull.

bottom Frederik Pohl and Dr. Jerry Pournelle with Lawrence Schliessmann, Third Place winner, 2004.

Dr. Jerry Pournelle

Dr. Jerry Pournelle was born in Louisiana in 1933. His formal education includes a bachelor's degree in engineering, a master's degree in statistics and systems engineering, and two PhDs (psychology and political science). He credits his broad spectrum of practical knowledge to working in such fields as the military, aviation, aerospace, higher education, politics and computers. He has been a member of the Citizen's Advisory Council on National Space Policy since it was formed and an influential voice in the world of computers and digital technology.

In science fiction, Pournelle has written numerous novels, many of them in collaboration with fellow WotF judge Larry Niven. Among his numerous bestsellers are the blockbusters *The Mote in God's Eye*, *Lucifer's Hammer*, *Footfall* and *Oath of Fealty*. He has edited many anthologies and written a range of nonfiction pieces for the SF media. He is also a past president of the Science Fiction Writers of America.

Dr. Pournelle received the L. Ron Hubbard Lifetime Achievement Award for Outstanding Contributions to the Arts in 2006.

Pournelle has been a WotF judge since 1986.

" *I confess to being a skeptic when Writers of the Future was first announced, and after AJ (Algis Budrys) talked me into becoming a judge I was still skeptical. I told him I wasn't much impressed with the stories. "All of them?" Budrys asked. "Not one of them is good?" And of course, I had to admit that there were a couple of stories I liked a lot, and it was silly to worry about the rest. I hadn't thought it through. After a couple of years when the Contest became better known, it got harder and harder to pick the winners as the general quality of the stories went up. Sure enough, over time WotF became the most important first market for beginning writers.*

There's no such thing as instant success in writing, and it's still important to learn the craft, but one of the best ways of doing that is through success in WotF with its no-nonsense workshops and advice from working successful writers (including me). Not every WotF winner becomes a successful writer, but an astonishing number of them have managed that. I'm glad Algis talked me into being a part of it.

— Dr. Jerry Pournelle

above Roberta and Dr. Jerry Pournelle.

TIM POWERS

Tim Powers was born in Buffalo, New York, on Leap Year Day in 1952, but has lived in southern California since 1959. He graduated from California State University at Fullerton with a BA in English in 1976; the same year saw the publication of his first two novels, *The Skies Discrowned* and *Epitaph in Rust*. Powers' subsequent novels are *The Drawing of the Dark*, *The Anubis Gates* (winner of the Philip K. Dick Memorial Award and the Prix Apollo), *Dinner at Deviant's Palace* (winner of the Philip K. Dick Memorial Award), *On Stranger Tides*, *The Stress of Her Regard*, *Last Call* (winner of the World

Fantasy Award), *Expiration Date, Earthquake Weather* and *Declare* (winner of the World Fantasy Award). His most recent book is *Three Days to Never*. The *Manchester Guardian* called Powers "the best fantasy writer to appear in decades."

Powers has taught at the Clarion Science Fiction Writers' Workshop at Michigan State University six times and currently teaches the annual Writers of the Future workshop with K. D. Wentworth. He has been involved with the Contest since the early years, serving as one of the instructors (along with Algis Budrys and Orson Scott Card) at the very first official WotF workshop in Sag Harbor. He was formally inducted as a judge in 1993.

Powers lives with his wife, Serena, in San Bernardino, California.

"*I think I've been a judge for most of the quarters in the past two decades. This means that several times a year I get a stack of manuscript photocopies via next-day mail, and take a day off from my own writing to read them all and evaluate them; this is no chore, since Dave Wolverton or K. D. Wentworth has already culled them from the total volume of submissions, and invariably there is at least one story that I'm grateful to have a chance to read. I send my verdicts in, and usually I hang on to a couple of the photocopies, just because I want to have the chance to read them again before the actual anthology is published.*

The stories at this point have no provenance beyond their titles—I don't know the genders or ages or addresses of the writers; and not all of them turn out to live in North America, by any means. The only thing I can be fairly sure of is that I have not read anything by any of these writers before.

(Over the years, I have read a lot of subsequent books from many of them, with their names right there on the spines and their photos on the dust jacket flap—though since I'm not a very up-to-date reader, I generally don't get around to reading them until they've been nominated for Hugos or Nebulas or World Fantasy Awards.)

— Tim Powers

top Tim and Serena Powers.

50

MIKE RESNICK

One of the most facile, prolific and respected writers in the genre today, Mike Resnick has won five Hugos (and been nominated thirty-four times—a record for a writer); he has also won a Nebula and other major awards in the USA, France, Spain, Poland, Croatia and Japan, and has been short-listed for awards in England, Italy and Australia. According to *Locus* he is the all-time leading award winner, living or dead, for short science fiction.

He's the author of sixty-one novels, over 250 stories, fourteen collections and two screenplays, and the editor of more than forty anthologies. Some of his best-known novels include *Kirinyaga, Santiago*, the Widowmaker series and the Starship series. He recently served stints as consulting editor for BenBella Books and executive editor for *Jim Baen's Universe*. He became a new Writers of the Future judge in 2009.

I'm very pleased to have been asked to judge the Writers of the Future Contest. Over the years I've bought a number of stories by Contest winners and runners-up for my own anthologies, and have never been disappointed by their quality.

— *Mike Resnick*

KRISTINE KATHRYN RUSCH

Kristine Kathryn Rusch is an award-winning mystery, romance, science fiction and fantasy writer. She has written many novels under various names, including Kristine Grayson for romance and Kris Nelscott for mystery. Her novels have made the bestseller lists—even in London—and have been published in fourteen countries and thirteen different languages. She is married to, and has often collaborated with, fellow WotF judge, Dean Wesley Smith.

She and Kevin J. Anderson first met in a college creative writing class as young aspiring writers and have kept in touch ever since (when they found they learned more from each other than from the minimally published professor). They both entered the Contest many times, but neither placed in a quarter before becoming professional writers.

51

Now, Rusch's awards range from the Ellery Queen Readers Choice Award, to the Hugo Award, to the John W. Campbell Award. She was nominated for the Hugo, the Shamus and the Anthony Award all in the same year (2009). She is the only person in the history of science fiction to have won a Hugo Award for editing and a Hugo Award for fiction. Her short work has been reprinted in thirteen Year's Best collections (one story, "G-Men," appeared in both the best mystery and best SF collection, the first story ever to do so).

Under her own name, Rusch's novels include the Fey series, the Retrieval Artist series, *Hitler's Angel*, *The White Mists of Power*, *Alien Influences*, *Diving into the Wreck* and many more.

She is the former editor of the prestigious *Magazine of Fantasy & Science Fiction*. Before that, she and Dean Wesley Smith started and ran Pulphouse Publishing, a science fiction and mystery press in Eugene. She lives and works on the Oregon Coast and she became a WotF judge in 2010.

For more than twenty-five years, Writers of the Future has picked the brightest stars out of the annual pool of new writers. And not just stars from the science fiction universe, but stars who have gone on to make their mark in the literary mainstream (Karen Joy Fowler), in romance (Jo Beverley) and young adult (Nancy Farmer), just to name three. I've always floated around the edges of the Contest. I'm happy to finally have an official role.

— *Kristine Kathryn Rusch*

ROBERT J. SAWYER

Robert J. Sawyer, called "the dean of Canadian science fiction" by *The Ottawa Citizen*, has won all three of the science fiction field's top honors for best novel of the year, the Hugo, the Nebula and the John W. Campbell Memorial Award, as well as eleven Canadian Science Fiction and Fantasy Awards (Auroras). The ABC TV series *FlashForward* was based on his novel of the same name. *Maclean's: Canada's Weekly Newsmagazine* says, "By any reckoning, Sawyer is among the most successful Canadian authors ever."

top Kristine Kathryn Rusch with DC Comics editor Julius Schwartz.

bottom Kristine Kathryn Rusch and Dean Wesley Smith at the first "Lab Rats" workshop for WotF at Taos, New Mexico.

Sawyer's novels are top-ten mainstream bestsellers in Canada. His twenty novels include *Frameshift, Factoring Humanity, Calculating God, Wake* and the Neanderthal Parallax trilogy: *Hominids, Humans, Hybrids.* He's often seen on TV, including such programs as *Rivera Live* with Geraldo Rivera, *Canada AM* and *Saturday Night at the Movies,* and he's a frequent science commentator for Discovery Channel Canada, CBC Newsworld and CBC Radio.

Sawyer holds an honorary doctorate from Laurentian University and has taught writing at the University of Toronto, Ryerson University, Humber College, the National University of Ireland and the Banff Centre. He edits Robert J. Sawyer Books, the science fiction imprint of Red Deer Press. He was born in Ottawa in 1960, and now lives near Toronto with his wife, poet Carolyn Clink.

"*When I was approached to be a judge for Writers of the Future, I had only to look at the names of the other judges to know that this was a group that I wanted to be part of. Larry Niven! Fred Pohl! Anne McCaffrey! These were the authors I'd grown up reading, and I knew that if they were involved, this had to be a first-rate enterprise. And it is.*

The weeklong writers' workshop that Tim Powers and K. D. Wentworth run for the winners each year is phenomenal; I love presenting at it, and I always learn things from the other pros who give talks there. The Awards ceremony is without parallel in the science fiction field, classier than the Hugos, the Nebulas and the John W. Campbell Memorial ceremonies combined. The list of past winners and runners-up reads like a Who's Who of the last quarter century of the SF/F field. And the physical anthologies—packed with brilliant stories and thoughtful essays, all wonderfully illustrated by the artist winners—is always a joy to behold: a terrific book, and a terrific launch to the careers of the latest batch of the very best new writers in the field.

— *Robert J. Sawyer*

bottom right
Robert J. Sawyer with Illustrator judge Stephen Hickman and Lydia van Vogt.

DR. CHARLES SHEFFIELD

Dr. Charles Sheffield (1935–2002) published over thirty books, ranging from horror (*The Selkie, The Judas Cross*) to hard science fiction (*Godspeed, Cold as Ice, The Web Between the Worlds*) to sociological science fiction (*Brother to Dragons*), thrillers and detective fiction. In addition, he published over ninety short stories in nearly every major magazine in the fields of science fiction, horror and mystery. He won the Campbell Award for best science fiction novel and the Hugo and Nebula for his works at shorter length.

Born in England, he was educated at St. John's College, Cambridge, where he graduated with first-class honors in mathematics. Dr. Sheffield was also a bestselling writer of such nonfiction books as *Earthwatch, Man on Earth* and *Space Careers*. He authored over a hundred papers on astronomy, large-scale computer systems, earth resources, gravitational field analysis, nuclear physics and general relativity. He served as a reviewer for several publications, including the *New Scientist,* the *Washington Post* and *The World and I.*

Always erudite and insightful, Dr. Sheffield participated at the 1988 WotF ceremonies in Hollywood and the 1989 ceremonies at the United Nations in New York. He became a WotF judge in 2001 and passed away the following year.

I have one thing that I usually say to would-be science fiction writers: Never forget how lucky you are to be writing science fiction. A professional tennis player or professional football player must operate on a court or a field that is defined in advance, and is the same for everyone. You don't have that constraint. You get to choose your playing field, and you can place it in the area of your own greatest strengths. If you want to tilt the field a certain way for your particular advantage and convenience, that's your privilege. No level playing field for you. Science fiction writers are the most fortunate people on earth.

— *Dr. Charles Sheffield*

ROBERT SILVERBERG

In a career that goes back to 1954, Robert Silverberg has published hundreds of science fiction stories and more than a hundred novels. He has won five Nebula and five Hugo Awards and in 2004 was named a Grand Master by the Science Fiction Writers of America. Robert Silverberg is also a recipient of the L. Ron Hubbard Lifetime Achievement Award for Outstanding Contributions to the Arts (2003).

His best-known books include *Lord Valentine's Castle*, *Dying Inside* and *A Time of Changes*. A long-time and fervent supporter of the Contest, he has been a Writers of the Future judge since its first year.

When I agreed to become a judge for the newly established Writers of the Future Contest back in 1984, I assumed that this would be a well-intentioned program that at best would give two or three young writers a leg up as they began their careers. If you had told me then that twenty-five years later I would be celebrating the continued success of an established, flourishing program with a long list of alumni swelling the ranks of professional SF and fantasy writers, I probably would have smiled and said something like, "Well, yes, maybe so." But here we are a quarter of a century down the line and that is exactly what has happened.

Writing is not an easy profession, and the path to a professional career is a daunting one. Under the guidance of such fine advisors as Algis Budrys, Tim Powers, K. D. Wentworth and Dave Wolverton, the Contest—and the writers' program that grew out of it—marches forward, providing support to young writers. WotF is unique in its dedication to developing great writing careers. A few may be getting started this very day. My congratulations to you all, and to the program for its splendid efforts over these many years.

— Robert Silverberg

DEAN WESLEY SMITH

As a published Finalist at the inaugural Writers of the Future ceremonies in 1985, Dean Wesley Smith was the first person ever to receive a WotF Award, accepting his framed certificate from judges Dr. Gregory Benford, Roger Zelazny, Robert Silverberg and Algis Budrys.

Over the following twenty-five years, Smith published more than ninety popular novels and over one hundred short stories. He has over eight million copies of his books in print and has been published in nine different countries. He has written many original novels in science fiction, fantasy, mystery, thriller and romance as well as books for television, movies, games and comics. He is also known for writing quality work very quickly and has written a large number of novels as a ghostwriter or under house names. With his wife (and fellow WotF judge) Kristine Kathryn Rusch, he has written The Tenth Planet trilogy and *The 10th Kingdom*. Smith has also written books and comics for all three major comic book companies, Marvel, DC and Dark Horse.

Smith is an avid poker player and a former golf pro. With Rusch, he was also cofounder and publisher of Pulphouse Publishing (which earned them a World Fantasy Award), before editing for *VB Tech Journal,* then for Pocket Books.

He became a WotF judge in 2010.

above Kristine Kathryn Rusch and Dean Wesley Smith, guest presenters at the 1991 Awards ceremony.

After ten years of editing Strange New Worlds, a contest patterned after Writers of the Future, it is a real honor to return to where I started back in Volume One and be a judge for Writers of the Future. I think this Contest has done more to help new writers achieve their dreams than anything that has come before. I know it gave me a huge push. It's wonderful to return to be a part of it again as a judge.

— *Dean Wesley Smith*

THEODORE STURGEON

Theodore Sturgeon (1918–1985) began his professional writing career while still in his teens and became a major player in what is now seen as science fiction's Golden Age. Sturgeon wrote numerous classic novels and short stories, including *More Than Human*, "Microcosmic God," "Shottle Bop," "Slow Sculpture," "Killdozer," "Thunder and Roses," as well as two popular episodes of the original Star Trek ("Amok Time" and "Shore Leave"). His first story saw print in 1939 in *Astounding Stories*, and his work appeared in many of the popular magazines of the day. His six-decade career embraces fantasy as well as science fiction, and he won multiple awards for his stories and novels. His personality exhibited boundless joy in life, a constant sense of wonder and a delight in creativity.

Theodore Sturgeon was one of the first WotF judges. He died in 1985, only months after writing the following testimonial:

The [Writers of the Future] Contest is one of the greatest things ever to happen in the field. I wish it had been around when I was starting out. I'd advise, don't do anything to dilute it. I anticipate that these anthologies will continue at least as long as Damon Knight's Orbit (twenty years) and will introduce and encourage thousands of new writers."

— Theodore Sturgeon

JOHN VARLEY

John Varley went to college first as a physics major, then English, before dropping out to move to San Francisco in 1967. He began publishing short stories in the mid-1970s and became a prominent and influential figure in SF in that decade. His story "The Persistence of Vision" won both the Hugo and Nebula Awards in 1979, and he received great acclaim and a widened audience for his Gaia trilogy that includes *Titan, Wizard* and *Demon*. *The Encyclopedia of Science Fiction* calls his fiction "urgent and risk-taking." Among his other well-known novels are *The Ophiuchi Hotline, Steel Beach* and *Mammoth*.

John Varley served as a Writers of the Future judge from 1989 to 1992.

K. D. WENTWORTH

K. D. Wentworth was a Contest winner (1988), then a judge (2000) and is now First Reader and Coordinating Judge, as well as primary workshop instructor and current editor of the annual *L. Ron Hubbard Presents Writers of the Future* anthology.

Born in Tulsa, Oklahoma, K. D. attended thirteen different schools before graduating from high school in upstate New York and returning to Oklahoma to earn her BA in liberal arts from the University of Tulsa. An elementary school teacher, she entered and became a winner in the Contest. Since that auspicious start of her professional writing career, she has sold over fifty short stories (two of which have been Nebula nominees) to such markets as *Aboriginal SF, Pulphouse, Return to the Twilight Zone, Fantasy & Science Fiction* and *Realms of Fantasy*. She has also published seven novels including her two most recent, *Stars over Stars* and *This Fair Land*, several of them in collaboration with fellow WotF winner and judge, Eric Flint.

Why are the Contests important? Their scope extends far beyond the impact they have upon the actual winners themselves. They are invaluable to everyone who enters. So much of the publishing world is a closed door to the beginner. When we start out, we send in story after story only to receive form rejections which give us no clue what we're doing wrong. This is because we are competing with seasoned professionals like Tim Powers, Robert Sawyer, Orson Scott Card, Nina Kiriki Hoffman, Sean Williams or Robert Silverberg (all Writers of the Future judges, by the way) whose work is professionally polished and whose name on the cover of a publication will help sell copies.

But the single most crucial thing that will make you a better writer or artist is to practice your craft and keep producing new work. If you get discouraged and quit, you will certainly never make it. The Contests keep us working when we might otherwise give up and for many that industriousness will get us there eventually. I entered the Contest five times and each of those five stories, including the one which won, would not have been written if I had not had the Contest as my goal.

— K. D. Wentworth

above K. D. Wentworth with fellow judge Sean Williams.

Sean Williams

Australian Sean Williams is another Contest winner turned successful author and now WotF judge. Author of seventy published short stories and thirty novels, nominated for the Ditmar, the Aurealis and the prestigious Philip K. Dick Award for *Saturn Returns*, Williams has been published around the world in numerous languages, online and in spoken word editions. After winning the Writers of the Future Contest in 1992, he has never looked back. He is currently the bestselling science fiction writer in Australia and is also a #1 *New York Times* bestseller.

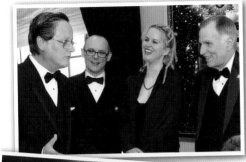

Williams lives with his wife and family in Adelaide. He completed a master's in creative writing at Adelaide University in 2005 and is currently a PhD candidate at the same institution. He is a founding board member of the award-winning Big Book Club Inc., and was recently elected to the role of Overseas Regional Director in the SFWA. He has been a guest of all the literary festivals of Australian capital cities (some of them more than once) and various national SF conventions.

Sean Williams became a WotF judge in 2003, only ten years after becoming a Contest winner.

After nearly twenty years, the Contest feels like family, one that has been there to support me as I grew as a writer. I am proud to be part of that ever-growing family as it evolves with us even further into the future.

— *Sean Williams*

top right Tim Powers, Sean Williams, Amelia Beamer (*Locus* magazine) and Illustrators of the Future judge and instructor Ron Lindahn.

center right Past winner Eric James Stone and Sean Williams talk to WotF workshop attendees.

JACK WILLIAMSON

A towering figure in the history of the genre, named a Grand Master by the Science Fiction Writers of America, Jack Williamson (1908–2006) was a working writer across more decades than any other writer in the history of SF. His first published short story, "The Metal Man," appeared in 1928, and he continued to publish novels until his death in 2006.

His Legion of Space trilogy and his Legion of Time stories are classics, as is his Humanoid series. He is generally credited with coining the terms "genetic engineering" and "psionics." Williamson was also a revered educator: a retired professor of literature in New Mexico, he produced a major scholarly analysis of H. G. Wells and several works on teaching science fiction. He was among the initial judges in the first year of the Contest and an instructor at the initial WotF test workshop in Taos, New Mexico. He received the L. Ron Hubbard Lifetime Achievement Award for Outstanding Contributions to the Arts. He served as a judge for more than two decades until his death in 2006 at the age of 98.

For the new writer, science fiction can be the last green oasis in a grimly forbidding desert. Getting a start is commonly hard, maybe harder than it used to be. When I was beginning, back in the 1920s, there were scores of pulp magazines; devoted to every sort of fiction, they bought millions of words a month. Their editors encouraged new talent, best of all by printing what we wrote.

With the story Contests . . . L. Ron Hubbard is opening new trails into the new worlds of SF—worlds still alluring to me, even after exploring them for nearly sixty years. As one of the judges, I enjoyed reading the stories. I must admit that I found the winners hard to pick.

— Jack Williamson

top Jack Williamson with Tim Powers.

bottom Jack Williamson with Algis Budrys.

GENE WOLFE

Gene Wolfe is well known for his distinctive writing style and evocative prose. He greatly influenced the SF genre with his four-volume epic The Book of the New Sun (1981–1983) and his stand-alone novels *Peace, The Fifth Head of Cerberus* and *Free Live Free*. Wolfe won the World Fantasy Award for Life Achievement and was inducted into the Science Fiction Hall of Fame. His work has received a great deal of critical acclaim, two Nebula Awards (and sixteen nominations) and eight Hugo nominations.

Wolfe has helped and influenced many writers. He was one of the instructors Algis Budrys selected for the very first test-run Writers of the Future workshop in Taos, New Mexico, was a presenter and speaker at some of the early Awards ceremonies and served as a Contest judge until 1988.

DAVE WOLVERTON

Dave Wolverton began writing during college and entered short stories into various contests, but his career began in 1987 when he won the top award in the Writers of the Future Contest.

Wolverton published several science fiction and fantasy novels including *On My Way to Paradise, Star Wars: The Courtship of Princess Leia* and, under the name David Farland,

above Dave Wolverton and Gene Wolfe in 1987.

several bestselling fantasy series including The Runelords and Of Mice and Magic. He has been nominated for the Nebula Award and Hugo Award.

Wolverton became a Contest judge in 1991 and was an esteemed instructor at the annual WotF workshop for several years. He also edited the annual *L. Ron Hubbard Presents Writers of the Future* anthology for several years before passing the role back to Algis Budrys.

As Coordinating Judge of Writers of the Future, I had the privilege of seeing thousands of stories. As I studied each one, I began by looking for a promising start—perhaps the author promised adventure or a penetrating insight into the human heart. Perhaps he or she promised a glimpse of a strange new world or perhaps the author's facility with language itself promised a rich experience. It is the very first test I make of a story. Each of the winners has made that promising start.

The Writers and Illustrators of the Future Contests have become an invaluable institution in the field, discovering important new talent, and both Contests are still growing. No other program offers the unique combination of high-paying prize money, payment for publication, workshops with blue-ribbon professionals for the winners, along with continued promotion long after the Contest. We owe a debt of gratitude to L. Ron Hubbard who recognized the need for such an institution and who, in 1983, created and launched the program.

People often ask me, "How can I win the Contest?" And the answer is simple. Write an excellent story.

— Dave Wolverton

ROGER ZELAZNY

One of the most interesting and individual stylists in the field, Roger Zelazny (1937–1995) was a full-time writer for more than three decades. He won six Hugo and three Nebula Awards for novels and shorter work; such creations as *A Rose for Ecclesiastes*, *Lord of Light* and *This Immortal* stand as enduring classics in the field. His most successful series was the bestselling Chronicles of Amber.

His work was characterized by a "science-fantasy" touch—a blend of science fiction plots and fantasy images, so that he became noted as one of our great makers of legends. He served for twelve years as a Contest judge, from the first year to his untimely passing in 1995.

A day or so after my first professional sale as a writer the activity in my pleasure center died down sufficiently to permit me to begin writing again. I sold sixteen more stories that year and I learned a lot of narrative tricks. The following year I stretched my efforts to novelette length, to novella length. I felt then that I had learned enough to try writing a novel. I did it and I sold it and the moment was golden.

I did not quit my job to write full time for another five years, however. I had seen others do this after an initial book sale—chuck everything and Be A Writer—with disastrous results. I realized that there was more to being a writer than the act of writing, that there were other lessons to be learned, that one could not rely on current sales for one's support, that one required an economic cushion and a plan for maintaining it. So I made my plans, I followed them and they worked.

There is no use in going into autobiographical detail about this. The times have changed, the markets are different. Only the principles stand. A writer still has to hustle in the beginning, and there seem to be as many different ways of going about it as there are writers. What I am saying is that the ones who succeeded and exhibited staying power had a plan. They followed it, they established themselves, they became secure. They sell everything they write now. They learned the extraliterary considerations as well as the writing reflexes necessary for the successful pursuit of the writer's trade. I counsel all new writers to begin learning about publishing, distribution, agenting,

contracts, to talk with other writers and other people in the publishing business whenever possible, to learn how things work. The actual writing is in some ways the easiest part of this business once you've mastered certain essentials, and the business side is the hardest part of writing when you are getting started.

So much for the crass, commercial end of things. It is a delight to a tourist such as myself to see the opening of new realms each time that someone learns the magic words and shows us the way. It is a sign, I feel, of the strength and attraction of this area of writing that so many new people have been moved to make the effort, and that some good things have been done as a result. For long-range success, I can only counsel perseverance.

After luck, I think it is one of the best things a writer can have.

— Roger Zelazny

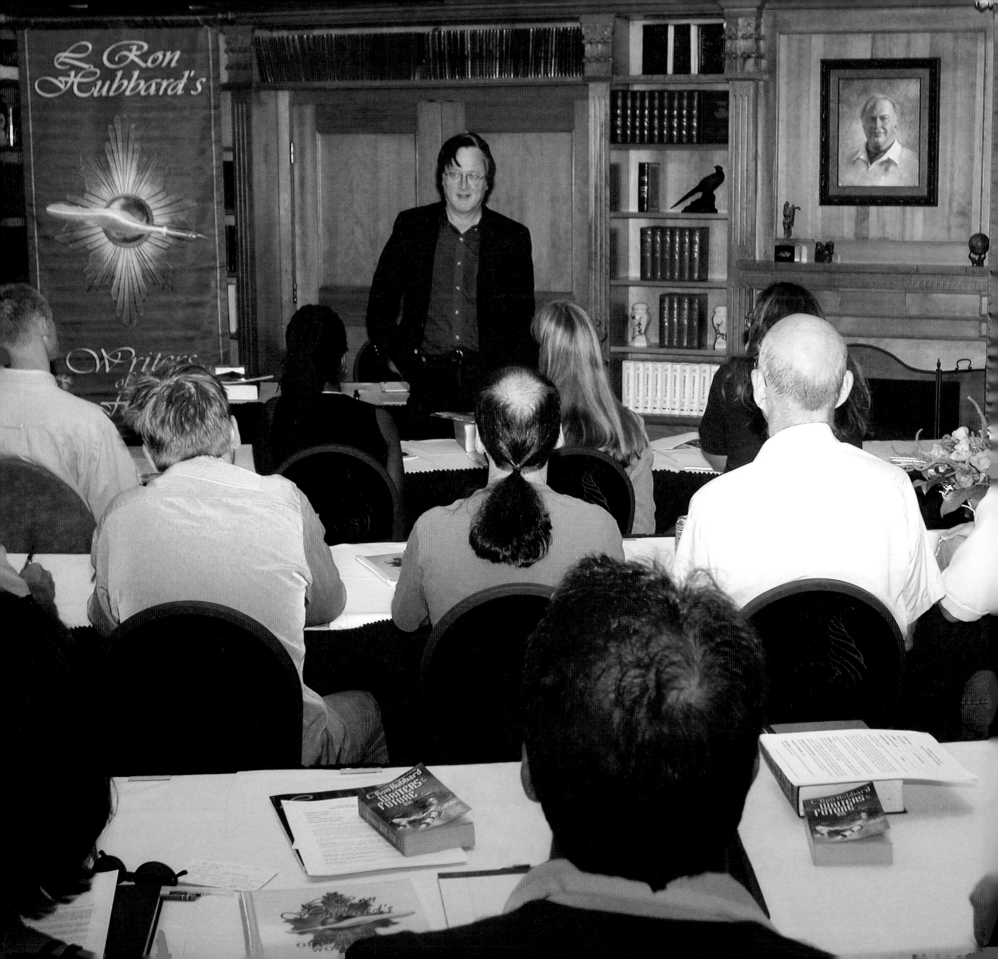

the workshop

"What astonished me was how much more was accomplished in only a few days than most workshops accomplish in weeks or months or even years." — Orson Scott Card

A wise old Chinese proverb states "If you give a man a fish, he will eat today. If you *teach* a man to fish, he will eat every day."

Along the same principle, it isn't enough for the Writers of the Future Contest just to hand the winners prize money and a trophy and be done with it. An integral part of the WotF experience is a world-class, hands-on writing workshop unlike any other, which teaches these ambitious and inspired new authors the tools they need to become true professionals with long-standing careers.

After the first two annual WotF Awards events, first at Chasen's Restaurant in Beverly Hills, then at the Norwescon Science Fiction Convention in Seattle, Algis Budrys designed the Writers of the Future workshop, armed with a repertoire of L. Ron Hubbard's classic—and still entirely valid—writing

left The Writers of the Future workshop has frequently been held in the library of Author Services, Inc.

right middle Instructors Algis Budrys and Dave Wolverton.

right bottom In 2005, the futuristic Seattle Public Library provided a fitting location for the writers' workshop.

articles published in the 1930s and 1940s. Most of the Contest winners agree that the workshop itself is a far more valuable prize than the actual trophy.

Budrys drew up the curriculum for a prototype workshop, a test run of what would become the standard. He gathered his fellow instructors—Gene Wolfe, Frederik Pohl and Jack Williamson—then

invited up-and-coming writers he had met during the first two years of WotF, as well as other contacts in the science fiction world. In May 1986, they all met in Taos, New Mexico.

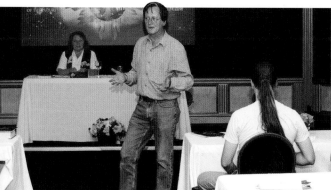

The twelve students were Ray Aldridge, Marina Fitch, Jon Gustafson, Howard V. Hendrix, Bridget McKenna, Kristine Kathryn Rusch, Ken Schulze, Dean Wesley Smith, Martha Soukup, Jay Sullivan, Lori Ann White and Mary Turzillo. "We each got a call only one week before the workshop," remembers Dean Wesley Smith. "We had to get there on our own dime, and pay our own food and rooms. The workshop itself was free."

Kristine Kathryn Rusch recalls, "We had 'twins'—people we paired up with to do assignments. We had class in the mornings and worked on assignments the rest of the day, usually getting together in the evening for one more session."

Left The 1986 Taos workshop. Back row (L to R): Jon Gustafson, Jay Sullivan, Frederik Pohl, Kristine Kathryn Rusch, Dean Wesley Smith, Mary Turzillo, Jack Williamson, Howard V. Hendrix, Algis Budrys. Front row (L to R): Ken Schulze, Marina Fitch, Ray Aldridge, Lori Ann White, Bridget McKenna, Gene Wolfe, Martha Soukup.

bottom Instructors at the Taos workshop: Gene and Rosemary Wolfe, Edna and Algis Budrys, Frederik Pohl and Jack Williamson.

"We called ourselves the Lab Rats," said Smith, "since they were all flying by the seat of their pants trying to do it."

As a testament to the genius and teaching skill of Algis Budrys and his fellow instructors, as well as the validity of the core learning material, at least eight of the newbie students went on to publish

 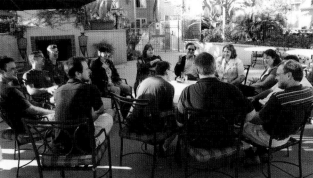 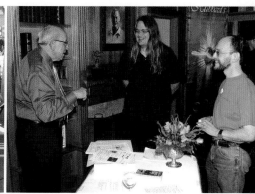

above The workshop week: After listening to lectures on writing, then studying articles by Hubbard and Budrys, students receive a random object as inspiration for a story. They learn how to research their stories, and spend off-hours time discussing writing. On the final day, guest lecturers talk about writing and publishing (pictured far right, William J. Widder).

novels or award-winning short stories, and some even have full-time careers as professional authors.

With the Taos workshop a resounding success, the following year the full-fledged workshop was incorporated into the Writers of the Future week, and the workshop was held at Sag Harbor (described in full in Tim Powers' article, which follows).

Though the order and format have been changed over years of trial-and-error, the basic curriculum has changed little since Budrys' first model. In the evening on the arrival day, the winners and instructors meet and introduce themselves, and the students receive their first homework assignment, to read two articles: "A Note on Apprentice Writing," by L. Ron Hubbard and "What a Story Is" by Algis Budrys.

ARTICLES STUDIED AS PART OF THE WRITERS OF THE FUTURE WORKSHOP:

"A Note on Apprentice Writing" *by L. Ron Hubbard*

"What a Story Is" *by Algis Budrys*

"Suspense" *by L. Ron Hubbard*

"Steps in the Right Direction" *by L. Ron Hubbard*

"The Fast Production Writer" *by L. Ron Hubbard*

"Magic Out of a Hat" *by L. Ron Hubbard*

"Circulate" *by L. Ron Hubbard*

"Story Vitality" *by L. Ron Hubbard*

"Search for Research" *by L. Ron Hubbard*

"Art, More About" *by L. Ron Hubbard*

"Art" *by L. Ron Hubbard*

"The Manuscript Factory" *by L. Ron Hubbard*

The following morning, instructors—currently K. D. Wentworth and Tim Powers—match the students up in "twin" pairs, the idea being that each winner has one specific person with whom to exchange ideas, share reactions and so forth. Throughout the day, interspersed with lectures from the instructors, they read the Hubbard articles on "Suspense," "Steps in the Right Direction" and "Magic Out of a Hat," and discuss the ideas with their twins.

In between reading these articles, the instructors teach them about plot, characterization, dialogue and how to make stories plausible and tangible.

Finally, each student receives a random object—a key, a lighter, a coin, a little statue—and, using the points in the "Magic Out of a Hat" article, they try to imagine how their objects might figure in a story. For homework that night, they read L. Ron Hubbard's "Circulate," "Story Vitality" and "Search for Research."

On the second day, the students discuss the articles with their twins, and the teachers lecture on research—the various ways to do it, its benefits—and how to start a story. "Then we turn them loose in whatever city we're in," says Tim Powers. "They're supposed to meet a stranger and strike up a conversation and learn as much as they can from the person, without saying that it's an assignment." When they return from that, the students go to the local library to research the ideas sparked by the

Left Students with random objects that must appear in their new stories, based on article "Magic Out of a Hat."

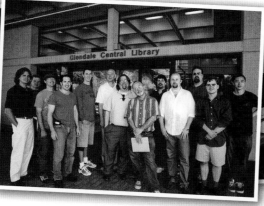

Left Researching story ideas in the library, based on article "Search for Research."

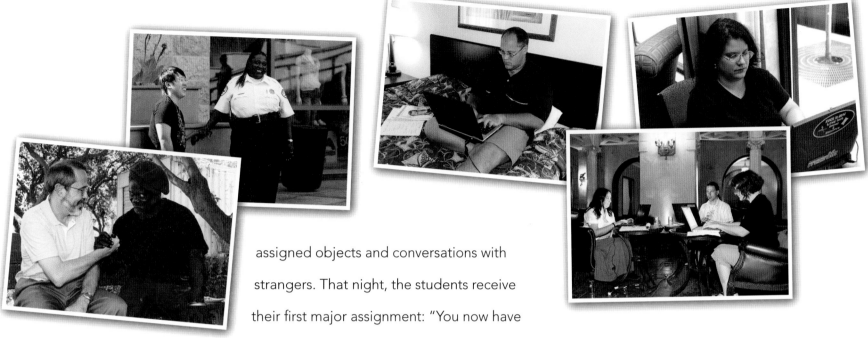

assigned objects and conversations with strangers. That night, the students receive their first major assignment: "You now have twenty-four hours in which to write a story. Go!"

above Talking with strangers to pick up character details, based on "Circulate."

right Pulling together all the pieces and using what they've learned, students write a new story in twenty-four hours.

By the following evening, they turn in the finished stories, which are always surprisingly good! Three of the stories are randomly selected for all the students to workshop.

The following day, they listen to guest lecturers on various areas of science, publishing and professional careers in writing. In the past, guest speakers have included publishing representatives on

marketing and publicity, Kevin J. Anderson and Rebecca Moesta on the business of writing, Charles N.

Brown of *Locus* magazine on the state of the genre, Dr. Jerry Pournelle, Larry Niven, Dr. Yoji Kondo and

Dr. Doug Beason on science in science fiction, as well as Dave Wolverton, David Brin, Anne McCaffrey,

Steven Savile, Robert J. Sawyer, Jack Williamson, Orson Scott Card, Kristine

Kathryn Rusch, Dean Wesley Smith, Sean Williams and many others.

On the last day, after the stories are workshopped, the writer winners

meet the corresponding winners of the Illustrators of the Future Contest,

and for the first time see the artwork that has been done for their stories in

the forthcoming anthology. This meeting of artist and writer is one of the

most popular parts of the entire week.

On the final night before the Awards

event, students and guest lecturers

gather for a casual and energetic

right After a long, hard week, the writers, artists, instructors, judges and other guests relax for a social evening to talk shop and network.

barbecue, where they have a chance to talk, exchange advice and engage in some serious "networking."

Algis Budrys ably taught the workshop for several years, always with guest instructors. Later, he was assisted by Dave Wolverton, an early winner in the Contest who became a Coordinating Judge. Although Budrys taught for many more years, he eventually handed over the reins to Tim Powers and K. D. Wentworth, herself a Contest winner in 1989.

In various years, the workshop has been held at Pepperdine University, Sag Harbor in New York, Las Vegas, Hollywood, George Washington University and the Library of Congress, Rice University, Cape Canaveral,

right A wide range of guest lecturers have given presentations at the Writers of the Future workshops. Top row: Jay Lake; past winners Eric James Stone, Sean Williams, Steven Savile. Bottom Row: Larry Niven and Dr. Jerry Pournelle; David Brin.

Seattle Public Library, Caltech and other locations. It is not the locale that matters, however, but the camaraderie and the shared wisdom.

Tim Powers sums it up: "The new writers all work like mad, learning, through action, truths about writing that would otherwise require many years of trial-and-costly-error work."

The students form lasting friendships in the workshop, colleagues who assist one another in their budding writing careers, many of whom now help other new authors to overcome the hurdles of the business.

Many attendees have gone back to their home communities and created workshops of their own for new writers. In addition, private sponsors, including a number of colleges and universities, have begun using Writers of the Future workshop methods in their own classes, as well as adopting the annual prizewinner anthologies as texts.

The philosophy of the workshop is to nurture and help, to give tools and techniques that will serve a writer well over the course of a career.

Left Workshop students, class of 2000, gather on Hollywood Boulevard.

Left After completing the workshop, the students receive a certificate during the graduation ceremony.

In the fourth volume of L. Ron Hubbard Presents Writers of the Future *(1988), Tim Powers described his experiences as a guest instructor with Algis Budrys and Orson Scott Card at the first official Contest workshop. At the time, though he may have felt like a relative newcomer himself, Powers was an award-winning author with six novels in print.*

diving in at sag harbor

Tim Powers

It was early in the overcast morning of the day after Easter Sunday, and Sag Harbor was cold. I wasn't in the harbor, of course—though a giant black dog named Buster was gaily swimming through the low gray waves after a stick his owner kept throwing out into the water—but even on the shore, with a jacket on and a cup of steaming coffee in my hand, I was realizing that they make a whole different kind of cold on this northeastern coast. It was coming in from Greenland—Sag Harbor is an old whaling village on the tip of Long Island.

In spite of having flown in to New York from California the previous evening, my wife, Serena, and I had gotten up early to walk around the village a little. I was nervous—I had to begin to "help run a writers' workshop" in a little less than an hour. I'd never attended any sort of writers' workshop aside from college-year sessions in which people tell each other how wonderful their pretentious poetry is.

More than a year earlier, in Seattle, Algis Budrys had asked me if I would work with him, and I had agreed blithely. I always agree to anything that's to take place more than a year in the future.

Now it was only minutes away. My coffee cup was empty, and though Buster had paddled back in to shore and dropped the stick at his owner's feet—and was wagging his soaked tail eagerly, hoping to be able to jump one more time into the unthinkably frigid water—I had to go jump into this workshop business. Serena and I walked back up the sand slope and crossed the pavement to the meeting room of the Baron's Cove Inn where we were all staying. A number of the students were already there. I certainly didn't know any of them well, and we all chatted in that cheery, vaguely on-edge way that people do with strangers at airports.

Then Algis and Orson Scott Card walked in—Scott was my fellow instructor, with Algis in charge— and things got down to order. In spite of having read all the stories the students had submitted, I felt the way I used to feel when I hadn't done my homework and Sister Clementissima would look straight at me. I had a fresh cup of coffee, but I don't think I got a chance to take a sip of it until we broke for lunch.

First, Algis provided a lecture on story structure—Scott and I would lecture on topics of our own later in the week—and then we workshopped stories. For that, we all wound up sitting in a wobbly circle, and

above left Scenes from Sag Harbor, New York and the WotF workshop: Tim Powers (far left), students discuss their stories (center).

74

when Algis announced which story we would workshop first, the student sitting to the right of the author said what she had thought of it: where the story worked effectively, where it had seized up, how to salvage it if indeed it could be salvaged; then the next person to the right got a chance, and so it went around the circle, with Scott and me commenting after all the students had had their says, and Algis delivering his judgment last of all. The author got to reply, after this, if he or she cared to.

above right Tim Powers and Orson Scott Card cut the graduation cake (second from right).

If this sounds a little rough, that's because sometimes, it was—everybody was at least civil, but at the same time everybody was serious and opinionated about the craft of writing, and there were to be only four days in which to cover more than a dozen stories, plus a hefty set of assignments designed to show ways to approach stories like a pro . . . which is a big step not all promising novices ever take on their own. I quickly caught on that I wouldn't be doing any of these people any favors if I were less than absolutely frank.

And so it was, and we all were, and, after my initial thankfulness at not having to bring a story of my own, I half began to wish I had—there were a lot of sharp, merciless scalpels being brandished, and I'd have been curious to see whether my own fiction would repel them or be gutted.

That took care of the morning. There'd be another batch tomorrow. The students' afternoon would be taken up with other tasks. Just before the lunch break Algis gave the students an assignment—I don't remember which it was; go interview chance-met citizens or research in the local library or write a scene based on some randomly chosen object—and told them to write it up as a brief paragraph or two. The assignments were based on some pragmatic nuts-and-bolts writing articles done by L. Ron Hubbard; every student got copies, along with reading assignments every day.

It was a busy schedule for them.

Serena and I walked along the beach to the village and had scallops and crabs at one of the restaurants on the main street. I was glad I was having more free time than the students.

Back in the meeting room, we continued to work on assignments and discuss them until about five, and then Algis and Scott and I took the index cards on which the students had written their assignment results and adjourned to Algis' room to write comments on them. After that, most of us wandered back to town for dinner.

Back in our room at last, I managed, before we turned out the light, to read a little of the book I had brought along; but our room had a connecting door with Algis', and I could faintly hear the keyboard of his portable word processor clicking away—he was writing himself a memo, as it turns out, on how to improve getting the students in tune with the principles behind the assignments. God knows what Scott Card was doing—probably writing something of his own. I just went to bed, marveling at the industry of all these people.

The next day went the same way, though Serena and I got up even earlier and managed to explore the beach quite a ways before having to head back. Buster was as busy as ever, bounding off into the surf and then coming out to shake a shower of cold Atlantic water over anyone near him. I said hello to his owner, hoping to get the chance to throw the stick out myself a time or two, but nine o'clock was looming over us, and I had to get to the meeting room.

Again the students were given an assignment to do after their lunch break, and as Serena and I sat over our own unhurried lunch—and saw a couple of the students at the next table scribbling furiously on cards, between bites of unconsidered food—it occurred to me that Buster wasn't by any means the only one in town being sent out into the cold waters to fetch things.

Again Scott and Algis and I spent the early evening going over the cards the students had written—they could fit a lot of words on one of them—and again I heard Algis' keyboard going as I turned off our light. This time, it was a book review column.

The day after that the students were assigned to write a short scene involving suspense and, just as I was getting to my feet and thinking about where to go for lunch today, Scott Card cheerfully said that this time the instructors, too, should do the assignment.

I stared at him in horror. This was like having asked Buster's owner if I could participate in the game and him hauling the stick back over his shoulder and pointing at the water and saying to me, "Sure, go out for it!"

I don't remember what I had for lunch. I spent the whole hour scribbling and crossing things out, and came puffing back to the meeting room just as the session was starting up. Scott asked to read my scene, but my writing was so scrambled that he couldn't read it; I could hardly puzzle it out myself, when the moment came to read it aloud.

And I had not done perceptibly better than most of the students—and the criticism was polite, or at least civil, and I had to admit most of it was valuable.

The next day was our last. We workshopped the last three stories mercilessly enough, but afterward we had a graduation party with a huge cake. The night before, our last night, the whole gang of us had gone exploring the docks and piers, and wound up at a 7-Eleven where, as I recall, Scott bought M&Ms for everybody. Several of us sat up very late in the meeting room; this was the last time we would be there, and this time there was none of the formality there had been the first time. We had argued and gossiped and joked until well past midnight. I had been impressed with how quick to learn they were, and how eager they were to do it. I was glad Scott and Algis and I had had this chance to pass on some hard-won know-how.

Tomorrow would be the Hubbard Awards ceremonies, and a grand time it was, with rooms at the "Vista in Manhattan" and great meals and drinks—but it's the Sag Harbor days, with their nonstop focus on writing *purposefully,* that I remember best from that trip. Many of the students have sold stories

77

since, several have written novels, and at least one has a multibook contract with a major New York publisher.

I've had to revise my original opinion of workshops and the teachability of writing. No doubt many of these people would have published eventually, but I really don't think they'd have done it nearly as fast without the focused assignments I saw at Sag Harbor.

And they're out there somewhere today, diving into waters colder and deeper than old Buster could ever swim in, buoyed by the confidence that the stick is worth the effort to go in after, and then go in after again. It may well be a delusion, but it's one that I share, and I'm proud to have had some part in their progresses.

looking back, from contestant to judge

K. D. Wentworth

In 1989, I stood on a carpeted dais with twelve other writers at the United Nations and accepted my framed plaque for winning Third Place in the last quarter of the 1988 L. Ron Hubbard Writers of the Future Contest. I felt I was on the brink of my career—I had gotten my foot in the door at last. What I had dreamed of for so many years was all about to happen. As it turned out, I was both right and wrong.

I went back to Tulsa and resumed teaching, kept in touch with some of my workshop friends, and wrote. The publisher of *L. Ron Hubbard Presents Writers of the Future* scheduled radio interviews for me all across the country, as well as a local newspaper interview. My name and

picture were in *Locus*. I was invited to the local science fiction convention as a program participant. I was getting a lot of attention as well as good experience, but it was for just one story. And I was still getting rejections, lots of them, both on my short stories and the two novels I had completed up to that date.

Still, it was a heady sort of "honeymoon" period. I remember the first time a radio interviewer asked my opinion about something. My opinion? Someone, anyone, actually cared what I thought? The notion was dizzying. I wasn't in Oz yet, but the landscape did indeed seem to be changing.

The years have been very good to me. I have been a Nebula Finalist for Short Fiction four times and have sold more than eighty pieces of fiction to such markets as the *Magazine of Fantasy & Science Fiction, Alfred Hitchcock's Mystery Magazine, Realms of Fantasy, Weird Tales* and to several volumes of the Sword and Sorceress series. I've provided cover quotes for several novels and edited a middle-grades book for Hawk Publishing. I am invited to speak at writers' conferences and universities on a regular basis. My eighth novel, *The Crucible of Empire,* has just been published by Baen.

But, even more amazing, Algis Budrys selected me to be First Reader for the Contest and then, after he retired, I advanced to the position of Coordinating Judge. Now, I not only select the Finalists each quarter, I teach the Writers of the Future workshop with Tim Powers and edit the annual anthology of winners. Every year, I get the chance to help a new crop of writers as I was helped, to give back some small portion of what was once so generously given to me.

So, how does it feel all these years later? It feels . . . like I finally understand what I'm doing, that I'm on the brink, about to make the grade, and it's all really going to happen this time.

But, mostly, it feels like I need to work harder.

the experience

"You, the science fiction writers and illustrators, led us to the space program starting over one hundred years before we ended up in space."
— Astronaut Story Musgrave

It's an old writing adage—some might even call it a cliché—that an author should write about what he or she knows about.

For science fiction and fantasy writers, this poses a particular challenge. How do you acquire firsthand knowledge of alien planets, strange medieval cultures, horrific monsters, titanic astronomical events or even the end of the world itself?

The best we can do is come close, by experiencing different things, learning about science, technologies, history, politics, culture—in effect, by conducting secondhand adventures so that we can write about them in greater detail. We have to fill in the blanks with our imaginations. The most important tool a science fiction writer can draw upon is his or her own imagination, a personal sense of wonder and an insatiable curiosity.

As L. Ron Hubbard himself wrote, "Raw materials are more essential than fancy writing. Know your subject."

Left WotF winners and judges have been treated to spectacular behind-the-scenes tours in some very science-fictional settings. Here, the Kennedy Space Center rocket garden.

right The Space Needle in Seattle.

During his career as a Pulp fiction writer, Hubbard undertook a widely varied set of adventures in his real life. He traveled extensively, worked many jobs, fought in the war effort and captained scientific research expeditions. He personally walked the gloomy streets of China in the company of an officer in the British Secret Service, he served aboard a working schooner on the high seas and helped engineer a road through subtropical jungles—all of which provided fodder for numerous adventure tales. He even wrote a popular series of stories about his experiences, "Hell Jobs," for *Argosy* magazine. All of these activities granted him the raw material for the countless stories he wrote and published.

In an interview, science fiction Grand Master and WotF judge Jack Williamson said, "It seems to me that Ron's real life, as far as I know anything about it, was pretty much the same background as Indiana Jones—they were both wild travelers, world adventurers interested in unknown things at the ends of the Earth."

The Writers of the Future Contest has given the judges and winners a chance to do some innovative learning and—yes—adventuring of their own. "You must have raw material," Hubbard wrote. "It gives you the edge on the field."

During the workshop and in preparation for the Awards ceremony, Contest judges and winners are often treated to special once-in-a-lifetime experiences, which they can add to their writer's toolkit. They have taken behind-the-scenes tours of Mission Control in the Houston Space Center, the

above Winners and judges tour the Jet Propulsion Laboratory and the California Institute of Technology robotics laboratory.

below left The San Diego Aerospace Museum.

opposite page, top row Hollywood, California; the Library of Congress; the National Archives.

middle row Beverly Hills, California; the United Nations, New York City; the UN Trusteeship Council Chamber.

bottom row The Hollywood "Walk of Fame"; the Smithsonian Air & Space Museum; the World Trade Center Towers, New York City.

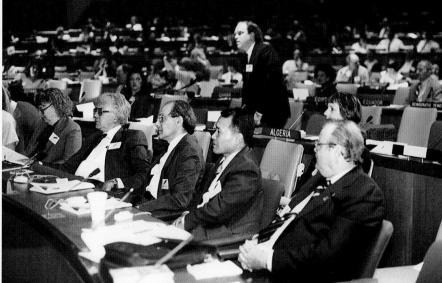

Aerospace Museum in San Diego, the Caltech Jet Propulsion Laboratory in Pasadena and the Science Fiction Museum in Seattle. They attended a nighttime space shuttle launch at Cape Canaveral, learned the ropes at the American Booksellers Association National Conference in Las Vegas and attended special conferences at the United Nations, the National Archives and the Library of Congress. They gathered atop the Space Needle, received rare briefings at the Kennedy Space Center and researched stories while strolling down the "Walk of Fame" on Hollywood Boulevard.

Real working scientists, astronauts and innovators have been extremely generous to share their experiences (in fact, many of them are just as thrilled to meet their favorite SF authors as the authors are to get a sneak peek at places that are not open to the public).

Many of these experiences have either found their way, directly or just through a spark of inspiration, into later stories written by the attendees.

opposite page top row Kennedy Space Center Vehicle Assembly Building; nighttime launch of Space Shuttle *Atlantis*; the Johnson Space Center Museum.

middle row United States Astronaut Hall of Fame; the Science Fiction Museum in Seattle.

bottom row Mission Control Center in Houston, Texas; the Johnson Space Center Museum.

right In 1997, the Writers and Illustrators of the Future were VIP guests for a spectacular nighttime launch of *Atlantis*, flight STS-86.

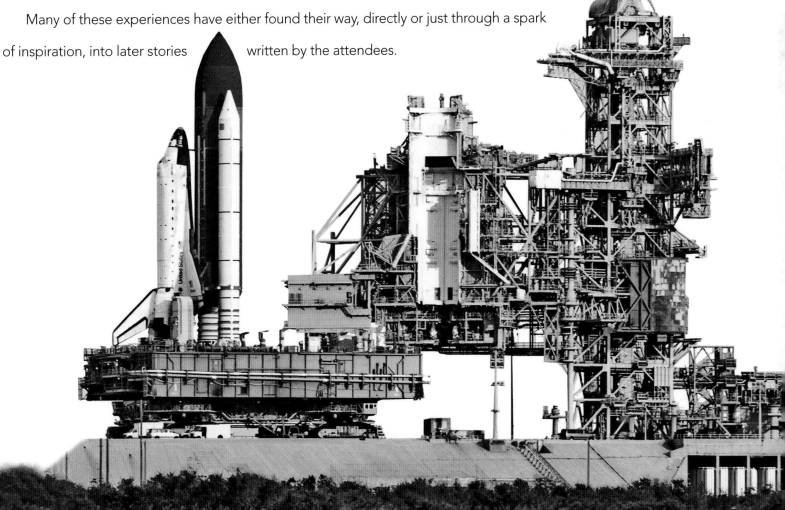

the awards event

" Writers of the Future is a terrific program for new writers, and goodness knows, there are few enough of those. It has my heartiest support and unqualified recommendation." — Terry Brooks

After the winners have spent an intensive week learning the ropes from well-established writers and respected professionals in the publishing world, the Writers of the Future experience culminates in the gala Awards ceremony.

Put on as a professional event of the highest caliber, the Writers of the Future Awards are truly the equivalent of the Academy Awards in science fiction and fantasy.

The day of the event is a busy one. Each student has just rushed to write a story in twenty-four hours and then workshopped it, but now there are other responsibilities.

A writer must be a professional entertainer who uses words as his or her repertoire, and now, for the evening's presentation, every winner participates in meticulous run-throughs and rehearsals. Even the judges attend a detailed dry run, finding their marks, practicing their lines and preparing so that the annual WotF Awards ceremony will go off without a hitch.

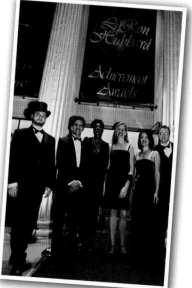

Left Seattle's Science Fiction Museum was the venue for the 2005 Writers and Illustrators of the Future Awards event.

right Winners arrive on the red carpet in Hollywood, 2002.

In the afternoon, the winners are fitted with tuxedos or dresses; their invited guests arrive for the celebration. Men and women undergo professional makeup and styling. Often the winners are interviewed by the media.

Then it's time to get dressed and meet for transportation to the evening's lavish banquet, often

 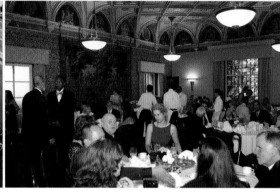 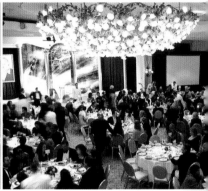

being delivered in stretch limousines. Banquets for the winners and judges have been held at Chasen's Restaurant in Beverly Hills, Windows on the World in the World Trade Center in New York, atop the Space Needle in Seattle, the Renaissance Restaurant at Hollywood's fabulous Chateau Elysée and the ballroom of the Beverly Hills Hotel.

Excitement builds as the audience gathers for the Awards presentation. In addition to the venues mentioned previously, the ceremony has taken place at the Trusteeship Council Chamber of the United Nations, the US National Archives, the Houston Space Center, the Kennedy

above from left Arriving by limousine; walking the red carpet; banquet (Caltech Athenaeum); Chick Corea performs; Crystal Ballroom, Beverly Hills Hotel; interpretive dance performance in the Blossom Room, Roosevelt Hotel; the audience watches; the ceremonies begin.

left Getting prepped for the event.

Space Center, the Flamingo Hilton in Las Vegas, the Roosevelt Hotel in Hollywood, the Science Fiction Museum in Seattle, the San Diego Aerospace Museum, the Caltech Athenaeum and other locations.

Guest speakers are drawn from visionaries, scientists and science fiction luminaries. Before the Awards themselves are presented, the publisher, Galaxy Press, releases that year's *L. Ron Hubbard*

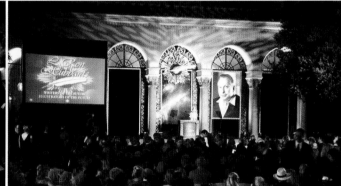

Presents Writers of the Future volume. Judges and celebrity presenters introduce the winners and present awards to the writers and illustrators of the future who placed First, Second and Third in each quarter.

Over the years, winners have accepted their trophies with powerful, emotional reactions—rejoicing, cheering, crying, kissing the award (and sometimes the presenter). Finally, in the climax of the evening, the recipients of the L. Ron Hubbard Gold Award are announced with an additional trophy and a $5,000 bonus check.

A glitzy reception follows the ceremonies, at which all attendees receive a personal copy of that year's anthology volume, and the

right Winners and judges at the 2009 Awards ceremony.

winners conduct a book signing, many of them autographing their fiction for the very first time.

But it will not be the last.

the 1ˢᵗ autograph

Tim Powers

I don't think there's any moment in your writing career quite as affecting as the first time you autograph a published copy of a story of yours. There's a sense of breaking a bottle of champagne over the bow of a vessel that you can hardly make out the shape of, and it occurs to you that this action—signing your autograph under your printed name—might one day become routine, unremarkable.

It's certainly not unremarkable the first time it happens. And you think about all of the copies you won't autograph, the copies that are bought in states and countries you'll never visit, to be read by people who will never meet you. Inevitably, someone born long after your death will pick up a copy of the book and read your story, and perhaps wonder who you were, what you were like.

I think this is for me the most memorable moment in the weeklong itinerary of the winners of the Writers of the Future Contest—the moment when the newly published book is unveiled, and I get to pick up a copy and take it around the crowded room to the authors whose stories are in it, and say to each of them, "Could you sign this for me?"

By this time, the winners have spent nearly a week in an intensive writers' workshop, in

Left After the ceremonies and the release of a new Writers of the Future anthology, winners autograph their first copies of the book at the Science Fiction Museum, Seattle (top); San Diego Aerospace Museum (middle); Science Fiction Museum (bottom).

which they've read articles by L. Ron Hubbard on everything from plotting to research to marketing; listened to frank nuts-and-bolts lectures from writers like Dave Wolverton, K. D. Wentworth, Orson Scott Card, Kevin J. Anderson and myself.

By this time, they've done research at the library, outlined plots, argued about every aspect of fiction writing, interviewed strangers they've found on the streets—and they've discovered, generally to their astonishment, that they can write a story in one day.

It's a busy week, culminating in the Awards ceremony and a big party for the release of the new anthology. The next day they all fly back to their various homes, all over the world—but while it was a group of gifted amateurs that originally assembled, it's professional writers who disperse afterwards.

the anthology

"The Writers of the Future Contest has not only provided a place where new writers could break into print for the first time—and gain real financial rewards for their stories—but it also has a record of nurturing and discovering writers who have gone on to make their mark in the SF field. Long may it continue!" — Neil Gaiman

Even from the beginning, Writers of the Future drew some of the best, most innovative new fiction from authors destined to be future stars of the genre. It was a natural extension of the Contest to publish an anthology of the prizewinning stories. The very first volume of *L. Ron Hubbard Presents Writers of the Future,* released at the Awards ceremony in 1985, was a resounding success, both in popular and critical acclaim. A new anthology has been released every year since, twenty-five volumes, as well as a *Best of Writers of the Future* trade paperback in 2000.

The anthologies boast covers by legendary artists in science fiction, including Frank Frazetta, Frank Kelly Freas, Paul Lehr, Gary Meyer, Andrew Tucker, Stephan Martiniere, Stephen Hickman and Bob Eggleton—many of whom are judges in the sister contest Illustrators of the Future. Over the past twenty-five years, we have lost some of these artistic legends: Paul Lehr in 1998, Frank Kelly Freas in 2005 and most recently, during the final layout stage of this book, Frank Frazetta, whose paintings graced more covers of the WotF anthologies

Left Following the 2007 Writers and Illustrators of the Future Awards ceremony at the Caltech Athenaeum, winners autograph the first copies of the new anthology.

than any other artist's. The complete collection of *Writers of the Future* volumes (as shown on the facing page) stands as an enduring legacy of their artwork.

The book series is not part of the Contest structure, but as with the workshop, publication and additional payment are bonuses to the winners. Algis Budrys, editor of sixteen of the twenty-five volumes, said, "We don't even reserve any rights in the entered stories; when these anthologies are put together, we contact the authors and make them an entirely separate—and generous—offer for limited use of their stories. They are under no obligation to accept it (although it's *quite* generous)."

Each volume contains the year's twelve winners, plus a selection of Finalists to balance out the book, each prefaced with a detailed biography and introduction, since most of the authors will be entirely unfamiliar to readers—at present. The stories are illustrated with magnificent new

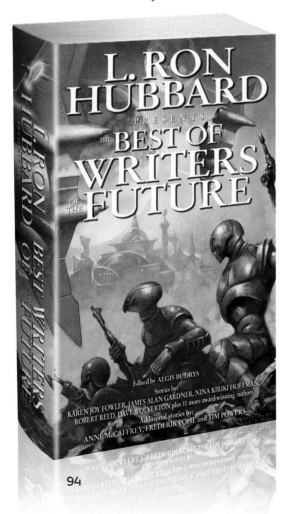

artwork created by the commensurate winners of that year's Illustrators of the Future Contest. And if that's not enough, the anthology contents include reprints of classic articles on writing by Hubbard and entirely new essays that give inspiration and advice, written by Contest judges or guest writers.

The stories in *L. Ron Hubbard Presents Writers of the Future* exhibit the widest spectrum of speculative fiction. The judges have no predisposition other than to choose good stories, as the anthology contents show, year after year after year. The Writers of the Future annual volumes have been called "the best selling science fiction anthology series of all time."

the winners

"The Contest has opened the way for scores of writers and has set them out on the fine careers they deserve." — Jack Williamson

The success of a writing contest and workshop can be defined in many ways: books and stories published, bestseller lists, awards won, longevity of careers.

Of the 300 writer winners in the first twenty-five years of the Writers of the Future Contest, at least a hundred have gone on to professionally publish novels or multiple stories in major magazines. WotF winners have received forty-three nominations (and seven wins) for the Nebula Award, twenty-five nominations (and three wins) for the Hugo Award, nine nominations for the Philip K. Dick Award (two wins), numerous nominations and wins for the John W. Campbell Award and the Locus Award, and have won the Newbery, the National Book Award, the Pushcart Prize and countless other prizes and accolades.

Many books by Writers of the Future winners have appeared on the *New York Times* bestseller list, reaching even the #1 slot; winners' books have also filled international bestseller lists, and risen to #1 bestseller on the London *Sunday Times* list.

left Some of the books published by WotF Award winners.

And as for career longevity, many writers who received their first break in the publishing world during the first years of the Contest are still full-time writers more than two decades later.

The Writers of the Future Contest can't take sole credit for launching these careers. The winners already demonstrated a great deal of talent, or they would not have risen above the thousands of submissions. They already showed the drive and persistence necessary by entering the quarterly Contest (most of them repeatedly). However, the Writers of the Future experience—the award itself, professional publication in a major anthology, the exposure and attention and the intensive information-packed WotF workshop—was often enough to set these writers on their course and give them a platform, as the following testimonials demonstrate again and again.

In this section, we spotlight more than ninety winners who have emerged from the Contest to establish themselves as professional writers, working in science fiction, fantasy, horror, romance, young adult, mainstream, comics, computer games, political commentary, nonfiction books and science journalism.

Winners from the more recent years have not had as much time to build up the momentum for their writing careers; even so, many of them have already accumulated additional publication credits in professional magazines or anthologies. Clearly, given the track record of the Contest, we can expect great things from them.

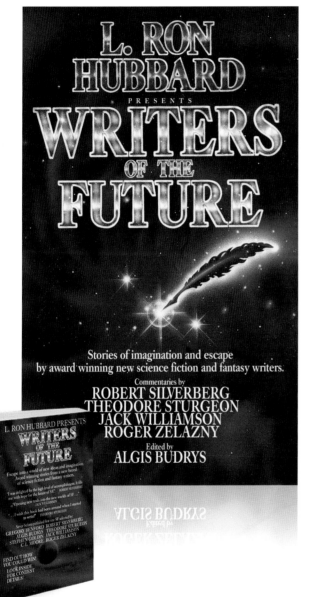

The first Writers of the Future Awards ceremony took place at the famous Chasen's restaurant in Beverly Hills, California on February 6, 1985. The launch year of the Contest included only three quarters before the Awards ceremony.

Algis Budrys remembers the event: "We met in a side room of Chasen's restaurant to celebrate the conclusion of the first year of L. Ron Hubbard's Writers of the Future Contest.

"It seems barely credible now. We had twelve writers—among them Leonard Carpenter, Karen Joy Fowler, Nina Kiriki Hoffman, Dean Wesley Smith, Mary Frances Zambreno and David Zindell, none of whom were household names at all.

"And we had judges and friends—Ray Bradbury, Robert Silverberg, Theodore Sturgeon, Jack Williamson, Dr. Gregory Benford, Roger Zelazny and A. E. van Vogt, who, no question, clearly were household names."

The Contest winners were also treated to a special tour of Forrest J. Ackerman's legendary "Ackermansion," a veritable museum collection of genre film and book memorabilia.

top Ray Bradbury, A. E. van Vogt and Jack Williamson.

middle The First Place trophies and the newly released Volume I of *L. Ron Hubbard Presents Writers of the Future.*

bottom Algis Budrys begins the Awards ceremony as judges Robert Silverberg, Roger Zelazny and Dr. Gregory Benford stand by to present awards.

1985

winners

First Quarter

1. "Arcadus Arcane" by Dennis J. Pimple
2. "The Ebbing" by Leonard Carpenter
3. "A Step Into Darkness" by Nina Kiriki Hoffman

Second Quarter

1. "Tiger Hunt" by Jor Jennings
2. "A Way Out" by Mary Frances Zambreno
3. "Anthony's Wives" by Randell Crump

Third Quarter

1. "Shanidar" by David Zindell
2. "The Two Tzaddicks" by Ira Herman
3. "Tyson's Turn" by Michael D. Miller

Published Finalists

"One Last Dance" by Dean Wesley Smith
"Without Wings" by L. E. Carroll
"Recalling Cinderella" by Karen Joy Fowler
"Measuring the Light" by Michael Green
"The Land of the Leaves" by Norma Hutman
"In the Garden" by A. J. Mayhew
"The Thing from the Old Seaman's Mouth"
by Victor L. Rosemund

top A. E. van Vogt and wife Lydia.

top middle Forrest J. Ackerman gives a tour of his famous "Ackermansion." Jack Williamson, seated.

bottom middle Robert Silverberg and Roger Zelazny.

bottom Dean Wesley Smith and Nina Kiriki Hoffman with Algis Budrys at one of the first book signings for *Writers of the Future* Volume I. Lori Ann White (left, who would be a winner in 1987) joins them.

below A selection of Dean Wesley Smith's published novels.

winner spotlights

DEAN WESLEY SMITH

Bestselling author Dean Wesley Smith has written more than ninety popular novels and well over a hundred published short stories. His novels include the science fiction novel *Laying the Music to Rest* and the thriller *The Hunted* (as D. W. Smith). With his wife Kristine Kathryn Rusch, he is the coauthor of The Tenth Planet trilogy and *The 10th Kingdom*. He writes under many pen names and has ghosted for a number of top bestselling writers. Dean has written books and comics for all three major comic book companies, Marvel, DC and Dark Horse, and has done scripts for Hollywood.

Over his career he has also been an editor and publisher, first at Pulphouse Publishing (where he won a World Fantasy Award), then for *VB Tech Journal*, then for Pocket Books. Currently, he is writing thrillers and mystery novels under another name. He is now a WotF judge.

"*I was the very first person across the stage in the very first Writers of the Future Awards ceremony in Chasen's restaurant. On the stage were Robert Silverberg, Greg Benford, Roger Zelazny and, of course, Algis Budrys doing the announcing. I don't think that up until that moment I realized just how big getting into that first volume was. That picture of me on that stage is still treasured on my office wall.*

Since I started selling short stories regularly after that, I was invited back to the very first workshop Algis Budrys put on in Taos, New Mexico. And there I met my wife, writer Kristine Kathryn Rusch. She and I have been together now for twenty-four years. I can pretty much safely say that I wouldn't

have the hundred or so novels published without that workshop and meeting Kris and building a writing life with her.

Over the years I have attended at least ten of the Awards ceremonies and been a huge supporter of the Contest. While writing for Pocket Books, I was hired to edit a young writers contest for Pocket Books and Star Trek that was patterned after Writers of the Future. For ten years I edited that contest and yearly anthology called Star Trek: Strange New Worlds, whose very existence sprang from WotF and my being in that very first volume. I was proud to help many new writers get their start as well, since I had such great help myself from Writers of the Future.

— Dean Wesley Smith

DAVID ZINDELL

David Zindell expanded his Contest-winning story "Shanidar" into the ambitious novel *Neverness*, which brought him great critical acclaim and earned him a nomination for the John W. Campbell Award for Best New Writer in 1986. He followed that novel with *Broken God, The Wild, War in Heaven, The Lightstone, The Diamond Warriors* and others.

Original WotF judge Gene Wolfe said that Zindell is "one of the finest talents to appear since Kim Stanley Robinson and William Gibson—perhaps the finest."

"*About a quarter of a century ago, my then-wife, Melody, saw a magazine ad telling about a new contest for aspiring science fiction writers. At first I didn't think very much about entering a story in it, as I am a novelist by nature and at the time I was finishing up a degree in mathematics. Then I thought some more. It seemed to me that L. Ron Hubbard, who had always loved science fiction, wanted to discover a whole new generation of science fiction writers and supply a rocket boost to their careers. So he enlisted as judges for his contest some of the giants of the old generation of the SF field: Algis Budrys, Jack Williamson, Fred Pohl and Robert Silverberg. That impressed me. I decided that maybe I should write a story after all.*

"Shanidar," set in a universe that I had been creating for the novel I someday planned to write, tells of a man who seeks a primeval innocence in going back to humankind's natural

state: my hero sculpts his body into the form of a Neanderthal and journeys to an icy world where he builds igloos and harpoons seals for food and tries to live a simpler and better life. After finishing this story, I packed it off and went back to studying probability theory and complex variables.

Then one evening, as I sat eating pepperoni pizza and watching Hill Street Blues with Melody, the phone rang. Melody answered it. I paid little attention as she spoke a few words into the mouthpiece. Then she said to me: "Robert Silverberg wants to talk to you."

It was like God calling. I always considered Silverberg's Dying Inside to be one of the most brilliant novels ever written. It turned out that "Shanidar" had won first prize. After a short conversation in which Silverberg congratulated me and complimented my work, he informed me that in addition to judging contests and writing he was also editing for a new publishing house called Donald I. Fine Books.

"Would you be interested," he asked me, "in writing a novel set in your 'Shanidar' universe?"

Would I be interested? Would I want, after long years of slaving as a bartender, to finally begin publishing books and fulfill my dreams? Did I want to be happy, famous and rich?

"Sure," I told Silverberg, trying to play it cool, "I might be interested."

I told him that I had a novel in the works; I called it Neverness.

"Good, then you might want to get an agent," Silverberg suggested.

I immediately went out and got an agent. He proved to be a good one: he managed to negotiate Donald I. Fine's initial advance offer of $1,500 up to $2,200. I added that to the $1,000 Writers of the Future Contest First Prize. I realized that I wasn't going to become rich any time soon.

I didn't care. It looked as if I was going to get a chance to write my big novel a lot sooner than I'd thought—and with Silverberg as my editor, I could write in a blaze of splendor, just for the sheer, singing joy of it. How could anyone, I wondered, ask for more than that?

— David Zindell

right Roger Zelazny, David Zindell, Dennis J. Pimple, Robert Silverberg, Jor Jennings, Jack Williamson, Dr. Gregory Benford.

1985

NINA KIRIKI HOFFMAN

After her win in the first year of the Writers of the Future Contest, Nina Kiriki Hoffman has gone on to sell more than 250 stories, several short story collections and a growing list of novels. Her first novel *The Thread That Binds the Bones* won a Bram Stoker Award. Her novels have earned Nebula, World Fantasy and Sturgeon Award nominations. Some of her titles include *The Red Heart of Memories*, *Child of an Ancient City* (with Tad Williams), *Past the Size of Dreaming*, *A Fistful of Sky*, *A Stir of Bones*, *Fall of Light* and *Spirits That Walk in Shadow*. She has written a collaborative *Star Trek* novel, three R. L. Stine's Ghosts of Fear Street books and one Sweet Valley Junior High book.

"

I entered Writers of the Future in the very first quarter of 1984 because Algis Budrys sent me a copy of the rules. He was one of my teachers at Clarion in 1982, and he gave me wonderful encouragement, even before the Contest started.

Winning that first year of the Contest was thrilling. The Contest flew me and my best friend Dean Wesley Smith (a Finalist) down to Hollywood, put us and all the other Volume I writers up at a hotel with a revolving restaurant on top, and held an Awards ceremony at Chasen's of Beverly Hills. I saw in person some of my writing idols. Ray Bradbury came. Harlan Ellison came. My brother Kristian came, and Harlan showed us a party trick that cost us a quarter. We got to tour Forrest J. Ackerman's monster-filled mansion. It was a wonderful experience and a great early sale!

— Nina Kiriki Hoffman

KAREN JOY FOWLER

Karen Joy Fowler is the author of four novels and two short story collections. *The Jane Austen Book Club* spent thirteen weeks on the *New York Times* bestseller list and was a *New York Times* Notable Book before being made into a film of the same name. Fowler's previous novel, *Sister Noon*, was a finalist for the 2001 PEN/Faulkner Award for fiction. Her debut novel, *Sarah Canary*, was a *New York Times* Notable Book, as was her second novel, *The Sweetheart Season*. In addition, *Sarah Canary* won the Commonwealth Medal for best first novel by a Californian, and was short-listed for the *Irish Times* International Fiction Prize as well as the Bay Area Book Reviewers Prize. Fowler's short story collection *Black Glass* won the World Fantasy Award in 1999.

Fowler and her husband, who have two grown children, live in Santa Cruz, California.

One afternoon, Algis Budrys called to tell me I'd neither won nor placed in the Writers of the Future Contest. This might sound like a message that didn't need a phone call. But he went on to say that, as editor, he was able to include my story in the book anyway. Not only did he like the story, he told me, but he could tell by reading it that I had a career ahead. Maybe he said that to everyone. I don't want to know.

The publication money went immediately to the UC Davis Veterinary Hospital for cutting-edge cancer treatments. Such a science-fictional way to spend my first science-fiction-writing money—irradiating the cat. This Schrödinger-tinged experiment bought her a few more years. Money well spent.

My husband and I flew down to LA, got all dressed up, and went to the book launch party where I met a bunch of writers I'd been reading for years. We shared a ride from the airport with Roger Zelazny and generally had a high old time. Secretly I thought the illustration done for my story was the best.

I had decided to become a writer on my thirtieth birthday. I spent my thirty-fifth with my husband at the WotF book launch. I wouldn't have plotted it that way in a story—far too tidy. Very satisfying as real life, though.

— Karen Joy Fowler

LEONARD CARPENTER

Leonard Carpenter says, "Having It All can be tough. Writing, family-rearing, technical work, indoor and outdoor hobbies, travel, political involvement, education and re-education take a lot out of a guy. (Though long term, they hopefully put a lot in.)"

He has lived in Chicago, El Paso and California (with wife Cheryl), and worked as an accountant, then a technical writer. He considers raising twin daughters Amanda and Candace, now in their thirties, and son Axel, just out of his teens, to be an accomplishment greater than all the rest combined.

Even with such other preoccupations, Carpenter is the author of eleven Conan the Barbarian novels, an original novel, *Fatal Strain*, and professional stories in *Amazing*, *Asimov's* and *Year's Best Horror*.

"*For me the Writers of the Future Award was an incredible shot in the arm, a jolt of energy and confidence that propelled me as a pro writer. A dozen Conan and other novels later, I still treasure the memories of my contacts with the Contest as some of the most memorable and glamorous of my life. Sincerest thanks to you all, and to L. Ron Hubbard for showing us how it's done.*

— Leonard Carpenter

MARY FRANCES ZAMBRENO

Mary Frances Zambreno says she decided to become a writer at age twelve, when she first realized that writers were just people with a good supply of paper and a desire to tell stories. Along the way to becoming a writer, she earned a doctorate in medieval literature, learned

to read six languages (including English), and discovered that she enjoyed teaching almost as much as she enjoyed writing.

Since her Contest win, Zambreno's short fiction has appeared in numerous genre magazines and anthologies. Her young adult fantasy novel, *A Plague of Sorcerers*, was named to the American Library Association's list of Best Books for Young Adults in 1992; its sequel, *Journeyman Wizard*, was a New York Public Library Book for the Teen Age in 1994. She is also the author of *Firebird* and a short story collection, *Invisible Pleasures*.

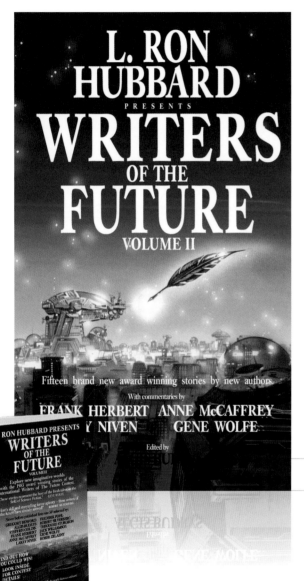

Cover painting by
Gary Meyer

The second annual Awards ceremony was held in conjunction with Norwescon at the Seattle-Tacoma Red Lion Inn in Washington on March 21, 1986. For the second year's event, a new grand prize was instituted, the L. Ron Hubbard Gold Award, which was won by Robert Touzalin (Robert Reed), who went on to publish numerous critically acclaimed novels, receive nominations for the Nebula, Hugo and John W. Campbell Award, and win the Hugo.

Judges presenting the awards included Anne McCaffrey, Stephen Goldin, Jack Williamson, Robert Silverberg and Larry Niven. Brian Herbert represented his father, the late Frank Herbert, a Contest judge who had passed away the year before.

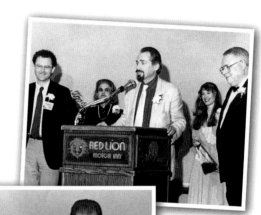

top Robert Silverberg takes the podium.

middle Bridget McKenna waits to receive her award from Larry Niven.

bottom Writers of the Future panel with (L to R) Jack Williamson, Anne McCaffrey, Robert Silverberg, Gene Wolfe, Frederik Pohl and Larry Niven.

1986

winners

L. Ron Hubbard Gold Award

"Mudpuppies" by Robert Touzalin (Robert Reed)

First Quarter

1. "The Book of Time" by Camilla Decarnin
2. "A Sum of Moments" by Laura E. Campbell
3. "Dream in a Bottle" by Jerry Meredith & D. E. Smirl

Second Quarter

1. "Mudpuppies" by Robert Touzalin (Robert Reed)
2. "Redmond" by Kenneth Schulze
3. "The Cinderella Caper" by Sansoucy Kathenor

Third Quarter

1. "In the Smoke" by Howard V. Hendrix
2. "All You Can Eat!" by Don Baumgart
3. "They That Go Down to the Sea in Ships" by Marina Fitch

Fourth Quarter

1. "The Old Organ Trail" by Bridget McKenna
2. "The Helldivers" by Parris ja Young
3. "Click" by Ray Aldridge

Published Finalists

"Beast" by Jon Gustafson

"The Trout" by Marianne O. Nielsen

"Welcome to Freedom" by Jay Sullivan

You could be a writer of the future!

That was the message which shoppers were given when an 8 ft high quill pen arrived in town, accompanied by two minders. The threesome were visiting local bookshops to promote the book "L. Ron Hubbard presents — Writers of the future", which has recently gone on sale in the area.

In late 1983, Hubbard sponsored a contest in America, to find new science fiction writers. Top SF authors such as Roger Zelazny, C.L. Moore and the Theodore Sturgeon gathered to judge the hundreds of entries received and the result is an exciting book containing the winning stories, published by New Era Publications.

Released in America last year, the book proved immediately popular and has broken sales records across the country since its release.

THE PEN IS MIGHTIER THAN THE SWORD, AND TWICE AS BIG

Proof that the pen is mightier than the sword was provided in Murraygate, Dundee, today, when a fearsome seven-foot wooden quill was used to publicise a competition.

Beside it, Mr Jimmy Peace, dressed as a medieval scribe, was handing out leaflets for a competition started by famous author, L. Ron Hubbard.

Mr Hubbard's "Writers of the Future" give aspiring writers a chance to make the big time and get published.

This year's contest launched in entrants from Europe as well.

Prizes quarterly for first for second for third 4000 dollars the best.

Mr Peace's entry form library.

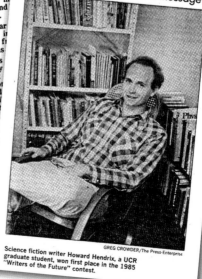

A WINNER

Writer believes in art with a message

GREG CROWDER/The Press-Enterprise

Science fiction writer Howard Hendrix, a UCR graduate student, won first place in the 1985 "Writers of the Future" contest.

top Brian Herbert speaks on behalf of his late father, Frank Herbert.

bottom In its second year, the Writers of the Future Contest began to generate substantial media coverage.

winner spotlights

RAY ALDRIDGE

Ray Aldridge was one of the attendees Algis Budrys invited for his "test" WotF workshop in Taos, New Mexico. Within two years of his Writers of the Future win, Ray Aldridge's professional fiction began appearing in major magazines of the field, and Bantam Books published his Emancipator trilogy (*The Pharaoh Contract*, *The Emperor of Everything* and *The Orpheus Machine*). His short fiction has also appeared in *Amazing Stories*, *The Magazine of Fantasy & Science Fiction* and *SF Age*. He is also a talented potter and stained-glass craftsman.

I'm ambivalent regarding workshops. When they're good they're great, and when they're bad they're horrid. I've been the beneficiary and victim of both varieties. My guess is that workshopping is a lot like learning to play tennis; you should always try to play with someone who's better than you are, if you want to learn the game as quickly as possible. Workshopping with folk who are getting together to socialize and play strokes-and-slashes is enough to make you want to tuck your keyboard under your arm and walk into the woods until someone asks you, "Whut's thet?"

On the other hand, one workshop I attended—so I believe—spared me years of laboring in the ranks of the Undiscovered. In the spring of 1986, the Writers of the Future people organized an experimental workshop in Taos for a dozen winners and finalists, a hungry bunch of Mostly Undiscovered Writers. Our instructors were Algis Budrys, Frederik Pohl, Gene Wolfe and Jack Williamson—four of the Ivan Lendls and Boris Beckers of our profession. If you can get into a workshop like that (by, for instance, winning a prize in the L. Ron Hubbard's Writers of the Future Contest), my advice is: go for it.

— Ray Aldridge

MARINA FITCH

Marina Fitch lives in Ben Lomond, California with her husband fellow WotF winner (1992) Mark Budz. She has published two novels to date, *The Seventh Heart* and *The Border*, as well as numerous short stories. When not writing she takes long walks, knits and plays for a living.

I was at the first workshop, the one in Taos. We called ourselves the Lab Rats because Algis Budrys and the other teachers—Jack Williamson, Fred Pohl and Gene Wolfe—tried out new workshop techniques on us. The very first day someone called the teachers "the Pros." We were told not to, because now we were pros.

Us.

Whoa.

So we started calling them "the Grownups."

— Marina Fitch

ROBERT REED

Within a year after receiving the first Gold Award for Writers of the Future, Robert Reed (who wrote his WotF story under the pen name Robert Touzalin) was prolific and successful enough to make his living as a full-time science fiction writer. His novels include *The Leeshore, The Hormone Jungle, Black Milk, Down the Bright Way, The Remarkables, Beyond the Veil of Stars, An Exaltation of Larks, Beneath the Gated Sky, Marrow, Sister Alice, Mere* and *The Well of Stars.*

Reed has also published over 180 shorter works, some of which are featured in his two collections, *The Dragons of Springplace* and *The Cuckoo's Boys*. He has won or been nominated for the major awards in the field. He lives in Lincoln, Nebraska, with his wife and daughter.

HOWARD V. HENDRIX

Howard V. Hendrix has held jobs ranging from fish-hatchery manager to university professor and administrator. His degrees range from a BS in biology to a PhD in English literature. He has published fifty short stories and numerous political essays, book reviews and works of literary criticism. His novels include *Spears of God*, *The Labyrinth Key*, *Empty Cities of the Full Moon*, *Lightpaths*, *Standing Wave* and *Better Angels*.

He lives with his wife Laurel in central California, where they enjoy backpacking in the Sierras and mushroom forays in the foothills.

"*I was working on my PhD in English literature when one of my fellow graduate students handed me a note on which he'd written some basic details from a flyer he had seen in the Creative Writing Program office at University of California, Riverside—for something called the Writers of the Future Contest.*

"Thought you might be interested in this," he said. "You're into science fiction, right?"

I was, and I was. I wrote a story, "In the Smoke," and submitted it. Many months later, the Contest Coordinator called to let me know I had gotten a First Prize in one of that year's quarters.

I was surprised—and pleased—not so much for the winning or the money or the publication themselves (although all of those were very nice indeed), but from a much deeper cause. My work had been judged impartially, by people who didn't know me from Adam or Eve—established writers I'd been reading all my life and who, now, had enjoyed and been impressed by something I had written. That level of independent confirmation of the talent one hopes one has is a very rare thing indeed.

Over the course of the months that led to the Awards ceremony and the writing workshop in Taos—all of which followed in the Contest's wake—I learned just how fortunate I'd been. At Taos, I made friends I'm still in touch with all these years later. I got a chance to workshop my fiction with the likes of Algis Budrys, Fred Pohl, Jack Williamson and Gene Wolfe. It took me a long time to learn how wise in the ways of the writing business they were, and I'm still learning. A quarter of a century after writing that winning story, however, I can in all honesty say that I would not have gone on to publish (so far) six novels and fifty short stories had it not been for the rocket-assisted takeoff the Writers of the Future Contest lit under my writing career. For that I am forever grateful.

— Howard V. Hendrix

BRIDGET MCKENNA

Bridget McKenna is the author of six mystery novels, three under her own name. She has published short fiction in *The Magazine of Fantasy & Science Fiction, Asimov's* and *Amazing Stories,* among other markets. From 2004 to 2008 she copublished and coedited *Aeon Speculative Fiction* with her daughter, writer and editor Marti McKenna. She is currently writing and editing for the computer game industry in Seattle, Washington.

I made my first science fiction sale—"The Old Organ Trail"—to Writers of the Future. This was after submitting a story a quarter for three quarters, so I guess they had to stop me somehow. The Contest win validated my writing efforts and jump-started my career, but that's only the tip of the iceberg; many of the friends I met there are still a wonderful part of my life today, and have made a larger contribution than they could ever know to my growth as a writer and as a person. In addition, my workshop teachers— people I'd admired most of my reading life—shared so much and contributed so much to what and who I am now, that I'm sure without everything WotF did for me my life would have taken quite a different path.

— Bridget McKenna

below First Place winners on stage with their awards.

1986

113

The third Writers of the Future Awards ceremony was held Friday, April 24, 1987 at the Windows on the World Restaurant atop the World Trade Center in New York City. Special guests for the event included legendary SF authors Isaac Asimov, Robert Silverberg, Roger Zelazny, Frederik Pohl, Larry Niven, Dr. Jerry Pournelle and Gene Wolfe, along with *Star Wars* actor Mark Hamill, editor Brian Thomsen (Warner Books) and DC Comics editor Julius Schwartz.

The cover for *L. Ron Hubbard Presents Writers of the Future Volume III* sported a gorgeous Frank Frazetta cover painting, the first of many Frazettas over the years.

A landmark for the third event was the institution of the writers' workshop for the Contest winners, one of the most valued parts of the WotF prize. The first workshop was held in Sag Harbor, Long Island, New York, and was taught by Algis Budrys, Orson Scott Card and Tim Powers.

Cover painting by
Frank Frazetta

top Warner Books editor Brian Thomsen, actor Mark Hamill, DC Comics editor Julius Schwartz, and Rosemary Wolfe applaud the winners.

middle and bottom The 1987 Writers of the Future panel with Isaac Asimov, Gene Wolfe, Robert Silverberg, Roger Zelazny, Larry Niven, and Dr. Jerry Pournelle.

1987

winners

L. Ron Hubbard Gold Award

"On My Way to Paradise" by Dave Wolverton

First Quarter

1. "Time and Chance" by Eric M. Heideman
2. "The Very Last Party at #13 Mallory Way"
 by L. E. Carroll
3. "In the Sickbay" by R. V. Branham

Second Quarter

1. "Jacob's Ladder" by M. Shayne Bell
2. "The Language of the Sea" by Carolyn Ives Gilman
3. "Old Mickey Flip Had a Marvelous Ship"
 by Lori Ann White

Third Quarter

1. "Living in the Jungle" by Martha Soukup
2. "No Pets" by Tawn Stokes
3. "Monsters" by Jean Reitz

Fourth Quarter

1. "On My Way to Paradise" by Dave Wolverton
2. "Long Knives" by J. R. Dunn
3. "A Little of What You Fancy" by Mary Catherine McDaniel

Published Finalists

"Resonance Ritual" by Paula May

"A Day in the Life" by Christopher Ewart

top Julius Schwartz, actress Victoria King and Mark Hamill.

top middle Dave Wolverton with writing workshop instructors Tim Powers, Orson Scott Card and Algis Budrys.

bottom middle Frederik Pohl congratulates Gold Award winner Dave Wolverton.

bottom Isaac Asimov.

winner spotlights

DAVE WOLVERTON

Dave Wolverton, who writes bestselling fantasy novels as David Farland, is the author of fifty novels. He wrote short stories as a child and dreamt of growing up to become a writer. He went to Brigham Young University to study writing.

While there, he became ill and feverish and started having fantastic dreams. In one such dream, two futuristic mercenaries took shelter in the skull of some giant beast and talked while waiting out a storm. He wrote that dream into "On My Way to Paradise," which won the WotF Gold Award. He expanded the short story into a novel, which spent several months on the *Locus* bestseller list and won a Philip K. Dick Memorial Special Award. He wrote several other bestselling SF novels under the name Dave Wolverton, including *Star Wars: The Courtship of Princess Leia*.

In fantasy, writing as David Farland, he is best known for his *New York Times* bestselling Runelords fantasy series and his YA series Of Mice and Magic. He currently holds the Guinness World Record for the "largest single-author book signing" for *A Very Strange Trip*, a novelization of an unproduced L. Ron Hubbard film script.

In 1991, Dave was the First Prize winner to become a judge for the L. Ron Hubbard Writers of the Future Contest. For the next several years he read thousands of stories each year, edited the annual anthology, and helped teach the writing workshop.

Dave eventually returned to BYU as a writing professor for several years, but now devotes his full time to writing. He still teaches writing workshops, having helped guide many great emerging writers and had a part in their success, including Stephenie Meyer, Brandon Sanderson and Eric Flint.

I think that if L. Ron Hubbard were still here, he would be very pleased to see what the Contest has done, but I do not think he would be surprised to see how the program has grown. I think he expected it to succeed. For myself and other authors, this Contest serves as one of those first rungs that one must climb on the ladder to success. It may not be the top rung, and one can only reach it if he has first sat down and written a worthy story. But the view from up there is breathtaking. . . .

— Dave Wolverton

CAROLYN IVES GILMAN

Carolyn Ives Gilman has been publishing science fiction and fantasy for over twenty years. Her first novel, *Halfway Human*, was called "one of the most compelling explorations of gender and power in recent SF" by *Locus* magazine. Her short fiction has appeared in magazines and anthologies such as *The Magazine of Fantasy & Science Fiction*, *The Year's Best Science Fiction*, *Realms of Fantasy*, *Interzone*, *Universe*, *Full Spectrum* and others. A collection of her short fiction, *Aliens of the Heart*, came out in 2007. Her fiction has been translated into Russian, Swedish, Czech, Polish and Romanian. She has twice been a finalist for the Nebula Award.

In her professional career, Gilman is a historian specializing in eighteenth and early nineteenth century North American history, particularly frontier and Native history. Her most recent nonfiction book, *Lewis and Clark: Across the Divide*, was published by Smithsonian Books. She has been a guest lecturer at the Library of Congress, Harvard University and Monticello, and has been interviewed on *All Things Considered* (NPR), *Talk of the Nation* (NPR), *History Detectives* (PBS) and the History Channel.

Gilman lives in St. Louis and works for the Missouri Historical Society as a historian and museum curator.

M. Shayne Bell

On the strength of his WotF entry, Shayne Bell's remarkable short fiction has appeared in *War of the Worlds: Global Dispatches*, *Star Wars: Tales from the Mos Eisley Cantina*, *Star Wars: Tales from Jabba's Palace* and *Star Wars: Tales of the Bounty Hunters*. His story "Mrs. Lincoln's China" was nominated for a Hugo and his novelette "The Pagodas of Ciboure" received a Nebula nomination. Two of his stories were included in *The Year's Best Science Fiction*.

His novel *Nicoji* was published in 1991, and he edited the critically acclaimed anthology *Washed by a Wave of Wind*, which earned him an award for editorial excellence. His short story collection, *How We Play the Game in Salt Lake and Other Stories* was released in 2001.

J. R. Dunn

J. R. Dunn has published three critically acclaimed novels, *This Side of Judgment* (1994), *Days of Cain* (1997) and *Full Tide of Night* (1998) as well as short stories and articles in numerous magazines. He worked for many years as an associate editor of *The International Military Encyclopedia*. He has also worked in real estate, infotech and public relations.

Dunn is most visible as a conservative political commentator who has written extensively on a wide variety of controversial issues.

"The best-selling SF anthology series of all time!" –*Locus*

L. RON HUBBARD
PRESENTS

WRITERS OF THE FUTURE
VOLUME IV

imagination by award-winning new authors
and commentaries by:

CAMPBELL ORSON SCOTT CARD
NK KELLY FREAS TIM POWERS

Edited by
ALGIS BUDRYS

1988

Yamashiro's Restaurant in Hollywood, California was the venue for the fourth Writers of the Future Awards ceremony, which was held on Tuesday, May 24, 1988. In the lush outdoor garden setting, judges presented the awards and also participated in panel discussions.

Speakers included Frank Kelly Freas, Ramsey Campbell, Larry Niven, Frederik Pohl, Dr. Jerry Pournelle, John Varley, Gene Wolfe and Algis Budrys. Among the other guests were Dr. Charles Sheffield, Orson Scott Card, Forrest J. Ackerman, Julius Schwartz and Frank Frazetta, who had painted the cover for the anthology. As a special surprise, the cover "came to life" with the arrival of a costumed horseman in identical dress to the image in Frazetta's painting.

The 1988 WotF workshop was held at Pepperdine University in Malibu, California.

top The panel of experts: Frank Kelly Freas, Ramsey Campbell, Larry Niven, Frederik Pohl and Dr. Jerry Pournelle.

middle Dr. Charles Sheffield was a guest speaker at the ceremonies. He later became a Contest judge.

bottom Gene and Rosemary Wolfe face a real, live Frank Frazetta character.

winners

L. Ron Hubbard Gold Award Winner

"The Mirror" by Nancy Farmer

First Quarter

1. "Buffalo Dreams" by Jane Mailander
2. "What Do I See in You?" by Mary A. Turzillo
3. "A Winter's Night" by P. H. MacEwen

Second Quarter

1. "The Mirror" by Nancy Farmer
2. "The Zombie Corps: Nine-Lives Charlie" by Rayson Lorrey
3. "6770: The Cause" by Mark D. Haw

Third Quarter

1. "Heroic Measures" by Paul Edwards
2. "Black Sun and Dark Companion" by R. Garcia y Robertson (Rod Garcia)
3. "The Gas Man" by Richard Urdiales

Fourth Quarter

1. "River of Stone" by Michael Green
2. "The Troublesome Kordae Alliance and How It Was Settled" by Flonet Biltgen
3. "Growlers" by Larry England

Published Finalists

"The Fruit Picker" by Jo Beverley
"Old Times There" by Dennis E. Minor
"Mother's Day" by Astrid Julian
"High Fast Fish" by John Moore

top Orson Scott Card and Gene Wolfe also participated in panel discussions.

top middle Gene Wolfe and Ramsey Campbell present the certificate to Richard Urdiales.

bottom middle Forrest J. Ackerman shows off his new copy of *Writers of the Future* Volume IV.

bottom Winners and judges.

winner spotlights

Jo Beverley

Not all successful WotF winners are confined to the genres of science fiction, fantasy and horror. After Writers of the Future, Jo Beverley went on to become a phenomenally popular international bestselling romance author. She has published more than thirty historical romances and many shorter works. She has received numerous awards including the Golden Leaf, the Award of Excellence, the National Readers Choice and two Career Achievement awards from *Romantic Times*. She is also a five-time winner of the RITA, the top award of the Romance Writers of America, and a member of their Hall of Fame and Honor Roll along with authors such as Nora Roberts and Susan Elizabeth Phillips.

Jo Beverley is one of the few authors writing English-set historical romance who is actually English. She was born and raised in England, and has a degree in English history from Keele University in Staffordshire. She and her husband emigrated to Canada, where they now live. They have two sons.

I heard that I was a Finalist in the Writers of the Future Contest at about the same time that I sold my first book, which is the sort of coincidence that makes a person think there might be something in astrology! The book was Lord Wraybourne's Betrothed, *a classic Regency romance (reissued in 2009), beginning my very successful romance career. My success meant less time for speculative fiction, but I've played with that part of my imagination whenever I could in a number of novellas. This year sees one in* Songs of Love and Death, *edited by Gardner Dozois and George R. R. Martin.*

The Writers of the Future Contest, and in particular the weeklong writing workshop, was definitely an accelerator to my writing development. I learned so much, and it came at just the right moment for me, when the demands of being a professional writer were about to hit. That first book is usually a play project for any author, written and rewritten over a number of years, and that was the case with me. Once we sell, the publisher wants commitment to steady productivity of high quality and careers have crashed there. The workshop prepared me by carrying me into an expanded world of craft and business, into the professional world of writing. Thank you!

— Jo Beverley

JOHN MOORE

John Moore is an engineer who lives and works in Houston, Texas. His stories have appeared in *Realms of Fantasy, Tomorrow Speculative Fiction, New Destinies, Aboriginal SF, Marion Zimmer Bradley's Fantasy Magazine, Fantastic Stories* and other magazines and anthologies. His humorous fantasy novels include *Heroics for Beginners, Slay and Rescue, The Unhandsome Prince, Bad Prince Charlie* and *A Fate Worse Than Dragons*.

1988

"*In 2007, I was at Conestoga in Tulsa, on a panel with some recent Writers of the Future winners. I mentioned that I had been published in Volume IV. "Volume four!" they said. "You must be really old!"*

Er, maybe. But I like to think I've aged well, like fine wine. I began entering the Writers of the Future Contest while I was an engineering student at the University of Houston. Alas, I did not get a story out in time for the very first contest, but I entered each quarter after that. And each quarter the judges would pick my story either as a runner-up or a finalist. Then I would submit the stories to magazines. I never actually won the Contest, but in Volume IV I was included as a published Finalist, and then the magazines began printing my stories and before long I was a pro. Agents who had read the anthology began contacting me and suggesting I try my hand at a novel. And I did, and to date there have been five of those.

So the Contest helped me in three ways. It gave me some name recognition with editors and agents, it gave me a quarterly deadline to work to and it gave me encouragement, because each quarter I would come close. Because of that feedback, I knew that if I kept at it I could produce publishable stories, and I did.

— John Moore

above Finalist John Moore, workshop instructors Dr. Michael R. Collings and Orson Scott Card and Finalist Dennis E. Minor.

NANCY FARMER

Nancy Farmer has published eight novels, three picture books and eight short stories; two of her books have appeared on the *New York Times* bestseller list. She has won three Newbery Honors, the National Book Award, the Commonwealth Club of California Silver Medal for Children's Literature, the Golden Duck Award (for science fiction), The Buxtehude Bulle (in Germany) and the Michael L. Printz Honor Award. In 1992 she received a National Endowment for the Arts grant for creative writing.

The Writers of the Future Award quite literally saved my family. We were trapped in Zimbabwe with no money and no future. The award allowed us to move to the United States, where my son could get an education and where I could begin a writing career. We have always been very grateful for this help.

I grew up in a hotel on the Mexican border. As an adult I joined the Peace Corps and went to India to teach chemistry and run a chicken farm. Later on I worked as an entomologist and ran a chemistry lab in Mozambique. I began writing in Zimbabwe, but my career didn't take off until I returned to the US.

— Nancy Farmer

R. GARCIA Y ROBERTSON

Rod Garcia, who writes as R. Garcia y Robertson, lives in Washington state with his wife and children. He has a PhD from UCLA in the history of science and technology.

Kirkus called his first novel, *The Spiral Dance*, "surely the best debut of the year." He followed that novel with *The Virgin and the Dinosaur, Atlantis Found, American Woman, Firebird* and the Knight Errant series.

One of the biggest benefits from Writers of the Future is going to the weeklong workshop. We stayed in Malibu for a week (without ever opening a wallet), while we got in-depth tutoring from SF pros, including Algis Budrys, Orson Scott Card and Kristine Rusch. This workshop helped me define the type of story I wanted to write.

The general techniques of writing—pacing, setting, dialogue, etc.—are fundamental. But they can be studied and learned. All that takes is hard work and the willingness to learn. The stories themselves have to come from within you. So understand what type of story you want to write—then listen for that inner voice. Listen to that voice even if what it says does not sound safe, or marketable. If you stifle that voice, you stifle your writing.

— R. Garcia y Robertson

125

MARY TURZILLO

Mary Turzillo's Nebula Award winner "Mars Is No Place for Children" and her novel *An Old-Fashioned Martian Girl* (serialized in *Analog*) have been selected as recreational reading on the International Space Station. She has published over fifty stories in magazines and anthologies in the US, UK, Italy, Germany, Japan and the Czech Republic, including *Asimov's*, *The Magazine of Fantasy & Science Fiction*, *Sky Whales and Other Wonders*, *Tails of Wonder and Imagination* (her story was a 2008 Nebula Finalist), *Goblin Fruit*, *Cat Tales*, *The Vampire Archives*, *Strange Horizons* and *Weird Tales*. Recent books include *Dragon Dictionary* (with Marge Simon) and *Ewaipanoma*, selected for *Year's Best Lesbian Fiction*. Her poetry collection, *Your Cat & Other Space Aliens*, was a Pushcart nominee.

above Mary Turzillo and Julius Schwartz, editor for DC Comics.

"

My best memory of the Taos workshop was Gene Wolfe line-editing a story of mine—it was amazingly generous of him, and I learned a whole Master of Fine Arts program from just that contact. (The story subsequently sold to Interzone, BTW.) The pros were so incredibly generous. And being up close to them, seeing how they brainstormed, was amazing. I never knew human minds could work like that.

— Mary Turzillo

The Best NEW SF of the Year

L. RON HUBBARD
Presents
WRITERS OF THE FUTURE
VOLUME V

Cover painting by
Frank Frazetta

The fifth Writers of the Future Awards ceremony was held in New York at the Trusteeship Council Chamber in the United Nations building on Saturday, April 29, 1989. The Society of Writers at the United Nations hosted the event and Hans Janitschek, President of the Society, gave the welcoming address. This was possibly the first celebration of SF on an official international stage.

During the afternoon, WotF presented a symposium of some of the world's leading scientific thinkers, including Nobel Prize-winning physicist Sheldon Glashow from Harvard, Professor Gerald Feinberg of Columbia, NASA's Dr. Yoji Kondo, former Skylab astronaut Dr. Edward G. Gibson and aerospace scientist and SF writer Dr. Charles Sheffield. Each of the judges received a medal on behalf of the UN Society of Writers to acknowledge their participation in the Writers of the Future Contest.

After a successful first run in 1987, the WotF writers' workshop was held once again at Sag Harbor, Long Island.

1989

top SF is recognized at an international venue.

middle Writer winners and judges at the UN symposium.

bottom Hans Janitschek, President of the United Nation's Society of Writers, opens the symposium and ceremonies.

winners

L. Ron Hubbard Gold Award

"The Disambiguation of Captain Shroud"
by Gary Shockley

First Quarter

1. "The Nomalers" by Jamil Nasir
2. "A Walk by Moonlight" by Mark Anthony
3. "Dear Mom" by Stephen C. Fisher

Second Quarter

1. "The Disambiguation of Captain Shroud"
 by Gary Shockley
2. "Blue Shift" by Stephen M. Baxter
3. "Prosthetic Lady" by Paula May

Third Quarter

1. "Rachel's Wedding" by Virginia Baker
2. "Under Ice" by C. W. Johnson
3. "Starbird" by J. Steven York

Fourth Quarter

1. "The Wallet and Maudie" by Dan'l Danehy-Oakes
 and Alan Wexelblat
2. "Despite and Still" by Marc Matz
3. "Daddy's Girls" by K. D. Wentworth

Published Finalists

"A Ghost in the Matrix" by Steve Martindale
"Just Don't" by Eolake Stobblehouse

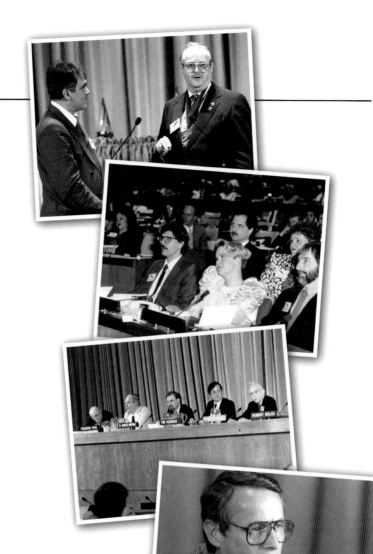

top Hans Janitschek and Dr. Jerry Pournelle prepare to present an award trophy.

top middle Winners and judges listen to the symposium speakers.

middle The United Nations WotF symposium.

bottom middle Skylab astronaut Dr. Edward G. Gibson joined the WotF symposium at the United Nations.

bottom Winners pose for photos in the Trusteeship Council Chamber.

winner spotlights

MARK ANTHONY

Mark Anthony is the author of *Beyond the Pale* and five other novels in The Last Rune series. His latest work, *The Magicians and Mrs. Quent*, is a gothic fantasy penned under the name Galen Beckett. He lives in Colorado with his partner, Chris, and will probably never figure out a way to stop writing.

"*When I look back, I'm amazed at how much of my writing career is founded in my experience in the Writers of the Future Contest. I learned how to sharpen my craft in workshops with brilliant writers like Tim Powers and Algis Budrys. I met so many great people, sowing the seeds of friendships and professional relationships. And I finally had a real story sale on my résumé, one that opened the doors to others.*

But more than anything, Writers of the Future helped me make the leap from thinking of myself as someone who aspired to write, to thinking of myself as a writer. And you know what? I've been one ever since.

— Mark Anthony

right Prize winners Mark Anthony, Marc Matz, C. W. Johnson and Stephen Baxter.

1989

K. D. WENTWORTH

K. D. Wentworth is currently the Coordinating Judge of the Writers of the Future Contest, which means she is the first person who reviews all the manuscripts as they come in—just as her own prizewinning manuscript came in, back in 1988, for which she won Third Place. With Tim Powers, she also teaches the intensive WotF writing workshop—just as she attended the second Sag Harbor workshop at the beginning of her career. She serves as editor of the annual *L. Ron Hubbard Presents Writers of the Future* anthology.

After her win, K. D. published short fiction in *Starshore, Pulphouse, Aboriginal SF*, then sold three novels to Del Rey, *The Imperium Game, Moonspeaker* and *House of Moons.* She has been nominated for the Nebula Award four times and has published many more novels, including *Black on Black* and her recent *The Course of Empire* and *The Crucible of Empire*, with fellow WotF winner and judge, Eric Flint.

Sometimes winning in the Contest is as far as a writer ever gets. That is because what Mr. Hubbard has generously provided here for us is a chance to jump-start your career, and what you make of that opportunity after going home from the workshop is up to the individual. L. Ron Hubbard, with his gift for getting to the heart of what makes a story work, has laid down a guide map for newcomers. We still have to put his lessons to work and remain committed to a difficult journey.

I know this program is effective, because it worked for me. In 1987, soon after I began writing seriously, I bought a copy of the L. Ron Hubbard Presents Writers of the Future *anthology in a bookstore and started entering the Contest. The only signs I'd ever had up to that point that I wasn't wasting my time writing were occasional scribbled lines of criticism on form rejections. Then in the last quarter of 1988, I won Third Place. It was the headiest moment in my life up to that date.*

When Algis Budrys, the Coordinating Judge, called me to see if I would be able to attend the weeklong workshop, I told him that winning was the best thing that had ever happened to me. He gruffly answered that he most sincerely hoped it was not, but in many ways, it was. That phone call telling me I had won was the first time in my life that it seemed possible I would achieve my long-cherished dream of having a career as a writer.

— K. D. Wentworth

above Third Place winners: K. D. Wentworth, J. Steven York, Stephen C. Fisher and Paula May

JAMIL NASIR

Jamil Nasir was born in Chicago, Illinois, but spent much of his childhood in the Middle East, surviving two major wars. He returned to the US in 1970, and started college at age fourteen, studying hard science, philosophy, psychology, Chinese history and many other things, finally graduating from the University of Michigan with a bachelor of general studies degree. He also attended the University of Michigan Law School, graduating magna cum laude in 1983. Between stints at school, he hitchhiked extensively around North America, working as a carpenter, fruit picker, warehouseman, gardener, shop clerk and paralegal.

He is the author of numerous short stories and five novels. His 1999 novel *Tower of Dreams* was runner-up for the Philip K. Dick Award, and won (in translation) France's top science fiction award, the Grand Prix de l'Imaginaire. Nasir currently works on large regulatory and litigation cases at a Washington, DC law firm, and lives in a suburb of Washington with his two daughters. He holds a black belt, second dan in tae kwon do, is an avid amateur photographer and a devotee of many subjects.

"

For me Writers of the Future was the first chance I had to meet, socialize with, and learn from some of the most wonderful and skilled science fiction and fantasy writers of our time, people such as Algis Budrys, Tim Powers, Steve Baxter, Kathy Wentworth and many, many others. It was also a chance (rare enough for any writer, but especially for short story writers) to feel like King for a Day: receiving an award on stage at a fabulous venue from science fiction luminaries, being covered by media, etc.

And last but not least, it was a credential that helped me enormously at the beginning of my career by singling me out from the very large number of young hopefuls submitting stories to magazines. Soon after I won the award, the large backlog of stories I had accumulated (almost as voluminous as my bales of magazine rejection slips) suddenly began to sell, and quite quickly sold out, so that I was in the enviable position of being accosted by the editor of a leading science fiction magazine at a convention with the words: "Do you have anything else for me?" What a difference from the early days!

— Jamil Nasir

VIRGINIA BAKER

Virginia Baker lives in Utah with a flock of large birds and the cats who fear them. She has a bachelor of science in Near Eastern studies and a master's degree in English from Brigham Young University. Her novel *Jack Knife* was published by Jove.

Writers of the Future is known for its extraordinary platform for showcasing new talents, and I was honored—and surprised—to be chosen as one of them. My experience with the Contest was my first introduction to the world of professional writing and, more important, to the incredible people who were a part of that world. There, I met the first person who would influence my career, the great and wonderful Algis Budrys. I could not have asked for a better mentor. It was also my introduction to Tim Powers, Orson Scott Card, Kristine Kathryn Rusch, Dean Wesley Smith and many more—truly generous professionals who have meant a great deal to my professional development.

I could not have asked for a better start. From my first short story to my first novel, I have been proud to have Writers of the Future on my fiction résumé, and I do believe it has made all the difference in opening the doors on those opportunities.

— Virginia Baker

J. STEVEN YORK

J. Steven York has published three Conan the Barbarian novels (*Scion of the Serpent*, *Heretic of Set* and *The Venom of Luxur*), one Bolo novel and an original novel *The Sky Is Falling*—all with fellow WotF winner Dean Wesley Smith; two X-Men novels, two Battletech: MechWarrior novels, and a series of Star Trek novels, both in the Next Generation and Deep Space Nine franchises, written with his wife Christina F. York. His short fiction has appeared in *Analog*, *The Magazine of Fantasy & Science Fiction*, *Pulphouse* and numerous anthologies. For several years, he coedited the writing magazine, *The Report*.

York has also worked in the development of computer games for Dynamix, writing stories and related materials for several major releases. He and his wife live on the Oregon coast.

"*Though they are wonderful things at the time, money gets spent, awards are just something to dust, and even publications get forgotten, but what has stuck with me most from my Writers of the Future experience is the wonderful people I met through the Contest. Many are still friends. Many were amazing people I could only have dreamed of meeting, like writers Tim Powers and Fred Pohl, and astronaut Ed Gibson. Others were literary heroes no longer with us, like Algis Budrys and Jack Williamson. Those people and the time I shared with them, is an award beyond price or replacement.*

— J. Steven York

STEPHEN BAXTER

One of the most noted and prolific speculative fiction authors in the UK, Stephen Baxter has published more than forty novels, collections and nonfiction works. He is best known as a hard-SF author for his Xeelee Sequence (*Raft, Timelike Infinity, Flux, Ring, Vacuum Diagrams*), his NASA trilogy (*Voyage, Titan, Moonseed*), Manifold trilogy (*Time, Space, Origin*) and Destiny's Children (*Coalescent, Exultant, Transcendent, Resplendent*), and the short story collection *Phase Space*. He has also written a series about the last surviving mammoths (*Mammoth, Longtusk, Icebones, Behemoth*) and the Time's Tapestry historical epic (*Emperor, Conqueror, Navigator, Weaver*). In addition, he has written *The Time Ships*—authorized by the H. G. Wells' estate as a sequel to *The Time Machine*—as well as four novels in collaboration with the late Arthur C. Clarke.

The Best NEW Speculative Fiction of the Year

L. RON HUBBARD
Presents

WRITERS OF THE FUTURE
VOLUME VI

SF DISCOVERIES

Brand-New Stories Plus Features By
RON HUBBARD • BEN BOVA
CHOMBURG • FRANK KELLY-FREAS

For the sixth annual Writers of the Future Awards workshop and ceremony, winners and presenters went to Las Vegas, Nevada. As part of the event, they participated in the American Booksellers Association convention, which gave them an opportunity to see and interact with the publishing and bookselling world.

The ceremony was held at the Las Vegas Flamingo Hilton on Saturday, June 2, 1990. Judge presenters included Jack Williamson, Frederik Pohl, John Varley, Ben Bova, Dr. Gregory Benford and Algis Budrys. The editor of *Publishers Weekly*, John Baker, was a special guest and presented the L. Ron Hubbard Gold Award to James Alan Gardner for his Grand-Prize-winning story.

The Flamingo Hilton ceremony was also the first Awards event to feature the newly established sister contest for Illustrators of the Future.

Cover painting by
Frank Frazetta

top The Flamingo Hilton in Las Vegas, venue for the sixth Writers of the Future event.

middle Frederik Pohl, Dave Wolverton, John Varley, Ben Bova.

bottom Dave Wolverton, Ben Bova, Stephen Whaley, Hal Clement.

1990

winners

L. Ron Hubbard Gold Award

"The Children of Crèche" by James Gardner

First Quarter

1. "The Children of Crèche" by James Gardner
2. "The Magician" by Michael I. Landweber
3. "Dancing with Dinosaurs" by Charles D. Eckert

Second Quarter

1. "Water" by John W. Randal
2. "Flutterbyes" by Jo Etta Ledgerwood
3. "A Foreign Exchange" by Matthew Wills

Third Quarter

1. "A Branch in the Wind" by Bruce Holland Rogers
2. "Riches Like Dust" by Scot Noel
3. "Under Glass" by David Carr

Fourth Quarter

1. "The Vintager" by James Gleason Bishop
2. "Kansas City Kitty" by Michael L. Scanlon
3. "Winter's Garden" by Sharon Wahl

Published Finalists

"The Bookman" by David Ira Cleary

"The Dive" by James Verran

"Eulogy for Lisa" by Jason Shankel

"Red Eyes" by Stephen Milligan

"The Scholar of the Pear Tree Garden" by Annis Shepherd

"Mothers of Chaos" by Pete D. Manison

top Dr. Gregory Benford, Larry Niven, Dr. Yoji Kondo and Ben Bova chat before the Awards ceremony.

top middle Former Gold Award winner Gary Shockley (right) and John Baker, editor of *Publishers Weekly* (center), present the 1990 Gold Award to James Gardner.

bottom middle Third Place winners David Carr, Sharon Wahl and Charles D. Eckert.

bottom James Gleason Bishop receives his First Place trophy from Tor Books publisher Tom Doherty and WotF judge Ben Bova.

winner spotlights

JAMES ALAN GARDNER

Canadian James Alan Gardner has published numerous critically acclaimed novels, including *Expendable, Commitment Hour, Hunted, Ascending, Trapped, Radiant* and *Vigilant*, and he also wrote a Tomb Raider novel, *Lara Croft and the Man of Bronze*. Gardner has degrees in applied mathematics and a second-degree black sash in Shaolin Five Animal kung fu. He has won the Theodore Sturgeon Memorial Award for his short fiction.

"*Winning Writers of the Future gave me (at least) three things that helped my writing career. First, it gave me a pat on the back . . . which may sound trivial, but writing is a lonely way to spend your time, and occasionally, you have to ask yourself, "Do I really have what it takes, or am I just fooling myself?" That pat on the back from Writers of the Future told me not to give up. The second thing WotF gave me was money . . . which may sound crass, but the prize money made it possible for me to be more active in the science fiction community, thereby establishing professional contacts and becoming more aware of the state of the art. The third thing the Contest gave me was a weeklong workshop under Algis Budrys . . . which shouldn't sound either trivial or crass, because it was a week polishing my craft under a master. All in all, the Contest was a fine finishing step from amateur to pro, and I'm grateful to all those involved.*

— James Alan Gardner

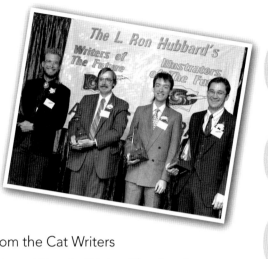

BRUCE HOLLAND ROGERS

Bruce Holland Rogers teaches fiction writing in the Northwest Institute for Literary Arts MFA program. He has been a guest lecturer on creative writing at universities in Lisbon, Vienna, Jyväskylä (Finland) and London. At this writing, he is at Eötvös Loránd University in Budapest on a Fulbright grant, but he makes his permanent home in Eugene, Oregon. His stories have won two Nebula Awards, two World Fantasy Awards, a Pushcart Prize and even something called the Jonny Cat Litter-ary Award from the Cat Writers Association. His story collections include *The Keyhole Opera, Thirteen Ways to Water, Flaming Arrows* and *Wind Over Heaven.* He also distributes thirty-six short-short stories a year by e-mail subscription.

right First Place winners Bruce Holland Rogers, James Alan Gardner, John W. Randal and James Gleason Bishop.

My writing career divides clearly into Before Writers of the Future and After. I had sold a couple of stories before winning the Contest, and I think I would have eventually had some publishing success in any case, but the Contest gave a huge boost to my confidence. I learned a lot about writing at the workshop, and I learned even more about publicity by working with Author Services.

Long before I won, the Contest gave me a quarterly deadline for writing the best story I could, and in the years since then I have met many writers who got their start by either winning the Contest or, in a few cases, writing stories for the Contest that didn't win but were professionally published elsewhere. As a program for encouraging and nourishing writers, Writers of the Future is hands-down the best thing going.

— Bruce Holland Rogers

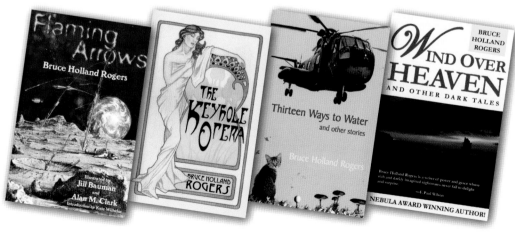

1990

SCOT NOEL

Scot Noel has worked as the executive editor of a local community magazine, while keeping his hand in fiction, most recently with zombie-themed stories in *The Book of All Flesh* and *The Book of More Flesh*; his stories have also been published in *Tomorrow* magazine, *Vision* and *Pandora*. He has worked on developing the game text and companion fiction for successful computer games, including *DarkSpyre*, *Dusk of the Gods*, *Veil of Darkness*, *Ravenloft*, *Anvil of Dawn* and *War Wind*.

My Contest win changed the course of my life in every way. A director of transportation and planning at the time, I quickly moved into computer game development based on my win, writing novellas and content for the newly emerging field of computer games and going on to become project manager for award-winning games like Anvil of Dawn *and* Sanitarium.

Being immersed in the tech world led to me and my wife Jane owning our own Web development company. To date, CMEwebsites.com has developed over 130 websites, including my own fiction website ScienceandFantasyFiction.com.

It is certainly true that, after two decades, the Writers of the Future Contest continues to have an amazing impact on my life. Best wishes and long life to Writers of the Future!

— Scot Noel

below Second Place winners Scot Noel, Jo Etta Ledgerwood and Michael L. Scanlon.

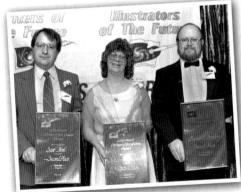

The Best New Science Fiction and Fantasy of the Year

L. RON HUBBARD
Presents
WRITERS OF THE FUTURE
VOLUME VII

NEW SF DISCOVERIES!

Brand-New Stories & Prize-Winning Illustrations
Special Features on Writing and Art by:
...BBARD · FRANK FRAZETTA · and Others

Cover painting by
Frank Frazetta

The seventh annual Awards ceremony was held on Thursday, August 8, 1991 at the Roosevelt Hotel in Hollywood, California; the Roosevelt would serve as a hub for the Writers and Illustrators of the Future three times over the first twenty-five years. The workshops for both the writers and illustrators were held at Author Services, Inc., in Hollywood, a venue that would also frequently host the workshops.

Among the judges in attendance were Jack Williamson and Roger Zelazny, as well as special guests Julius Schwartz (long-time DC Comics editor) and illustrator Bob Kane, the creator of Batman.

1991

top The Roosevelt Hotel, on Hollywood Boulevard, was the venue for the 1991 Writers and Illustrators of the Future ceremonies.

middle Algis Budrys, Kristine Kathryn Rusch, and Dean Wesley Smith present the Third Place Award to Allen J. M. Smith.

bottom Writers and Illustrators of the Future winners, 1991.

winners

L. Ron Hubbard Gold Award

"Georgi" by James C. Glass

First Quarter

1. "Georgi" by James C. Glass
2. "17 Short Essays on the Relationship Between Art and Science" by Michael C. Berch
3. "Hopes and Dreams" by Mark Andrew Garland

Second Quarter

1. "The Trashman of Auschwitz" by Barry H. Reynolds
2. "Yarena's Daughter" by Terri Trimble
3. "The Cab Driver from Hell in the Land of the Pioux Hawques" by Allen J. M. Smith

Third Quarter

1. "Sensations of the Mind" by Valerie J. Freireich
2. "A Plea for Mercy" by Öjvind Bernander
3. "Balanced Ecology" by William Esrac

Fourth Quarter

1. "Relay" by Michelle L. Levigne
2. "A Plumber's Tale" by Merritt Severson
3. "Crow's Curse" by Michael H. Payne

Published Finalists

"Pandora's Box 2055" by David Hast

"The Raid on the Golden Horn" by Don Satterlee

"An Exultation of Tears" by Ross Westergaard

top Gold Award winners James C. Glass (writer) and Sergey Poyarkov (illustrator) show off their trophies.

top middle Roger Zelazny and Jack Williamson at the banquet before the Awards ceremony.

bottom middle Third Place winners Michael H. Payne, William Esrac, Allen J. M. Smith, Mark A. Garland and Finalist David Hast.

bottom Tim Powers and Roger Zelazny present First Place trophy and certificate to Valerie J. Freireich.

winner spotlights

MARK A. GARLAND

Mark A. Garland's original novels, written with Charles G. McGraw, include *Demon Blade*, *Dorella*, *Frost* and solo novel *Sword of the Prophets*; his Star Trek novels are *Ghost of a Chance* and *Trial by Error*, and he has also written a Dinotopia novel, *Rescue Party*. Garland's short fiction has appeared in anthologies *Xanadu 3*; *Bruce Coville's Book of Aliens: Tales to Warp Your Mind*; *Monster Brigade 3000*; *Space Stories*; *The UFO Files* and many others.

The first day we all gathered at WotF, Algis Budrys told us, "This is the most fuss and money for a short story you will ever see." He was right, and that was fine. It made me believe I could write, that I was getting somewhere, that it was real. It made me want to work harder, to reach higher, because now I had proof that it might be worth the effort. Those few days of classes were invaluable, as was the interaction with the other winners, the writing, the information we were given, but so was being able to walk into any bookstore in America and pick up a book with my story in it.

I think being published in WotF gave me credibility with the professional publishing industry as well. I'd sold some fiction to smaller markets, but nothing big, nothing that might cause an editor to really take notice. My WotF story credit opened some eyes. I published seven novels and dozens of short stories in magazines and anthologies since winning, and had the privilege of working with two of the top agents in the field along the way. It is difficult to say precisely how much WotF helped that to happen for me, but I know it did, and I will never forget it.

— Mark A. Garland

MICHELLE L. LEVIGNE

Michelle L. Levigne has been a story addict since *The Cat in the Hat*, graduating to Narnia, Greek mythology and Star Trek, and then starting to write while being involved in fandom. She has more than forty short stories and poems in various universes. From fanzine writing, she worked up to sending out original short stories and novels. She has a BA in theater/English from Northwestern College and an MA in communication. WotF was her first professional sale, and she has since published numerous books in science fiction and fantasy, YA and many subgenres of romance. She is a nine-time finalist in the EPPIE/EPIC Awards competition, winning twice.

"*In a lot of ways, WotF had a long-lasting impact on my career. I learned persistence, and the value of feedback. As Algis Budrys noted in the preface to my story in Volume VII, I entered the Contest twelve times. (Either persistence, or being too stubbornly oblivious to quit when there was little hope.) Quite a few times, there were notes scribbled on the papers returned to me, making suggestions, pointing out what worked or didn't work. Just knowing someone thought enough of my story, whether the execution or the premise, to offer advice, gave me the energy to keep trying. I ended up making Honorable Mention three times, before finally making First Place with "Relay."*

Then the actual event itself had an enormous impact—I met people who spoke my language! Not just science fiction and fantasy, but writing. People who traveled to distant worlds and times without getting out of their chairs. People who had conversations with people who weren't in the room. People who understood why it was so important to find the right word. People who didn't expect me to have conversations with them while I was trying to conquer the Evil Overlord! Writing is still a lonely occupation, despite the advent of the Internet, with chat rooms and Instant Messaging, Facebook, etc. Evidence that, yes, there were people like me out there, was a big help.

When I apply for writing jobs, when I advertise my editing business or on other occasions where I need to list my writing credits and awards, winning WotF is at the top of the list.

— Michelle L. Levigne

bottom
First Place winners:
Barry H. Reynolds,
Valerie J. Freireich,
James C. Glass and
Michelle L. Levigne.

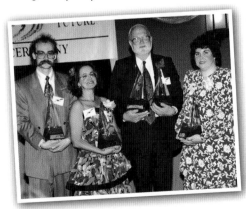

VALERIE J. FREIREICH

Though her major in college was anthropology, Valerie J. Freireich is a practicing attorney, a partner in a greater Chicago law firm. Her interests are banking law, commercial real estate law—generally, anything to do with business and the owners of business. She says, "When I am not doing legal-oriented activities, I like to read, especially science fiction." Her short fiction has been published in *Starshore*, *Aboriginal SF* and the anthology *Sisters in Fantasy 2*. After WotF, she published four SF novels, *Testament*, *Becoming Human*, *Impostor* and *The Beacon*.

Mr. Hubbard was a colorful character; this Contest is the best legacy, except for the body of work a writer leaves behind, that any science fiction writer has given the field. It is something for which he must be gratefully remembered and of which all his successors and descendants can rightfully be proud.

— Valerie J. Freireich

MICHAEL H. PAYNE

Michael H. Payne's short stories have appeared in *Tomorrow Speculative Fiction*, *Asimov's* and Marion Zimmer Bradley's Sword and Sorceress anthologies, and his novel *The Blood Jaguar* was published by Tor Books. He spends most of his time these days on the two webcomics he writes and draws: *Daily Grind* and *Terebinth*.

The Contest introduced me to Algis Budrys, the gentleman who bought a fair percentage of my subsequent short stories for his magazine, Tomorrow Speculative Fiction. *He also serialized my novel there and spent the last ten years of his life as my agent, shepherding my novel into print. The workshop gave me some very good tools for structuring stories and for getting ideas, tools I still find myself using every day.*

— Michael H. Payne

JAMES C. GLASS

James C. Glass feels that winning the WotF Gold Award was responsible for the start of his successful writing career. Since then he has published nearly fifty stories in anthologies and magazines such as *Analog, Aboriginal SF, Talebones* and *Figment*. His first novel *Shanji* was published by Baen Books in 1999. Since then he has sold five more novels and two story collections. He is active in the convention scene, giving panels on science and writing and serving in writing workshops.

He retired from his academic job in 1999 and continues to write both novels and short stories. He is also a professional artist, doing desert and mountain scenics in oils, pastels and watercolors.

above James C. Glass receives his First Place trophy from Roger Zelazny.

When I won the WotF Gold Award, I was a physics professor and dean at Eastern Washington University. I had written off and on since my teen years, but began doing it seriously around 1984 when my academic career was well established. "Georgi" was my second submission to the Contest. It was the experience of a lifetime, conducted with elegance and style, and I continue to teach what I learned in the workshop.

— James C. Glass

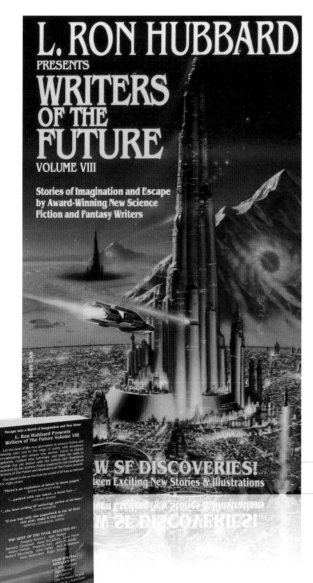

Cover painting by
Gary Meyer

The National Archives in Washington, DC was the site of the Writers and Illustrators of the Future Awards ceremony on Monday, August 24, 1992. WotF judges Roger Zelazny, John Varley, Frederik Pohl, Jack Williamson, Dave Wolverton and Algis Budrys were among the presenters. Jerald C. Newman, chairman emeritus of the National Commission of Libraries and Information Sciences, presented the Gold Award.

The writers' workshop was held at George Washington University and the Library of Congress. Judges, winners and their guests were treated to tours of the National Archives and the Smithsonian National Air and Space Museum.

1992

top Contest winners and judges on the steps of the National Archives following the ceremony.

middle Attendees file in for the panel and Awards event.

bottom Jack Williamson presents a Second Place Award to Wendy Rathbone.

winners

L. Ron Hubbard Gold Award

"The Last Indian War" by Brian Burt

First Quarter

1. "Anne of a Thousand Years" by Michael Paul Meltzer
2. "Invisible Man" by Larry Ferrill
3. "A Cold Fragrant Air" by C. Maria Plieger

Second Quarter

1. "The Last Indian War" by Brian Burt
2. "Bringing Sissy Home" by Astrid Julian
3. "Subterranean Pests" by James S. Dorr

Third Quarter

1. "Surrogate" by M. C. Sumner
2. "Pale Marionettes" by Mark Budz
3. "Winter Night, with Kittens" by Sam Wilson

Fourth Quarter

1. "Scary Monsters" by Stephen Woodworth
2. "The Augmented Man" by Wendy Rathbone
3. "Timepieces" by Mike E. Swope

Published Finalists

"The Winterberry" by Nicholas A. DiChario
"Blueblood" by Bronwynn Elko
"Not Simply Blue" by Gene Bostwick
"The Coat of Many Colors" by Christine Beckert
"Running Rings Around the Moon" by Kevin Kirk

top Dave Wolverton addresses the audience.

top middle During the workshop week, winners had a chance to tour the Smithsonian National Air & Space Museum.

bottom middle Roger Zelazny keeps a tight grip on the Award he's about to present.

bottom Frederik Pohl presents the Third Place Award to Mike E. Swope.

winner spotlights

MICHAEL PAUL MELTZER

Michael Paul Meltzer has a doctorate in environmental science and engineering from UCLA, is a full-time space history writer for NASA and has been writing for the Agency since 2000. The manuscript of his current book, *Meeting the Lord of the Rings: A History of the Cassini-Huygens Mission to Saturn*, is nearly completed. His previous book, *When Biospheres Collide*, tells of NASA's efforts to study planets without infecting them with Earth organisms, or bringing extraterrestrial life back to Earth. It also has a section on the influence of certain science fiction books, such as *War of the Worlds*, *The Andromeda Strain* and *Red Mars* on NASA's planetary protection program. His first book, *Mission to Jupiter*, gives the political, engineering and scientific history of the Galileo Mission.

Meltzer's day job for many years was as an environmental engineer at Lawrence Livermore National Laboratory developing pollution-prevention technologies and strategies. He lives in Oakland, California with wife Naisa and daughter Jordana.

The most valuable thing that the Contest gave me was the knowledge that I really am a fiction writer, not just a wannabe. I derived a lot of confidence from that. I believe that this confidence was key in finishing several different types of novels, as well as three space history books (so far). I also got a sense, from Algis Budrys and some of the other Contest winners, of the power of a good story. When I wrote my first book proposal to NASA, I wrote it as a speculative fiction writer in love with space travel, who also knew a bit about science and writing. And NASA bought it!

— Michael Paul Meltzer

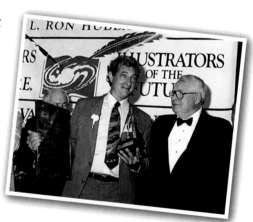

STEPHEN WOODWORTH

Stephen Woodworth has published speculative fiction for more than a decade. His work has appeared in such venues as *The Magazine of Fantasy & Science Fiction, Weird Tales, Aboriginal Science Fiction, Gothic.Net* and *Strange Horizons*. In addition to Writers of the Future, he attended the Clarion West workshop.

A native Californian, Woodworth has achieved great success writing his Violet series of supernatural thrillers, *Through Violet Eyes, With Red Hands, In Golden Blood* and *From Black Rooms*.

At the time I won Writers of the Future, I had been writing and submitting my short stories since junior high school. After ten years and more than two hundred rejections, I despaired of ever achieving my heart's desire of becoming a professional writer. Then I got the call informing me that I'd won First Place in the Contest for my story "Scary Monsters," and everything changed. Awards ceremony at the National Archives in Washington, DC! Dining and chatting with childhood heroes like Contest judges Frederik Pohl and Roger Zelazny! Publication in Writers of the Future *Volume VIII! And, most especially, the wonderful workshop taught by Dave Wolverton and the amazing Algis Budrys.*

During the two years that followed the Awards ceremony, however, in which I collected another hundred rejections without selling a single story, I discovered that Writers of the Future had given me an even greater reward: the gift of hope. Winning the Contest had proven to me that I could write publishable fiction, the workshop had given me the chance to become comrades in arms with other aspiring writers to whom I could turn for mutual encouragement and commiseration, and the memory of the whole wonderful experience comforted me in moments of doubt. The affirmation that I got from Writers of the Future gave me the resolve I needed to go on to write and publish four novels and counting, as well as numerous short stories. And every time I attend an Awards ceremony and see the joy it gives a new corps of fledgling writers, I feel my own love for the art of storytelling reenergized. For that and so much more, I thank L. Ron Hubbard and the Contest's entire devoted crew, and I wish all winners and contestants, past and future, the best. May we always be Writers of the Future!

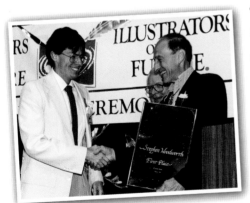

— Stephen Woodworth

NICK DiCHARIO

Nick DiChario's short stories have appeared in many magazines and anthologies including *The Year's Best Science Fiction*, *The Year's Best Fantasy and Horror* and *The Best Alternate History Stories of the 20th Century*. He has been nominated for two Hugo Awards and a World Fantasy Award. His first two novels were published by Robert J. Sawyer Books: *A Small and Remarkable Life* (2006) and *Valley of Day-Glo* (2008), and both books were nominated for the John W. Campbell Memorial Award. In addition to writing fiction, Nick is a business writer and editor, and his freelance film and book reviews have appeared in *Philosophy Now* magazine.

Since 1992 (the year he appeared at Writers of the Future), Nick has taught creative writing workshops for people of all ages and backgrounds at Writers & Books, a nonprofit literary center in his hometown of Rochester, NY. He has also been a writing professor and visiting lecturer at several universities and conferences in the US and abroad.

In 1992, my short story "The Winterberry" was a Finalist for the Writers of the Future. Although, technically, it did not win a prize, I can't in good conscience say that I lost. The judges liked my story and were kind enough to publish it in Writers of the Future *Volume VIII. I was thrilled to be included, certainly, but that was not the end of my story. "The Winterberry" went on to find a place in* Alternate Kennedys *(Tor Books, 1992), and eventually received Hugo and World Fantasy Award nominations that year. In fact, much to my surprise and delight, "The Winterberry" has been reprinted many times in many different languages over the years. Ultimately, in 2001, it was chosen for Del Rey's* The Best Alternate History Stories of the 20th Century, *an honor that leaves me dizzy with astonishment to this day. I hope that WotF continues to open doors for new writers for many years to come.*

— Nick DiChario

MARK BUDZ

Mark Budz is the author of *Clade, Crache, Idolon* and *Till Human Voices Wake Us*. *Clade* received the Emperor Norton Award "in recognition of extraordinary creativity and invention unhindered by the constraints of paltry reason." In addition to *Writers of the Future* Volume VIII, his short fiction has appeared in a number of magazines and anthologies, including *Amazing Stories, Pulphouse, The Magazine of Fantasy & Science Fiction, Quick Chills II: The Best Horror Fiction from the Specialty Press, High Fantastic: Colorado's Fantasy, Dark Fantasy and Science Fiction* and *Seeds of Change*.

 He is married to fellow Writers of the Future Contest winner (1986) Marina Fitch.

Memories of WotF in 1992: Air and Space. Algis Budrys and Sarah Jane. Charles Brown and the Library of Congress. I learned a lot from all of them—especially the ones who are now gone. I wish I had learned more while I had the chance. I wish I remembered more of what I did learn and what they had to teach, not just about writing and how to write, but about life and how to live.

— Mark Budz

ASTRID JULIAN

Technothriller writer and NASA consultant Astrid Julian has been published in the US, the UK, Russia and Germany. Her nonfiction for NASA includes speeches and DVDs and spans topics from colloidial physics (a.k.a. watching paint dry), to aviation, to quantum dots, to the Shuttle *Columbia* accident investigation, which became a NASA "bestseller."

"*My first contact from Writers of the Future was a telephone call from Algis Budrys. "Holy cow, I don't believe it," I said. "Yup, I just pinched myself. It really is me," Algis responded.*

The problems in believing continued even after Algis and I met in person. I liken being a WotF writer to living in a fairy tale, perhaps one written by Dr. Seuss . . . Oh, the places you'll go . . . workshops and events in Malibu, Washington, NYC and Hollywood . . . to see the great sights and join the high fliers who soar to high heights. . . . Writing tips from Algis Budrys, Orson Scott Card and Kristine Kathryn Rusch helped me to take those first tentative steps in becoming a professional writer and let me meet writers and artists from all around the world.

— Astrid Julian

below Frederik Pohl, Second Place winner Astrid Julian and Jack Williamson.

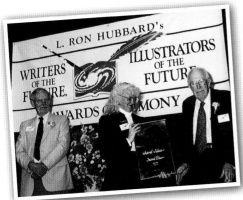

The Best New Science Fiction/Fantasy of the Year

L. RON HUBBARD
PRESENTS

WRITERS
OF THE
FUTURE
VOLUME IX

Cover painting by
Gary Meyer

This was the first of many years in which the annual Awards ceremony was held at Author Services, Inc., in Hollywood, California. Author Services also again provided the facilities for both the writers' and illustrators' workshops. The event was held on Saturday, September 25, 1993. Nancy Cartwright, the voice of Bart Simpson on *The Simpsons,* helped with the presentation and preparation of the time capsule.

Two of the winners from this year, Sean Williams and Eric Flint, have now gone on to become Writers of the Future judges.

1993

top First Place winners Eric Flint, Steve Duff, Karawynn Long and Lisa Maxwell.

middle Dr. Yoji Kondo and Frederik Pohl help guest speaker Nancy Cartwright prepare the annual time capsule.

bottom The class of 1993.

winners

L. Ron Hubbard Gold Award

"Adjusting the Moon" by Karawynn Long

First Quarter

1. "M" by Lisa Maxwell
2. "Fire" by Elizabeth E. Wein
3. "Ghosts of the Fall" by Sean Williams

Second Quarter

1. "Adjusting the Moon" by Karawynn Long
2. "The Dictates" by Vaughn Heppner
3. "Lady's Portrait, Executed in Archaic Colors" by Charles M. Saplak

Third Quarter

1. "An Afternoon with George" by Steve Duff
2. "The Witchin' Man" by Douglas Jole
3. "Memorease of Tommy" by Pete D. Manison

Fourth Quarter

1. "Entropy, and the Strangler" by Eric Flint
2. "Messages" by Stoney Compton
3. "A Child's Handful of the Moon" by David Phalen

Published Finalists

"The Children China Made" by Tom Drennan

"The Monitor" by John Richard DeRose

"Borealis" by D. A. Houdek

"Cinders of the Great War" by Kathleen Dalton-Woodbury

"Los Muertos" by Lisa Smedman

top Lisa Smedman receives her Finalist certificate from Tim Powers.

top middle Elizabeth E. Wein with Illustrator of the Future winner Yuri Galitsin, who illustrated her story.

bottom middle Eric Flint with Anthony Carpenter, the Illustrator winner who provided the artwork for his story.

bottom Frederik Pohl and Gold Award winner Karawynn Long sign copies of the newly released *Writers of the Future* Volume IX.

winner spotlights

STONEY COMPTON

Stoney Compton's short fiction has appeared in *Universe 1, Tomorrow, Speculative Fiction* and his novel *Russian Amerika* was published in 2007. During his thirty-one years in Alaska he worked many jobs including produce apprentice, gandy dancer for the USAF/Alaska Railroad, emergency firefighter for the Bureau of Land Management, school bus driver, and newspaper art director. His fine art has appeared in juried shows in New York, Hawaii, Alaska and Washington.

He served an enlistment in the US Navy aboard the *USS Yorktown, CVS-10,* as well as in *VR-24 Det* in Naples, Italy. He is a Visual Information Specialist for the 6th Combat Training Squadron, Nellis AFB, Nevada. He lives northeast of Las Vegas with his wife, Colette, and an ever-changing number of pets. He is an avid hiker and velocipede enthusiast.

The Writers of the Future Contest is a superb memorial to L. Ron Hubbard. I discovered the Contest by stumbling over a copy of Writers of the Future *Volume I and being thrilled that such a thing existed. I had just started writing as a creative outlet and wanted to enter the Contest before it evaporated as so many similar competitions before it had.*

In early 1993, I received the magic phone call that I had placed second in the fourth quarter of 1992. That July in Hollywood, I met people there who are still friends today; Eric Flint and Sean Williams come immediately to mind.

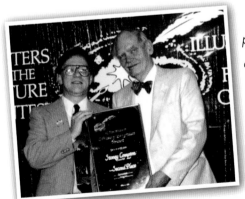

It was a week of true magic and made me realize that writing fiction people would want to read was more than a dream. The two certificates of Honorable Mention and the certificate for Second Place for the Fourth Quarter of 1993 hang on my office wall and are talismans of a sort. They personify initial hope, a goal, and for so very many fellow award winners and myself, a sense of accomplishment and victory.

Here it has already been twenty-five years of a contest I feared would go under before I could participate. My sincere congratulations to all those connected with the Writers of the Future Contest (and the Illustrators of the Future Contest!); you are keeping Hubbard's spirit alive by lifting so many others.

— Stoney Compton

SEAN WILLIAMS

Number one *New York Times* bestselling author Sean Williams has written over seventy short stories and thirty novels for readers of all ages. He lives in Adelaide, Australia, where he is a multiple recipient of the Ditmar and Aurealis Awards. He won Third Prize in the first quarter of 1992, and after his career had flourished, he returned as a judge in 2005.

The Writers of the Future Contest has had a profound impact on my career, ever since I submitted my first story in 1989. That story didn't win anything, but the quarterly deadline was my first taste of the self-discipline required to progress in this most difficult of fields. I stuck to it religiously for the next two and a half years, until I did finally win a prize.

Attending the workshop introduced me, not only to my fellow winners and finalists in Volume IX, but to the judges, among whom were numbered some of my favorite authors. Until that moment, I hadn't truly understood how important the global community of writers is to all new voices. This meeting of like minds resulted in several enduring friendships, and it shaped my career in ways that I couldn't have imagined.

Then and in subsequent years, the Contest threw many new skills and opportunities my way. The media training I received still proves invaluable every time something breaks into the news; my initial (and enduring) reserve at public appearances has been eroded by numerous tuxedo-clad stage events and signings; the many contacts I made have proved both professionally advantageous and personally inspirational, over and over again. Most important, it has provided a chance to give something back to the community.

— Sean Williams

1993

ERIC FLINT

Eric Flint's novel writing career began with the science fiction novel *Mother of Demons*. With David Drake, he has collaborated on the six-volume Belisarius series, as well as a novel entitled *The Tyrant*. His alternate history novel *1632* was published in 2000 and has led to a long-running series with several novels and anthologies in print. He recently began a new alternate history series set in North America with *1812: The Rivers of War* and *1824: The Arkansas War*. He's written many other science fiction and fantasy novels, including two with fellow WotF winner and judge, K. D. Wentworth.

Flint graduated from the University of California at Los Angeles in 1968, majoring in history (with honors), and later received a master's degree in African history from the same university. Despite his academic credentials, Flint has spent most of his adult life as an activist in the American trade union movement, working as a longshoreman, truck driver, auto worker, steel worker, oil worker, meatpacker, glass blower and machinist. He has lived at various times in California, Michigan, West Virginia, Alabama, Ohio and Illinois. He currently resides in northwest Indiana with his wife Lucille.

The Writers of the Future Contest played a critical role in the early stages of my career as a writer. I'd been writing speculative fiction off and on since I was fourteen years old, but I never buckled down and seriously tried to get published until I was forty-five. At that point, still unsure if I had the talent to have a realistic chance of becoming a professional writer, I ran across the WotF Contest. I decided the Contest would be an excellent way to get a professional assessment of my writing, free of charge. Up till then, the only reactions I'd gotten were from friends and family—each and every one of which was glowingly positive, and not one of which I trusted to be objective.

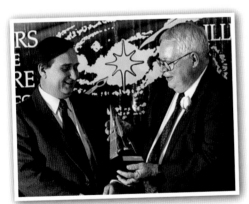

So, I sent off a story and, a few months later, discovered that I'd been chosen as the First Place winner for the winter quarter of 1992. That convinced me that I wrote well enough to try to become a professional writer. The panel of judges that year was Larry Niven, Jerry Pournelle, Anne McCaffrey and A. J. Budrys, which was as prestigious and authoritative as any group of judges you could ask for. And, best of all, not one of them knew me from Adam, so I could be certain their assessment was impartial. In a very real sense, my writing career began that moment.

— Eric Flint

ELIZABETH E. WEIN

Elizabeth E. Wein has lived in Perth, Scotland, for ten years and wrote four of her five published novels there. The books are a cycle of young adult fiction set in Arthurian Britain and sixth-century Ethiopia. Elizabeth's recent sequence, The Mark of Solomon, is published in two parts as *The Lion Hunter* (2007) and *The Empty Kingdom* (2008). *The Lion Hunter* was short-listed for the Andre Norton Award for Best Young Adult Fantasy and Science Fiction.

Elizabeth has written and published many short stories for teens and is currently working on something completely different, a thriller set during the Second World War.

My Writers of the Future Award came, coincidentally, at the same time as the acceptance for publication of my first novel, The Winter Prince—the novel actually appeared in print about a month before my winning short story, "Fire." So it's not true to say that the Writers of the Future Contest provided my big publishing break.

But it gave me something equally, if not more, important to my writing career. It introduced me to a community of writers that I did not know existed. Before that fabulous week in Hollywood sharing a workshop with such names as Eric Flint, Lisa Smedman, Sean Williams—unknown then—I had no idea of the existence of "cons," "SFWA," or "GEnie." Now, of course, I can't imagine my life as a writer without the attendant deep connection to fans, other writers and the Internet. Writers of the Future provided my initial lifeline to all three.

I've never looked back!

— Elizabeth E. Wein

LISA SMEDMAN

Lisa Smedman is the *New York Times* bestselling author of numerous novels set in the worlds of the Dungeons & Dragons role-playing game's Forgotten Realms universe, including *Extinction, Sacrifice of the Widow, Storm of the Dead, Ascendancy of the Last, Heirs of Prophecy, Venom's Taste, Viper's Kiss* and *Vanity's Brood*. For the Shadowrun role-playing game, she has written five novels, *The Lucifer Deck, Blood Sport, Psychotrope, The Forever Drug* and *Tails You Lose*.

She has also written children's books, among them *Creature Catchers, From Boneshakers to Choppers: The Rip-Roaring History of the Motorcycle*, and *The Apparition Trail*. She has published short fiction, written plays produced by a Vancouver theater group, and was one of the founders of *Adventures Unlimited* magazine. She has designed and written for other Advanced Dungeons & Dragons game lines, and has designed gaming products for *Star Wars, Indiana Jones, Cyberpunk, Immortal, Shatterzone, Millennium's End* and *Deadlands*, as well as creating original games.

Lisa has a journalism degree and works as an editor for the weekly newspaper, the *Vancouver Courier*; she also has an anthropology degree and is fascinated by history and archaeology, particularly the Bronze Age.

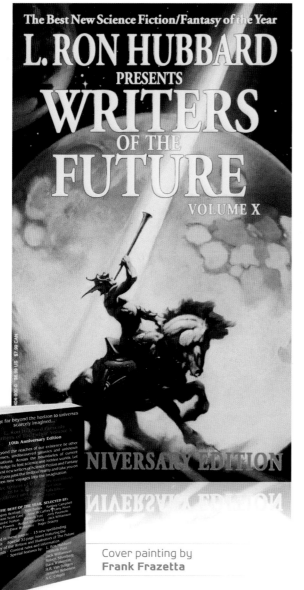

The Best New Science Fiction/Fantasy of the Year

L. RON HUBBARD
PRESENTS

WRITERS
OF THE
FUTURE

VOLUME X

Cover painting by
Frank Frazetta

1994

A decade of the Writers of the Future Contest! The tenth anniversary celebration was held in the lush Garden Pavilion at the Chateau Elysée in Hollywood, California on Friday, May 27, 1994.

Hans Janitschek, president of the Society of Writers at the United Nations (who had hosted the WotF event in 1989), returned to deliver a brief address. Ray Bradbury was among the special guest attendees. As in other years, winners, judges and attendees placed their thoughts and predictions inside a time capsule.

All of the active founding Contest judges received a plaque of appreciation for their service in helping new writers. Ceremony attendees were treated to a special commemorative booklet celebrating a decade of the Contest.

In the week prior to the Awards event, as an experiment for WotF's tenth anniversary, the workshop was opened to a much larger pool of aspiring writers beyond just the Contest winners.

top The Tenth Anniversary commemorative booklet.

middle Susan J. Kroupa receives her workshop completion certificate from Algis Budrys.

bottom Frederik Pohl addresses the workshop attendees.

winners

L. Ron Hubbard Gold Award

"Schrödinger's Mousetrap" by Alan Barclay

First Quarter

1. "Seekers" by Bruce Hallock
2. "Where Memories Go" by Lauren Fitzgerald
3. "After the War Is Over" by Dan Gollub

Second Quarter

1. "Storm Jumper" by James Gladu Jordan
2. "Winter's Cycle" by Ron Ginzler
3. "Queries Concerning the Negation of Belief" by Andrew W. Mackie

Third Quarter

1. "The Healer" by Susan Kroupa
2. "And Abel Begat . . ." by Audrey Lawson
3. "A Handful of Stones" by Mark Schimming

Fourth Quarter

1. "Schrödinger's Mousetrap" by Alan Barclay
2. "Kidswap" by Sheila Hartney
3. "Silicon de Bergerac" by W. Eric Schult

Published Finalists

"The Bridge to Over There" by C. Ellis Staehlin
"Achilo" by D. E. Lofgran

top Ray Bradbury and old friend Jack Williamson.

top middle Hans Janitschek from the United Nations addresses the audience.

bottom middle Jack Williamson is presented with a plaque for his service as a judge over the first ten years of the Contest; all of the remaining original judges also receive plaques.

bottom Dr. Gregory Benford presents the Third Place certificate to W. Eric Schult.

winner spotlights

SUSAN J. KROUPA

Susan J. Kroupa has sold short fiction to *Realms of Fantasy* as well as to various anthologies, including *Bruce Coville's Shapeshifters* and *Beyond the Last Star*. She sold a young adult fantasy in 2008 to Wizards of the Coast (that, alas, was part of a line cancelled before publication). She has also won awards in the Deep South Writers Conference Competition, Writers at Work, the Frank Waters Writers of the Southwest and the Utah Arts Council contests. Currently, she lives in southwest Virginia and is busy marketing a historical fantasy and a new young adult fantasy.

When I won first prize in the Writers of the Future Contest, I was a single parent, fresh from a divorce, struggling to make a new life. I badly wanted to break into the science fiction and fantasy market and was also trying to find a way to connect to the considerable community of writers in Utah, but hadn't had much luck with either. Winning the Contest changed everything.

Not only did my WotF credential open doors to other sales, shortly after the announcement of the winners for my quarter, I was invited to join a writing group that had included Dave Wolverton, M. Shayne Bell, Ginny Baker, Lee Allred and a host of others, some already WotF winners and many who became winners down the road. And then there was the workshop, which opened up a whole world of knowledge, instruction and friendship from professional writers who, without the Contest, I may not have met for years or at all.

The Contest gave me hope at a difficult time in my life. But more than that, it supplemented that hope with a wealth of contacts and practical resources that continue to help me to this day. All I can say is thanks to L. Ron Hubbard for founding the Contest and to all those who have worked so hard to provide this opportunity.

— Susan J. Kroupa

BRUCE HALLOCK

Former technical writer Bruce Hallock was born in Austin, Texas, and lived there all his adult life until 2008 before moving to Corvallis, Oregon, with his wife Leela Devi. As a full-time freelance writer, he now uses the pen name Austin Bruce Hallock. His recently published *Sky Full of Dreams* is an aviation biography of his father, Bruce K. Hallock.

When I think of the Writers of the Future Contest, I'm reminded of its enormous influence on the lives of not only the winners, but also those who have entered the Contest over the past twenty-five years. I started entering the Contest in its very first year. I didn't enter every quarter, but I entered regularly. Not winning did not discourage me, because I knew the impetus of the Contest was helping me get better. Somehow, just participating made real success seem reachable. So I kept at it, and in the tenth year, I won. It was a guidepost on the road to attaining my dream, and I think it has been that for countless others. Now I look back on winning as one of the turning points in my life. I gained confidence and experience through the process, as well as through winning.

— Bruce Hallock

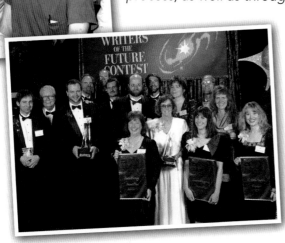

Cover painting by
Frank Kelly Freas

This was the first of two years in which the annual Awards ceremony was held at the Destiny Theater, Johnson Space Center, Houston, Texas. The ceremony took place on Friday, June 16, 1995. Story Musgrave, the only astronaut to fly on all five space shuttles, was one of the presenters at the ceremony. Along with Master of Ceremonies Jim Meskimen, he helped prepare the annual time capsule.

The 1995 writers' workshop was held at Rice University. Prior to the Awards event, winners and guest speakers were treated to a tour of the Johnson Space Center and Mission Control. A special space symposium featured NASA representatives Joseph P. Loftus, Dr. Wendell Mendell, Dr. Yoji Kondo and astronaut Story Musgrave as well as science fiction authors Kevin J. Anderson, Algis Budrys and Larry Niven.

1995

top A perfectly science-fictional site for the Writers and Illustrators of the Future Awards.

middle The Destiny Theater at Houston Space Center, crowded with attendees for the eleventh annual Awards ceremony.

bottom Astronaut Story Musgrave serves as guest speaker for the event.

winners

L. Ron Hubbard Gold Award

"Sea of Chaos" by Julia H. West

First Quarter

1. "Sea of Chaos" by Julia H. West
2. "Ghost Woman" by
 Gordon R. Menzies
3. "The Last Blade" by
 Elisa Romero-McCullough

Second Quarter

1. "Rosita's Baby" by Beverly Suarez-Beard
2. "Harpbreak" by Melissa Lee Shaw
3. "The Witch's Cat" by Ann Miller Jordan

Third Quarter

1. "Merchant Trust" by Susan Urbanek Linville
2. "Not Worth Fixing" by Brian Plante
3. "Ears" by Steve Rissberger

Fourth Quarter

1. "Patient's End" by J. F. Peterson
2. "Burnt Offerings" by Shira Daemon
3. "Oh, Jungleland" by Grant Avery Morgan

Published Finalists

"Final Jeopardy" by William J. Austin

"A Portion for Foxes" by Brook West

top Story Musgrave and Master of Ceremonies Jim Meskimen prepare the time capsule.

top middle Tim Powers and Jack Williamson.

middle A meeting of scientists, space professionals and science fiction writers for the afternoon symposium at the Space Center: Kevin J. Anderson, Joseph P. Loftus, Algis Budrys, Dr. Wendell Mendell, astronaut Story Musgrave and Larry Niven.

bottom middle Algis Budrys and astronaut Story Musgrave.

winner spotlights

MELISSA LEE SHAW

Melissa Lee Shaw is an aficionado of early music, animals in general and dolphins in particular. She got her master's degree conducting dolphin language research. In addition to her Writers of the Future win, she is also a graduate of Clarion West and has sold stories to professional anthologies including *Sirens and Other Daemon Lovers*, *Silver Birch, Blood Moon* and *Children of Magic*, as well as top magazines in the field, including *Asimov's*, *Analog* and *Realms of Fantasy*.

In 1994, I had been trying to sell my fiction for more than ten years, and was despairing that I ever would. I was at Clarion West when the call came in that I had placed second in the Writers of the Future Contest. At first, I was in shock; then, I was deliriously happy and surrounded by writers who understood how important this first sale was. It was the perfect way to find out that my dream of being published was coming true.

What I remember most clearly is the WotF Awards event itself: how glamorous it seemed, how lavish, how celebratory. It was an experience that I carry with me to this day, because it's easy to forget what a huge achievement it is to sell that first story. You habituate, you grow blasé, you think, "Well, yeah, but what have I done for me lately?" I'm grateful that the WotF staff kept contacting me about the Contest, the anthology and the upcoming Awards event, which reminded me to be excited about that first sale throughout the months between winning Second Place and the Awards event itself. Those reminders helped solidify for me that yes, I really was a writer, and I was good enough that someone wanted to pay me money for my work. And I can't begin to describe the reverence with which I picked up the anthology when I finally saw it at the Awards event. There it was, my name in lights.

After that first sale, I was able to join SFWA as an associate member, and I had something of substance to put in my cover letters. The confidence I gained from that WotF success egged me on to approach markets I would have thought were out of my reach, and consequently, I sold stories to professional-level anthologies, and then to top magazines in the field.

— Melissa Lee Shaw

JULIA AND BROOK WEST

Brook and Julia West are the only married couple to attend the Writers of the Future workshop with Julia winning the Gold Award and Brook selected as a published Finalist. Since winning the Contest, Julia West has published stories in magazines including *Spider, Oceans of the Mind* and *Realms of Fantasy*, and anthologies including *The Shimmering Door, Enchanted Forests* (both collaborations with her husband Brook) and *Sword and Sorceress 24*. Her story in *Spider* was reprinted several times in fifth- and sixth-grade readers.

Brook has continued to publish and administer the Science Fiction and Fantasy Writers of America's Nebula Awards for ten years.

What I remember most about the 1995 workshop for Writers of the Future are the people. As are many writers, I'm quite shy, so I was amazed at how quickly we became a cohesive group. We enjoyed each other's company so much that we kept up with each other through a quarterly newsletter for several years thereafter.

I am more of a novel writer, used to plenty of space to explore character and milieu, so the skills necessary to write a shorter piece came with some difficulty. At the workshop, we had to write a story in a day, and I still use the exercises that we learned to make this possible.

My story was liked enough by the judges (one of whom was my idol since childhood, Andre Norton) that it won First Place in my quarter and then Grand Prize for the year. This knowledge helps me realize, when I'm feeling unsure of my work, that I can write a story people will enjoy.

Over the years, I have used the Contest as a goal for the writers in my local group. Having a good place to submit a new story every three months encourages them to write more, complete stories and (the most important thing) submit them to the Contest.

— Julia West

The Contest got me writing real stories. I was always writing snippets, poetry, scenes and the like, but Dave Wolverton, who was the Contest Coordinating Judge at the time, introduced me to the Budrys Seven-point plot at a workshop. That gave me an outline to hang things on and after a fair bit of workshopping (thank you, Kevin O'Donnell, Jr.), the first actual story I ever wrote was ready to submit. While it didn't place, it made Finalist and I was told that Jack Williamson had nominated it for First Place, saying (as I remember) "It's for stories like this that I became a judge for Writers of the Future."

My wife, Julia, won the Gold Award that year and I was a published Finalist, so we ended up between the covers together in Volume XI—as far as I know we are still the only couple to have done that. We had a great time as partners at the WotF workshop.

— Brook West

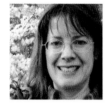

BEVERLY SUAREZ-BEARD

Beverly Suarez-Beard has published numerous professional short stories since attending Writers of the Future in 1995. Some of the magazines that have included her name in the contents are *Realms of Fantasy, Cicada, Talebones, Paradox* and *Century.*

Sometime in the early '80s I found a copy of a Writers of the Future anthology and was tremendously impressed by the stories. At the time, I knew a little about writing short stories and absolutely nothing about manuscript formats or cover letters or what it took to get published. I did know, however, after reading that book, that I wanted someday to write a story good enough to be included in that anthology. So winning the Contest (in 1994) was a dream come true for me.

As exciting as it was to win (this was also my first fiction sale), I had no idea that an even more exciting experience was in store. The workshop was intense and brain-expanding; we had to write complete and coherent short stories in a single day! We had the opportunity to meet and learn from giants in the field of science fiction. I made lasting friendships with other Contest winners, including the wonderful writers Elisa Romero-McCullough and Brian Plante. Brian introduced me to the best and most useful critique group I have ever had the opportunity to participate in. Some of my later stories probably saw print thanks to their helpful comments.

Winning the Contest gave me confidence as a writer. It gave me a foot in the door with editors. The story I wrote there (in that single day!) came closer to the Nebula short list than any of the stories I labored over for weeks. I don't think I can begin to express how much that experience meant to me, and I'll always be grateful for it.

— Beverly Suarez-Beard

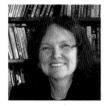

SUSAN URBANEK LINVILLE

Susan Urbanek Linville has published a dozen genre stories and many newspaper, magazine and encyclopedia articles on SF and science-related topics. Presently, she writes scripts for Indiana University's National Public Radio's series, *A Moment of Science.* Her nonfiction memoir for Jackson Kaguri, *The Price of Stones: Building a School for My Village,* about an AIDS orphans' school in Uganda, was released in June 2010 by Viking-Penguin; she has also completed an epic fantasy trilogy in collaboration with her husband.

I still remember the day the Writers of the Future Contest called. I was in the midst of preparing to defend my PhD in biology at the University of Dayton, and was in a very poor mood when I arrived home. Despite my annoyance, my husband just couldn't seem to wipe the Cheshire grin off his face. He was in on the surprise. The call arrived an hour or so later, informing me my story, "Merchant Trust," had placed first in the quarter. I was

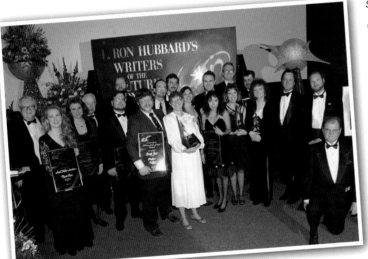

shocked. All the writing, rewriting and improving my writing skills had finally paid off. Now the question was, "Could I be a writer and a biologist at the same time?"

After finishing my degree, I could have ignored my writing for a long while. The WotF win was just the encouragement I needed to persevere.

— Susan Urbanek Linville

The Best New Science Fiction and Fantasy of the Year

L. RON HUBBARD
Presents
WRITERS
of The
FUTURE
VOLUME XII

NEW SF DISCOVERIES
16 Voyages into the Imagination plus Special Features on Writing and Art by: L. Ron Hubbard, Doug Beason and Paul Lehr

Cover painting by
Bob Eggleton

1996

The Writers and Illustrators of the Future Awards event was held at the Johnson Space Center in Houston, Texas for the second year in a row. The Awards ceremony took place on Friday, June 16, 1996 in the Destiny Theater. Astronaut Janice Voss volunteered to be a presenter at the ceremony. The annual anthology was unveiled during the event, featuring a cover painted by Bob Eggleton.

Previously, winners, judges and their guests received a special tour of the Space Center and museum and attended a symposium at NASA, which featured science fiction luminaries and space scientists.

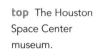

top The Houston Space Center museum.

middle Kevin J. Anderson and Dr. Doug Beason with astronaut Janice Voss.

bottom The audience applauds in the Destiny Theater.

winners

L. Ron Hubbard Gold Award

"His Best Weapon" by Arlene C. Harris

First Quarter

1. "Ploughshares" by M. W. Keiper

2. "Tempering Day" by Darren Clark Cummings

3. "Quixchotol" by E. Robertson Rose

Second Quarter

1. "Dead Faces" by Edwina Mayer

2. "Grail's End" by Callan Primer

3. "A Report from the Terran Project" by Scott Everett Bronson

Third Quarter

1. "His Best Weapon" by Arlene C. Harris

2. "Requiem for a Deathwatcher" by Carrie Pollack

3. "Devil's Advocate" by Syne Mitchell

Fourth Quarter

1. "The Unhappy Golem of Rabbi Leitch" by Russell William Asplund

2. "After the Rainbow" by Fruma Klass

3. "Narcissus Rising" by Roge Gregory

Published Finalists

"In the Elephant's Graveyard, Where Space Dances
with Time" by Sue Storm

"Reflections in Period Glass" by S. M. Azmus

"Eyes of Light" by Richard Flood

"The Savant Death Syndrome" by Jerry Craven

top The afternoon NASA symposium: Dr. Yoji Kondo, astronaut Janice Voss, Algis Budrys, Larry Niven and Dr. Doug Beason.

top middle Shuttle astronaut Janice Voss addresses the attendees at the ceremony.

middle Judge presenters for the 1996 Awards ceremony: Dr. Doug Beason, Kevin J. Anderson, Dr. Jerry Pournelle, Larry Niven, Algis Budrys, Jack Williamson, Frederik Pohl, Tim Powers, Dr. Gregory Benford, Dave Wolverton.

bottom middle Arlene C. Harris is ecstatic to receive her Gold Award.

bottom winners and presenting judges.

winner spotlight

SYNE MITCHELL

Since WotF, Syne Mitchell has published five science fiction novels (*Murphy's Gambit*, *Technogenesis*, *The Changeling Plague*, *End in Fire* and *The Last Mortal Man*), many short stories (including one in the prestigious journal *Nature*), and gone on to found an online magazine, *WeaveZine.com*. She currently spends most of her time exploring the technical wonders of online media, enhancing text with audio, video and interactive Web applications. She lives near Seattle with her husband (fellow writer Eric Nylund) and their son.

One of the things new writers need is validation, some indication that they're moving in the right direction, making progress. The other thing they need is instruction, teachers and mentors to help them take their writing to the next level. For me, the Writers of the Future Contest provided both.

Winning an award (even taking Third Place, as I did) is a tremendous boost to a new writer who is slogging their way through the submission/rejection process. Editors get so many story submissions, they often don't have time to provide feedback on why one story gets published, and another one doesn't. So as a new writer, there's a tremendous amount of doubt as to whether you're on to something, or simply wasting everyone's time. The award was a boost at a critical time in my career.

The other wonderful thing was the week I got to spend learning the craft of writing from Algis Budrys. He had a succinct way of breaking stories down into their component atoms, and I learned things from him that I still use in my writing today.

— Syne Mitchell

Cover painting by
Frank Frazetta

After two years at the Johnson Space Center, the Writers and Illustrators of the Future event moved to the Kennedy Space Center at Cape Canaveral, Florida. The winners, judges, and special guests were treated to a breathtaking behind-the-scenes tour of the Kennedy Space Center, the shuttle launch pads, rocket garden, Vehicle Assembly Building, the US Astronaut Hall of Fame, and then the unforgettable experience of witnessing a nighttime launch of the space shuttle *Atlantis* (flight STS-86), on a mission to the *Mir* space station.

Two days later, on Saturday, September 27, 1997, the Awards ceremony took place at the Kennedy Space Center. Astronaut Norman Thagard participated as guest speaker and presenter. Legendary artist Frank Frazetta (who painted the cover for that year's WotF anthology) received the L. Ron Hubbard Lifetime Achievement Award for Outstanding Contributions to the Arts.

Left Winners, judges, and guests take a special tour of the Kennedy Space Center.

1997

winners

L. Ron Hubbard Gold Award

"A Prayer for the Insect Gods" by Morgan Burke

First Quarter

1. "A Prayer for the Insect Gods" by Morgan Burke
2. "Wings" by Alan Smale
3. "Troder" by David L. Felts

Second Quarter

1. "Black on Black" by Kyle David Jelle
2. "Altar" by Malcolm Twigg
3. "The Winds" by Heidi Stallman

Third Quarter

1. "The Scent of Desire"
 by Bo Griffin (John Brown)
2. "White Jade" by Janet Martin
3. "Orange" by Sara Backer

Fourth Quarter

1. "For the Strength of the Hills" by Lee Allred
2. "The Gods Perspire" by Ken Rand
3. "Recursion" by S. Seaport

Published Finalist

"The Garden" by Cati Coe

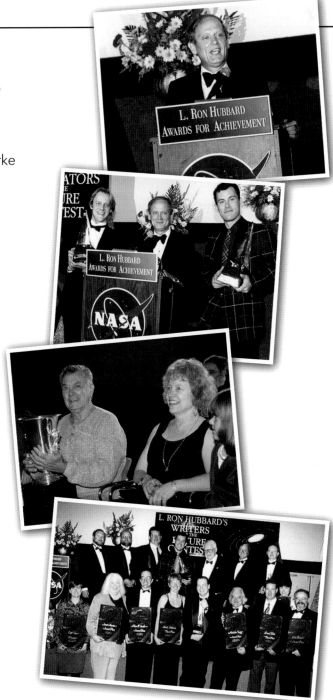

top Astronaut Norman Thagard gives his guest speech at the ceremonies.

top middle Gold Award winners, Illustrator Eric Williams and Writer Morgan Burke with Norman Thagard.

bottom middle Frank Frazetta, recipient of the L. Ron Hubbard Lifetime Achievement Award with Ellie Frazetta and granddaughter.

bottom The winners and presenting judges for 1997.

winner spotlights

KEN RAND

Ken Rand (1946–2009) was like a sponge, always interviewing writers, talking about writing, listening, asking questions and absorbing everything. I first met Ken around 1993 when my wife and I were guests at the Life, the Universe and Everything conference at Brigham Young University. Ken was assigned to watch over us (and to procure us coffee on a distressingly decaffeinated Mormon campus). We had only to mention that something "would be nice," and it would appear before the end of the next panel. But Ken got something out of all that work, too—he took every spare moment to ask me for advice on being a writer, as he did with any writer he met. Two years later, he won Second Place in the Writers of the Future Contest, then he won Third Place in the *Star Trek: Strange New Worlds* contest. He wrote many articles, interviewed dozens of successful writers, gave workshops, shared every bit of writing advice he learned with other aspiring writers. He was one of the most dedicated, persistent writers I have ever met, and he never, ever gave up and never stopped pushing.

Ken wrote quirky, noncommercial fiction that was always entertaining. Most of the stuff I remember belonged in a strange fantasy western universe: *Pax Dakota, The Golems of Laramie County, Fairy BrewHaHa at the Lucky Nickel Saloon.*

I last saw Ken in fall 2007 when a book-signing tour took me to Salt Lake City. While I was autographing stock at area bookstores, Ken called to see if we could arrange to meet somewhere. Even then, he was quite ill (abdominal cancer, though he only referred to it as "my owwie"), and he knew he could never make it to the formal signing, but he did meet me in a coffee shop at a Barnes & Noble and we sat for about an hour. As usual, he was intensely interested, asking me dozens of questions, trying to find ways to spread the word about his books from Yard Dog Press or Five Star.

The writing world is poorer for his loss, and I'm going to miss him a great deal.

— Kevin J. Anderson

JOHN BROWN

John Brown, whose prizewinning story was written under the pen name "Bo Griffin," has just published the first book in his epic fantasy series, *Servant of a Dark God*. Other forthcoming novels in the series include *Curse of a Dark God* and *Dark God's Glory*. He lives with his wife and four daughters in the hinterlands of Utah where one encounters much fresh air, many good-hearted ranchers and an occasional wolf.

I will always be grateful to Writers of the Future—both to Mr. Hubbard for setting it up and to all those who keep it running. Yes, it was grand getting a total of $2,000 for my first short story sale. Where does that happen anymore except right here with this Contest? Yes, the weeklong workshop at Cocoa Beach, Florida, watching a space shuttle launch, and hanging out with the other winners was a blast. I cannot think of a better way to celebrate the start of a journey to a writing career.

But more important than all that: it was this win that helped keep my dream alive during the next ten long freaking years before I finally sold my first novel. It was the workshop that allowed me to meet a number of generous pros, one of whom played an important part in helping me get that sale. But even before the win, it was this Contest that helped open my eyes to the possibility of becoming one of those folks whose names line the bookshelves and who deliver so many hours of the experience I love. So rock on, Writers of the Future! I hope the Contest runs at least another hundred years.

— John Brown

SARA BACKER

Sara Backer spent three years in Japan (1990–1993), as the first American and first woman to serve as visiting professor of English at Shizuoka University. Her novel *American Fuji* was a book club pick of the *Honolulu Advertiser* and a nominee for the Kiriyama Prize.

Backer, a Djerassi Program artist in residence in 1999, is also a poet whose work has appeared in numerous literary magazines including *Poetry, Southern Poetry Review, Poetry Northwest* and *Slant*. She has taught creative writing at conferences for Cuesta College, Maui Literary Circles and Northeast Cultural Cooperative. She currently teaches at the University of Massachusetts at Lowell and lives in the woods in New Hampshire.

"There is a tide in the affairs of men, which, taken at the flood, leads on to fortune."—Brutus (Shakespeare, Julius Caesar).

Writing fiction is a lot like investing in the stock market. You lose, you win, you never know what's going to happen next and the game isn't over until you die—which means you just keep at it and hope for the best. This requires confidence (as well as a certain amount of insanity). In the 1990s, I had published a few stories and poems, but I wasn't getting traction from my credits. Since the small press world is mostly a back-scratching exchange, getting a story in print was more likely to be proof that you had an editor as a friend than proof that you wrote well. I set my sights on winning a contest, believing that would at least prove I wrote better than all the other writers trying to prove they wrote better than I did. For several years, I was everyone's finalist, runner-up or honorable mention. Still no traction. The heck with contests.

In 1997, I happened to write a long futuristic mystery story I titled "Orange" (after finding out orange was the color least chosen as a favorite except by sociopaths). Frustrated by the lack of venues that considered submissions over 5,000 words, I once again sought contests. I found only one for which "Orange" fit the specs and rules: Writers of the Future. Since it was a large, established, annual contest with generous cash awards, I had no expectation of success. I entered regardless because I had nowhere else to go with the story (and I wasn't required to pay an entry fee). It took a full week after notification to realize I had won.

A big insight: had I been aiming too low? I tested this idea by applying for a Djerassi Writing Residency; I was accepted. At that residency, I wrote a play (which was produced at the Last Frontier Theatre Conference in Valdez, Alaska), a poem (which was accepted by Poetry magazine) and queries to agents about my first novel, American Fuji. I signed with an agent two months later, and had a book contract from Putnam within a week.

— Sara Backer

LEE ALLRED

Since winning First Place in WotF, Lee Allred has sold short stories to *Asimov's* magazine, DC Comics, Image Comics and several SF anthologies. His debut story was a finalist for the Sidewise Award for Alternate History and his "Batman A-Go-Go" story was awarded the Comicdom Award by European readers. Lee has spent the last twelve years travelling worldwide installing fiber optic and computer networks.

*Winning First Place in L. Ron Hubbard's Writers of the Future Contest was like somebody handing me an Aladdin's lamp with infinite wishes. *Poof!* Suddenly, my wish to break into the science fiction field was granted! The Contest genies whisked me away to a wonderful week of attending workshops taught by the legendary Algis Budrys, of writing stories, and of clutching with trembling hands a real live book with my real live name in it.*

Lots of other magical things happened to me after that. My WotF story then became a finalist for the Sidewise Award for Alternate History. That led directly to another alternate history story sale, then more story sales from that, including selling my WotF workshop story to an anthology where it appeared alongside Stephen King. The phrase "prizewinning author" also open-sesamed doors at Image Comics and DC Comics, letting me write Batman and Teen Titans and other comic book characters. And so on.

The secret to remember about magical lamps with infinite wishes, though, is that you have to keep working for the magic to happen. If you don't keep polishing the lamp, you don't get those next wishes!

— Lee Allred

The Best New Science Fiction and Fantasy of the Year

L. RON HUBBARD
PRESENTS
WRITERS OF THE FUTURE
VOLUME XIV

Cover painting by
Paul Lehr

The 1998 Writers and Illustrators of the Future workshops were held in Hollywood, California, in the lavish library setting of Author Services, Inc., on Hollywood Boulevard. Students also received a tour of Paramount Studios, the *Star Trek: Deep Space Nine* set and the recording studio for the show's musical score.

The fourteenth annual Awards ceremony was held on Saturday, October 3, 1998 at the L. Ron Hubbard Gallery at Author Services. During the ceremony, actress and stuntwoman Patricia Tallman *(Babylon 5, Army of Darkness, Night of the Living Dead)* and actor/producer Jeffrey Willerth presented awards and helped prepare a new set of time capsules.

As a special highlight of the event, Jack Williamson received the Lifetime Achievement Award for Outstanding Contributions to the Arts for his many decades of producing science fiction stories, then all attendees helped Jack celebrate his ninetieth birthday with a special cake.

top Patricia Tallman and Jack Williamson flanked by Writer Gold Award winner Brian Wightman (left) and Illustrator Gold Award winner Paul Marquis.

middle WotF helps Jack Williamson celebrate his ninetieth birthday.

bottom Jack Williamson and his Lifetime Achievement Award.

1998

winners

L. Ron Hubbard Gold Award

"Nocturne's Bride" by Brian Wightman

First Quarter

1. "Literacy" by Stefano Donati
2. "The Dragon and the Lorelei" by Carla Montgomery
3. "Red Moon" by Scott M. Azmus

Second Quarter

1. "The Dhaka Flu" by Richard Flood
2. "Conservator" by Steven Mohan, Jr.
3. "Agony" by Ladonna King

Third Quarter

1. "Nocturne's Bride" by Brian Wightman
2. "Broken Mirror" by David Masters
3. "Waiting for Hildy" by Chris Flamm

Fourth Quarter

1. "Spray Paint Revolutions" by J. C. Schmidt
2. "Red Tide, White Tide" by T. M. Spell
3. "Faller" by Tim Jansen

Published Finalists

"Jenny with the Stars in Her Hair" by Amy Sterling Casil

"Cyclops in B Minor" by Jayme Lynn Blaschke

"Silent Justice" by Maureen Jensen

"Metabolism" by Scott Nicholson

"The Disappearance of Josie Andrew" by Ron Collins

top Kevin J. Anderson (center) receives time capsule predictions from Patricia Tallman and Jeffrey Willerth.

top middle Jack Williamson surrounded by the WotF class of 1998.

bottom middle Writers workshop and guests tour Paramount Studios.

bottom Publicist William J. Widder talks to the students about publicity for their books.

winner spotlights

AMY STERLING CASIL

Amy Sterling Casil is a 2002 Nebula Award nominee and recipient of other awards and recognition for her short fiction, which has appeared in publications ranging from *The Magazine of Fantasy & Science Fiction* to *Zoetrope*. She is the author of twenty-one nonfiction books, one hundred short stories (primarily science fiction and fantasy), one fiction and poetry collection and two novels. She lives in Playa del Rey, California with her daughter Meredith and a Jack Russell Terrier named Badger.

Amy has worked since 2005 as the vice-president for development for Beyond Shelter in Los Angeles, and she teaches writing and composition at Saddleback College in Mission Viejo, California. She is currently the treasurer of the Science Fiction and Fantasy Writers of America and a cofounding member of Internet author cooperative Book View Cafe.

From 1995 to 1998, I entered the Writers of the Future Contest every quarter. However, this was not the first time I had aspired to be a science fiction writer. I had been a published writer of short stories and poetry while in college, and had attended the Clarion Science Fiction Writers Workshop in 1984. I was entirely too young to have gone, but I really wanted to go!

When I applied to Clarion, I confessed my lifelong, yet secret interest in writing science fiction to my boyfriend, a top engineering student and Harry Harrison fan. He responded, "But you have to be smart to write science fiction!"

I did write for a couple of years after Clarion, but it seemed immature to spend so much time writing when I should get a real job and support my family. I quit, and didn't write again for another eight years.

My daughter was in preschool when I started writing stories and enthusiastically sent my efforts to Analog, The Magazine of Fantasy & Science Fiction, Asimov's and others. I wrote a very good story in 1995, and sent it to the better magazines. One editor even said, "I would like to buy this story, but I can't pay you what it's worth." At that point, a dollar or two would have been fine with me! Finally, I decided to enter the story in the Writers of the Future Contest.

After a certain amount of time had passed, I went to the mailbox and saw that a big envelope had returned from the Contest, and my heart sank.

1998

I trudged back inside, nearly throwing the envelope away without opening it. I was ready to quit writing again, believing that I didn't have enough talent, and certain that I wasn't smart enough to be a science fiction writer.

I opened the envelope, sliding my finger under the manila paper and dislodging the clasp. Out came the sad white pages of the story and a paper clip. I pushed the manuscript into the trash before I saw other sheets of paper in the envelope. First came a five-page, single-spaced letter of detailed commentary and guidance from head judge Dave Wolverton. With it was a shorter letter, written by Contest judge Frederik Pohl. Both judges said that they had voted for First Place for my story, but that other stories had gotten more votes from others, and therefore, it was an "honorable mention."

Frederik Pohl also said, "The opportunity to read stories like this is why I have always agreed to judge this Contest." He added that in his opinion, it was a grand prize winner and one of the best stories he had read in a long while.

The story in question was "Jonny Punkinhead." With Dave Wolverton's help, I sent the story back to one of the editors who had previously rejected it, and it appeared in the June, 1996 "New Writers Issue" of The Magazine of Fantasy & Science Fiction.

After what Dave Wolverton and Frederik Pohl had done, I decided I would not quit writing science fiction again. I continued to enter the Contest and became a published Finalist and then won a Third Prize Award, enabling me to attend the workshop twice.

The Contest retained me to the field of science fiction writing and educated me in the wisdom of L. Ron Hubbard through the workshops I was fortunate to attend. I made lifelong friends in Ron Collins and Scott Nicholson, as the three of us attended two consecutive workshops together.

The Contest kept the spark and life of my science-fictional imagination going. I might have had little confidence before, but after the workshops, I received the great start that the Contest's visionary founder always hoped and knew that it could provide. After time passed and I published more work, a scientist wrote in Analog that I "wrote like Ray Bradbury on real science fiction." I have been privileged to write more stories that touched the lives of others. And now, I know I'm not too dumb to write science fiction.

— Amy Sterling Casil

RON COLLINS

Ron Collins holds a degree in mechanical engineering and has worked developing avionics systems, electronics and information technology. Since attending the Writers of the Future workshop, he has sold numerous professional stories. CompuServe named his story "The Taranth Stone" the best novelette of 2000.

He, Scott Nicholson and Amy Sterling Casil were published Finalists in 1998, and all three went on to become actual winners the following year.

Since attending the Writers of the Future workshop (twice—once as a finalist and once as a winner), I've sold over forty stories to professional publications.

I'm guessing I'm among the few contestants to publish three stories that I actually wrote while at the Writers of the Future workshop—"Stealing the Sun" went to Analog, "The Vacation" was published in the anthology Future Wars *and "Picasso's Cat" went to Nature.*

I'm currently working on a novel and several short stories.

— Ron Collins

The Best New Science Fiction and Fantasy of the Year

L. Ron Hubbard

PRESENTS

WRITERS OF THE FUTURE

VOLUME XV

New SF Discoveries

The Year's Top Stories, Plus Special Features by

For the Writers of the Future fifteenth anniversary, the Awards event was held in Hollywood, California at the L. Ron Hubbard Gallery on Friday, September 24, 1999. Famed artist Frank Kelly Freas received the Lifetime Achievement Award for Outstanding Contributions to the Arts at the ceremony. A reception at Author Services followed the event.

As a testament to the effectiveness of the WotF workshop experience, three of the previous year's published Finalists (Scott Nicholson, Amy Sterling Casil and Ron Collins) all returned as quarterly winners in 1999, including the Grand Prize winner, Scott Nicholson.

1999

top The Writers and Illustrators of the Future winners and attending judges for 1999.

middle Gold Award winner Scott Nicholson receives a congratulatory hug from fellow 1998 Finalist Amy Sterling Casil. Both returned as winners in 1999.

bottom Frank Kelly Freas accepting his Lifetime Achievement Award.

winners

L. Ron Hubbard Gold Award

"The Vampire Shortstop"
by Scott Nicholson

First Quarter

1. "Blade of the Bunny" by Jim Hines
2. "The One-Eyed Man" by Gregory Janks
3. "My Son, My Self" by Amy Sterling Casil

Second Quarter

1. "The Vampire Shortstop" by Scott Nicholson
2. "Bearing the Pattern" by G. Scott Huggins
3. "A Man More Ordinary" by Manfred Gabriel

Third Quarter

1. "By Other Windings" by Franklin Thatcher
2. "The Unbound" by Nicole Montgomery
3. "Out of the Blue" by Ron Collins

Fourth Quarter

1. "The Great Wizard Joey" by W. G. Rowland
2. "The Price of Tea in China" by David W. Hill
3. "Great White Hunter" by Don Solosan

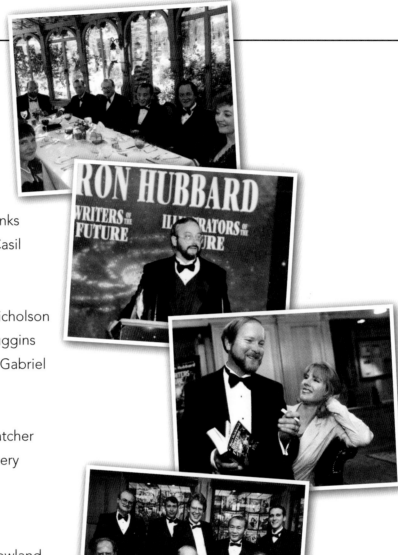

top The banquet before the Awards ceremony at the Renaissance Restaurant in Hollywood's Chateau Elysée

top middle Scott Nicholson accepts his First Place trophy.

bottom middle Kevin J. Anderson signs a copy of the new anthology for Patricia Tallman.

bottom The reception after the Awards. Front row: Larry Niven, Dr. Robert Jastrow, Dr. Doug Beason; back row: Dr. Jerry Pournelle, Don Solosan, G. Scott Huggins, Dr. Yoji Kondo and Gregory Janks.

winner spotlights

Jim C. Hines

Jim C. Hines has published forty short stories and five novels since winning Writers of the Future. His Goblin Quest trilogy has been translated into five languages, and his latest book, *The Mermaid's Madness*, was a #1 *Locus* bestseller. He intends to keep on writing until his fingers finally fall off, at which point he will learn to type with his toes. Jim lives in Michigan with his wife and two children, and spends far too much time online.

I wrote "Blade of the Bunny" in 1997, shortly before leaving for a graduate program in Creative Writing. I remember getting the phone call that my story had won the Contest, and I remember bouncing through the halls of the English Department. (After that, it's kind of a blur.)

I attended the Awards ceremony in 1999. In many ways, I learned more in one week at the Writers of the Future workshop than in two years of graduate school. I learned about the mechanics of stories. I learned I could draft an entire story in twenty-four hours. I learned that those trophies are a lot heavier than they look. Most importantly, I learned that I could be a writer. I could write what I loved and be successful. Writing what you know is fine, but writing what I love has kept me going for more than a decade.

— Jim C. Hines

SCOTT NICHOLSON

North Carolina author Scott Nicholson has published eight novels, sixty short stories, poetry and nonfiction magazine articles, and he has written six screenplays. As a newspaper reporter, he's won three North Carolina Press Association awards. Nicholson's first novel *The Red Church* was a Bram Stoker Award finalist and an alternate selection of the Mystery Guild. Much of his work is steeped in the milieu of his Appalachian home.

Nicholson has had the usual collection of odd jobs: dishwasher, carpenter, painter, musician, baseball card dealer and radio announcer. He had 105 rejections before his first story sale and over 400 before he sold a novel. He hasn't learned much from his mistakes but thinks he'll probably improve with practice. He recently edited the collection of writing advice articles from well-known authors, *Write Good or Die*.

I wish I could list the best thing the Writers of the Future Contest did for my career, but it's impossible. There are just too many "best things," and they are constantly emerging, even years later. The workshop was my first education from working, professional writers and I learned more in an hour than I had from half a dozen college writing courses. Appearing in and signing copies of the anthology were the first times I felt like a "real author," and the professional examples of success, from L. Ron Hubbard on, not only served as inspiration but showed that a professional career was within reach of anyone willing to work hard.

The Writers of the Future Contest sowed the seeds of my success. From the practical benefits to the ever-expanding community of writers and illustrators associated with the Contest, new opportunities and ideas continually blossom. So many people say a writing career is impossible, but WotF says, "Dreams are worth following."

— Scott Nicholson

The Best New Science Fiction and Fantasy of the Year

L. Ron Hubbard

PRESENTS

WRITERS of the FUTURE

VOLUME XVI

NEW SF DISCOVERIES
The Year's Top Stories plus Special Features by
L. Ron Hubbard
Judith Holman
Algis Budrys
Michael H. Payne

The Awards event was held on Friday, September 15, 2000 in Hollywood, California at the L. Ron Hubbard Gallery. The writers' and illustrators' workshops were again held at the excellent facilities of Author Services, Inc. A highlight of the event was the presentation of the Lifetime Achievement Award for Outstanding Contributions to the Arts to longtime judge and SF legend Frederik Pohl.

Also, with fifteen full years of the anthology to draw from, Galaxy Press released the *Best of Writers of the Future,* with stories and essays selected as the "best of the best" from the Contest. Many of the original winner contributors to the *Best of* volume were present at the Awards event and the release of the new book.

top Writer winners and judges, 2000.

middle and bottom Frederik Pohl and Elizabeth Anne Hull proudly show off his L. Ron Hubbard Lifetime Achievement Award.

2000

winners

L. Ron Hubbard Gold Award

"Pulling Up Roots" by Gary Murphy

First Quarter

1. "Pulling Up Roots" by Gary Murphy
2. "Like Iron Unicorns" by Paul D. Batteiger
3. "Atlantis, Ohio" by Mark Siegel

Second Quarter

1. "Your Own Hope" by Paul E. Martens
2. "Skin Song" by Melissa J. Yuan-Innes
3. "Guildmaster" by Dan Dysan

Third Quarter

1. "A Conversation with Schliegelman"
 by Dan Barlow
2. "The Quality of Wetness" by Ilsa J. Bick
3. "As the Crow Flies" by Leslie Claire Walker

Fourth Quarter

1. "In Orbite Medievali" by Tobias S. Buckell
2. "Home Grown" by William Brown
3. "Mud and Salt" by Michael J. Jasper

Published Finalist

"Daimon! Daimon!" by Jeff Rutherford

top Past WotF winners return for the release of *The Best of Writers of the Future.* Jo Beverley, Nancy Farmer, Leonard Carpenter, James Alan Gardner, Nina Kiriki Hoffman, Algis Budrys, Astrid Julian, Jamil Nasir, Michael H. Payne, Bruce Holland Rogers, Dean Wesley Smith, K. D. Wentworth.

middle Returning WotF authors Bruce Holland Rogers, James Alan Gardner and Dean Wesley Smith.

bottom Dean Wesley Smith signs a copy of *The Best of Writers of the Future.*

winner spotlights

TOBIAS S. BUCKELL

Tobias S. Buckell is a Caribbean-born speculative fiction writer who grew up in Grenada, the British Virgin Islands, and the US Virgin Islands, though he now lives in Ohio. He has published stories in various magazines and anthologies. He is a Clarion graduate and finalist for the John W. Campbell Award. His novels include *Crystal Rain, Ragamuffin, Sly Mongoose, Tides from the New Worlds* and the bestseller *Halo: The Cole Protocol*. He is also a well-known professional blogger.

"*I started submitting to WotF at the age of fifteen while I was still living on a boat with parents in the Caribbean. SF/F magazines didn't really make it down to bookstores in the islands but I found a copy of the Writers of the Future anthology. As a result of reading the Contest guidelines in the back, WotF became the First Place I figured out how to send a story to. For the next five years, I sent a new story in almost every quarter, teaching myself to finish and write stories while in high school.*

Winning one of the quarters five years later, after I'd moved to the US, was the cherry on a dream come true. It became my third professional story sale and allowed me to join the Science Fiction Writers of America. That story, and the two others I'd sold just before, got me nominated for the John W. Campbell Award for Best New SF Writer shortly afterward. My career was launched, and today I make a living writing and living the very life I'd dreamed of when in high school.

— Tobias S. Buckell

ILSA J. BICK

Before her WotF win, Ilsa J. Bick was a child psychiatrist, a surgeon wannabe and former Air Force major. Her first published story, "A Ribbon for Rosie," took Grand Prize in *Star Trek: Strange New Worlds II.* Two years later, she took Second for "Shadows, in the Dark" featured in *Strange New Worlds IV.* While all those wins were great, her Writers of the Future experience—meeting all the sci-fi legends she wouldn't mind being, and learning craft from A. J. Budrys and Tim Powers—really put wind beneath her wings.

Now a full-time writer of novels and short fiction, Ilsa has contributed to the Star Trek, MechWarrior, BattleTech and Shadowrun universes. Her first published novel cracked the Barnes & Noble bestseller list. Her forthcoming young adult novels include *Draw the Dark, The Sin-Eater's Confession* and *Ashes.*

So EVERYTHING was AMAZING. . . . The best was Tim Powers. Great teacher, nice guy. All us winners walked as this herd, jockeying for position to get close to Tim. (I figured greatness was contagious, so I would've elbowed my grandmother.) I talked poor Tim's ear off. Found out we both fenced saber. So it was like total karma.

Then he and A. J. Budrys gave us this assignment: write a story. In two days. Which, like, I thought was completely impossible.

So, after class, I'm gnawing my nails off and then there's this knock on my door. It's Tim and he wants to know if I want to walk. And I'm thinking: Duh, hello, of COURSE. . . .

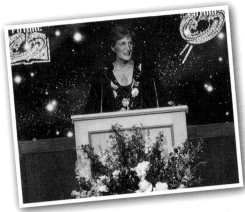

But there was the story. So I said no. And then I wrote. All afternoon. All night. About a pastry chef on the Moon. (Buttonholed the hotel chef for about five hours since I know nothing about cakes or sugar art.)

Best part was Tim liked the story, warts and all. First words out of his mouth: "Wow, that's some cake."

My best story ever? No. A lot of words later, and I'm still trying to write that. But if I do . . . Tim, that story's for you.

— Ilsa J. Bick

Melissa Yuan-Innes

Melissa Yuan-Innes calls herself a writer, physician and free spirit living with her family outside of Montreal, Canada. She has sold stories to *Nature*, *Weird Tales*, *Interzone* and anthologies like *The Dragon and the Stars*.

The Writers of the Future Contest helped me take myself seriously as a writer. I realized that a lot of the other writers had applied quarter after quarter and worked their way up to the winner's table. Meanwhile, I had sent a few stories and then landed a Second Place. I respected their determination and realized I'd need that in order to make it.

Second lesson: I browsed at a bookstore across the street from Author Services and agonized over buying a book called Poemcrazy. *Even though it called to me. Even though I could afford six dollars (they pay medical residents poorly, but not that poorly). But I couldn't part with the cash until fellow writer William Brown, asked me, "Do you think you would get six dollars' worth out of that book?"*

above Previous WotF winners Jo Beverley and James Alan Gardner with Melissa Yuan-Innes.

I bought the book and made the leap, committing myself to spending time and energy on my writing over the long haul. So even though I'm an emergency doctor and a busy mother now, I've stayed committed to my writing. Next stop: breaking into the novel biz.

— Melissa Yuan-Innes

Michael Jasper

Since 2000, Michael Jasper has published three novels, a short story collection and over four dozen short stories in places such as *Asimov's*, *Strange Horizons*, *The Pedestal Magazine*, *Black Gate*, *Interzone* and many other venues. *Publishers Weekly* called his story collection Gunning for the Buddha "evocative and vivid," while *Booklist* called Jasper a "speculative fiction rising star." His novels include *A Gathering of Doorways*, *Heart's Revenge* and *The Wannoshay Cycle*. His webcomic with artist Niki Smith, *In Maps & Legends*, recently began publishing on a weekly basis with DC Comics' Web imprint, Zuda Comics. He lives in Wake Forest, North Carolina, with his wife and two sons.

" *The Writers of the Future workshop had a huge impact on my writing career. Up until the day my story "Mud and Salt" was accepted for Volume XVI, I was feeling very frustrated with writing and considering giving up on it. But the news of my story's acceptance, followed by the amazing weeklong workshop capped off with the ceremony, not to mention meeting all my fellow writers and the other published writers from years before, all convinced me that I'd found my calling.*

— Michael Jasper

right Judges Tim Powers and Dr. Gregory Benford with winner Michael Jasper.

L. RON HUBBARD

PRESENTS

WRITERS

OF THE

FUTURE

VOLUME XVII

The Best New
Science Fiction and Fantasy
of the Year

Cover painting by
Frank Kelly Freas

Once again, Hollywood, California was the location for the annual Awards ceremony, which took place in the auditorium at the L. Ron Hubbard Gallery on Saturday, August 11, 2001. The workshops were held in the facilities at Author Services, Inc., in Hollywood, California.

For a historical perspective, Stephen D. Nagiewicz, Executive Director of the Explorers Club, displayed a Club flag which Hubbard had personally carried on one of his club-sponsored expeditions. Renowned astronomer Dr. Robert Jastrow was a special guest. Actresses Karen Black, Marisol Nichols and Patricia Tallman also helped present the awards to the winners.

Algis Budrys received a well-deserved Lifetime Achievement Award for Outstanding Contributions to the Arts to great applause after his many years of tireless work with the Writers of the Future Contest, its workshop and the annual anthology.

top The red carpet is out for the arrival of winners, judges and special guests.

middle Algis Budrys accepts his L. Ron Hubbard Lifetime Achievement Award.

bottom WotF judge Frederik Pohl and actress Karen Black present the First Place Award to J. Simon.

2001

winners

L. Ron Hubbard Gold Award

"Magpie" by Meredith Simmons

First Quarter

1. "An Idiot Rode to Majra" by J. Simon
2. "Black Box" by Janet Barron
3. "A Familiar Solution" by Marguerite Devers Green

Second Quarter

1. "The Plague" by A. C. Bray
2. "Time out of Mind" by Everett S. Jacobs
3. "Brother Jubal in the Womb of Silence" by Tim Myers

Third Quarter

1. "Marketplace of Souls" by David Lowe
2. "Dreams and Bones" by Eric M. Witchey
3. "The Sharp End" by Kelly David McCullough

Fourth Quarter

1. "Magpie" by Meredith Simmons
2. "Ten Gallons a Whore" by Anna D. Allen
3. "God Loves the Infantry" by Greg Siewert

Published Finalists

"Lucretia's Nose" by Philip Lees

"T.E.A. and Koumiss" by Steven C. Raine

"Life Eternal" by Bob Johnston

"Interrupt Vector" by Robert B. Schofield

"El Presidente Munsie" by Tony Daley

"Hello and Goodbye" by Michele Letica

top At the reception, Stephen D. Nagiewicz shows off the Explorers Club flag to actresses Marisol Nichols, Denice Duff and Gina St. John.

top middle Author winners at the release celebration and book signing after the Awards event.

bottom middle Astronomer Dr. Robert Jastrow with WotF judge Dr. Doug Beason.

bottom Marisol Nichols with the release of *Writers of the Future* Volume XVII.

winner spotlights

ERIC WITCHEY

Eric Witchey's fiction has appeared nationally and internationally in magazines and anthologies, such as *Jim Baen's Universe, Clarkesworld, Realms of Fantasy, The Mammoth Book of Best New Erotica 2* and *Fantasists.* He has published in multiple genres under several names. In addition to WotF, his fiction has won recognition from the New Century Writer Awards, *Writer's Digest* and ralan.com.

Witchey has been an active writing instructor with very successful seminars and courses. His how-to articles have appeared in *The Writer, Writer's Digest, Writer's Northwest Magazine, Northwest Ink* and in a number of online publications. When not teaching or writing, he restores antique HO locomotives or enjoys fly-fishing.

Congratulations to Writers of the Future on turning 25! I will never forget the experience created by the dedicated, selfless people who keep this amazing contest alive and kicking. Nine years later, I can look back and say that walking the red carpet, standing at the podium, and being surrounded by people who believe creativity and story are central to the health of culture was a defining moment in my pursuit of my dreams. It was an experience that helped me continue to believe that what I do alone in my office is valued and important.

below The Writers and Illustrators of the Future winners of 2001.

Almost sixty short story sales, a novel sale and nine years later, I've had the pleasure of watching eight more people from my writers group win and attend the annual seminar and event. With each one, my sense of the value of the Contest has been renewed. Thank you to Author Services, Galaxy Press, the late Algis Budrys, Tim Powers, K. D. Wentworth, Nina Kiriki Hoffman, Kevin J. Anderson and all the individuals who give their time and energy to the Contest in order to keep it going and keep it free for the writers and illustrators. You are all rare and wonderful people.

— Eric Witchey

KELLY MCCULLOUGH

Kelly McCullough is an international award-winning writer. His novels include the WebMage series: *WebMage, Cybermancy, CodeSpell, MythOS* and *SpellCrash* and the forthcoming Chronicles of Aral Kingslayer, beginning with *Broken Blade* in 2011, all published by ACE. His short fiction has appeared in numerous venues including *Weird Tales* and *Tales of the Unanticipated*. His illustrated serial novel, *The Chronicles of the Wandering Star*, is part of a National Science Foundation-funded middle-school science curriculum.

"*As the years go by and my career advances, I find that being a Writers of the Future winner is an experience that continues to change and grow for me.*

When I first got the call, I was rendered pretty much incoherent just at the thought of a second professional publication and getting paid for writing. A few days later, my focus shifted as I realized I was going to be learning from Algis Budrys and Tim Powers. AJ was a giant in the field, and Tim is simply brilliant and perhaps my favorite author.

Then came the actual workshop where I got to meet my fellow winners and the Contest judges. Spending a week among my genre-writing peers and heroes was a wonderful experience, and the workshop itself was great fun. I loved hearing about how Tim had created some of my favorite books, listening to AJ's stories of the industry, and learning about other peoples' writing processes.

Going forward, I've found one session in particular has been of tremendous continuing value to me as an author with an active career. William J. Widder, a publicist, came in and taught us about managing interviews and press releases and careers in general. I use those skills all the time. Another thing that came out of my Writers of the Future experience is the ongoing mentorship of authors whom I met through the workshop or through the writers I met there, most notably Dean Wesley Smith and Kristine Kathryn Rusch, who have helped me so much over the years.

The most important thing of all has been the lifelong friendships that I've developed with a number of my fellow winners and I hope that never changes.

— Kelly McCullough

TIM MYERS

While most of the Writers of the Future winners have focused on science fiction and fantasy, Tim Myers devoted his talents to writing children's fiction. He has published ten popular and critically acclaimed children's books, including the *New York Times* bestseller *Basho and the Fox*, which was also read aloud on National Public Radio by Daniel Pinkwater. His other books include *If You Give a T-Rex a Bone, The Furry-Legged Teapot, Basho and the River Stones, Dark Sparkle Tea, Good Babies, Tanuki's Gift* and *Let's Call Him Lau-wiliwili . . .* His short fiction has appeared in *Storyworks, AppleSeeds, Highlights* and *Chicken Soup for the Kid's Soul.* He still writes SF/F for adults, too, and his fiction has been published in *Realms of Fantasy, Worlds of Fantasy & Horror, Space and Time, Weird Tales, Abyss & Apex* and *Futures Mysterious Anthology Magazine.*

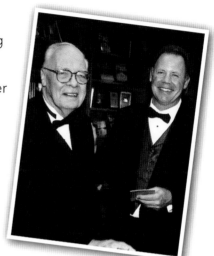

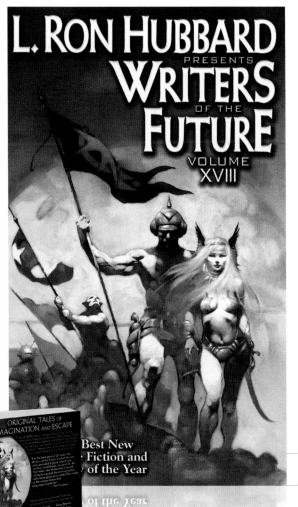

Cover painting by
Frank Frazetta

Actor Sean Astin (*Lord of the Rings* and many other film and TV roles) was a guest presenter at the Awards event held on Saturday, August 17, 2002 at the L. Ron Hubbard Gallery in Hollywood, California. The Awards ceremonies were followed by the traditional lavish reception at Author Services, Inc. *Writers of the Future* Volume XVIII was released at the event, featuring a spectacular Frank Frazetta cover, and the winners autographed copies for the guests during the reception.

This was the last year that WotF judge Hal Clement presented an award at the ceremonies; he passed away the following year.

top Sean Astin serves as one of the guest presenters at the 2002 ceremonies.

middle Kevin J. Anderson and Dr. Doug Beason present the Finalist certificate to Nnedi Okorafor.

bottom The Writers and Illustrators of the Future winners and judges, 2002.

2002

winners

L. Ron Hubbard Gold Award

"Eating, Drinking, Walking" by Dylan Otto Krider

First Quarter

1. "The Haunted Seed" by Ray Roberts
2. "Lost on the Road" by Ari Goelman
3. "Free Fall" by Tom Brennan

Second Quarter

1. "The Road to Levenshir" by Patrick Rothfuss
2. "Rewind" by David D. Levine
3. "Carrying the God" by Lee Battersby

Third Quarter

1. "Eating, Drinking, Walking" by Dylan Otto Krider
2. "Origami Cranes" by Seppo Kurki
3. "Worlds Apart" by Woody O. Carsky-Wilson

Fourth Quarter

1. "Graveyard Tea" by Susan Fry
2. "Memoria Technica" by Leon J. West
3. "All Winter Long" by Jae Brim

Published Finalists

"Windseekers" by Nnedi Okorafor
"What Became of the King" by Aimee C. Amodio
"The Art of Creation" by Carl Frederick
"Prague 47" by Joel Best
"The Dragon Cave" by Drew Morby

top Sean Astin with Gold Award winners Irena Yankova Dimitrova (illustrator) and Dylan Otto Krider (writer) at the formal release of *Writers of the Future* Volume XVIII.

top middle Sean Astin and Patrick Rothfuss puttin' on the Ritz.

bottom middle Patrick Rothfuss and Leon J. West enjoy autographing each other's copies at the reception following the Awards ceremony.

bottom Tim Powers presents David D. Levine with his workshop completion certificate.

winner spotlights

PATRICK ROTHFUSS

Patrick Rothfuss had the good fortune to be born in Wisconsin where long winters and lack of cable television brought about a love of reading and writing. A longtime student, grad student and finally teacher at the University of Wisconsin, Stevens Point, Rothfuss worked for many years at writing, building up a massive fantasy story, one small piece of which was his winning entry in Writers of the Future.

At the workshop, he met the writers and contacts that allowed him to get a major New York agent, which led to a book deal for his fantasy epic. The first novel, *The Name of the Wind*, was an instant hit both among fans and critics and became a *New York Times* bestseller.

I really can't say enough good things about Writers of the Future.

When I won, I'd been trying to get an agent for two years. Trying and failing. My writing was pretty solid, but I didn't know anything about the publishing world. I wrote query letters, sent them out and received rejection after rejection, most of them nothing more than form letters.

The weeklong workshop run by Tim Powers was absolutely invaluable, giving me information about agents, contracts, editors and how to comport myself professionally. The guest appearances by other authors, most notably Kevin J. Anderson, were eye-opening as well. By the time the week was up, I not only had a better understanding of the craft of writing and the landscape of the publishing world, I'd made my first professional contacts. Even better, I'd made my first professional friends.

Perhaps most importantly, Writers of the Future gave me hope. After that, I knew my writing was good enough to be published. That kept me sane over the next several years while I revised my book and worked with my new agent. It also gave me the strength to turn down the first offer on my trilogy, waiting until it found the perfect home at my current publisher, DAW.

It's fair to say that without Writers of the Future, I wouldn't be where I am today. . . .

— Patrick Rothfuss

DAVID D. LEVINE

David D. Levine is an award-winning short story writer, as-yet-unpublished novelist, and part-time cat substitute. He lives in Portland, Oregon and once portrayed a severed head in a musical comedy. In January 2010, he spent two weeks at a simulated Mars base in the Utah desert.

I must confess that I'm a workshop junkie. I've been participating in writers' workshops at science fiction conventions just about as long as I've been writing, I attended Clarion West, I participate in a regular critique group in my hometown, and I've attended a wide variety of afternoon, half-week, one-week and two-week workshops during my writing career so far. The one-week workshop that was part of the Writers of the Future Contest win was not the one from which I learned the most, nor the one that had the most impact on my career, but it was the most fun. How many other workshops conclude with a catered dinner with the leading lights of the SF field, a limousine ride and a spectacular gala Awards ceremony?

below David D. Levine receives his Second Place Award from Dr. Jerry Pournelle and actress Julie Michaels.

Also, because the competition to get in is so fierce, I have found that Writers of the Future was a much better predictor of future success than any of the other workshops for new writers I have attended. Although several of my Clarion West classmates have gone on to sell novels and short stories, that pales next to the impressive list of sales, awards and bestseller lists achieved by my WotF classmates.

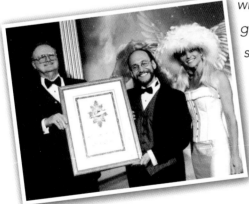

Since winning Writers of the Future, I've published over forty short stories and won numerous other writing awards, including a Hugo. Would I have achieved this success without Writers of the Future? Possibly. But the WotF win provided me an ego boost and kick in the pants that no other contest or workshop for new writers could match, and for that I'm very grateful.

— David D. Levine

NNEDI OKORAFOR

Nnedi Okorafor is a novelist of Nigerian descent known for weaving African culture into evocative settings and memorable characters. In a profile of Nnedi's work, the *New York Times* called Nnedi's imagination "stunning." Her young adult novels include *Zahrah the Windseeker* (winner of the Wole Soyinka Prize for African Literature), *The Shadow Speaker* (winner of the CBS Parallax Award) and *Long Juju Man* (winner of the Macmillan Prize for Africa). Her first adult novel, *Who Fears Death* (DAW), was released in 2010. Her YA novel *Akata Witch* (Penguin Books) and chapbook *Iridessa and the Fire-Bellied Dragon Frog* (Disney Press) are scheduled for release in 2011. Okorafor is a professor of creative writing at Chicago State University.

I was shocked when I received the letter in the mail telling me that my short story "Windseekers" was a finalist. "Windseekers" was about a mean, fearless, somewhat crazy, flying Nigerian woman who goes to an organic city. All I could think was, "They liked it? Really?" Then I thought, "Oh! They liked it!" It was a dawning moment for me in many ways. And the subsequent Writers of the Future week in LA

was equally so. I met and learned from so many budding and established writers and I felt comfortable amongst them. I was still growing into the idea that I was writing this strange stuff called "fantasy and science fiction" and the Writers of the Future experience played a pivotal role during a most impressionable time in my writing career. Everyone was so welcoming. And afterwards, the WotF folks were always around when I had questions or needed help. It was all far more than a mere writing contest.

— Nnedi Okorafor

The Best New ...and ...ear

VOYAGE TO THE FURTHEST REACHES OF THE IMAGINATION

WWW.WRITERSOFTHEFUTURE.COM

Cover painting by
Frank Frazetta

After five years in Hollywood, the Writers and Illustrators of the Future Awards moved to the famed Beverly Hills Hotel in Beverly Hills, California for their annual ceremonies. The event was held on Saturday, August 9, 2003 in the Rodeo Room.

The evening began with a breathtaking performance from Grammy Award–winning music legend Chick Corea, of an original composition created for the event. Actors Jason Lee and David Carradine were celebrity presenters.

Robert Silverberg, who had been a WotF judge from the very first year of the Contest, received the L. Ron Hubbard Lifetime Achievement Award for Outstanding Contributions to the Arts.

2003

top President SFWA, Catherine Asaro, and family arrive to the Awards ceremony.

middle top Celebrity presenter David Carradine.

middle bottom At the workshop, Tim Powers works with Steven Savile and Brandon Butler.

bottom Robert Silverberg receives his Lifetime Achievement Award.

winners

L. Ron Hubbard Gold Award

"Trust Is a Child" by Matthew Candelaria

First Quarter

1. "Trust Is a Child" by Matthew Candelaria
2. "A Few Days North of Vienna" by Brandon Butler
3. "Blood and Horses" by Myke Cole

Second Quarter

1. "Walking Rain" by Ian Keane
2. "Numbers" by Joel Best
3. "A Silky Touch to No Man" by Robert J Defendi

Third Quarter

1. "A Boy and His Bicycle" by Carl Frederick
2. "Bury My Heart at the Garrick" by Steven Savile
3. "From All the Work Which He Had Made . . ."
 by Michael Churchman

Fourth Quarter

1. "Into the Gardens of Sweet Night"
 by Jay Lake
2. "Beautiful Singer" by Steve Bein
3. "Dark Harvest" by Geoffrey Girard

Published Finalists

"A Ship That Bends" by Luc Reid

"Gossamer" by Ken Liu

top David Carradine with Gold Award winners Matthew Candelaria (writer) and Mike Lawrence (illustrator).

top middle Chick Corea performs a new composition at the Awards ceremony.

middle bottom Tim and Serena Powers peruse the newly released anthology.

bottom Writers and judges 2003.

winner spotlights

JAY LAKE

Jay Lake lives in Portland, Oregon, where he works on numerous writing and editing projects. His newest books are *Pinion* from Tor Books, *The Specific Gravity of Grief* from Fairwood Press, *The Baby Killers* from PS Publishing and *The Sky That Wraps* from Subterranean Press. His short fiction appears regularly in literary and genre markets worldwide. In addition to his WotF win, he is also a winner of the John W. Campbell Award for Best New Writer and a multiple nominee for the Hugo and World Fantasy Awards.

When I first set out to become a professional writer (ah, hubris), one of my key ambitions was to place in the top tier of L. Ron Hubbard's Writers of the Future Contest. The other was to attend Clarion, or Clarion West. I have friends who had placed in years before me, attending the workshop and ceremonies, who'd spoken highly of the experience. I'd been reading and reviewing the annual anthologies, and enjoying them immensely, where I discovered writers such as Tobias Buckell.

I was both good and lucky, and was a First Place winner in 2003. The weeklong workshop with Tim Powers and K. D. Wentworth, along with a rotating cast of special guests, was amazingly productive. My story "Into the Gardens of Sweet Night" was featured in the anthology that year and placed on the Hugo ballot for Best Novelette in 2004, the same year I won the Campbell, in large part on the strength of the Writers of the Future story and my placing in the Contest.

Without Mr. Hubbard's sponsorship, I wouldn't have had that fabulous, high-profile launch. More important, though, during that week in LA in the summer of 2003, I made friends, had fun and learned a lot. And no, I never did make it to Clarion or Clarion West. But I did make it onto the bookshelves as a novelist and a short story writer. For that, I will always be grateful.

— Jay Lake

2003

STEVEN SAVILE

Since being among the 2003 winners of Writers of the Future, Steven Savile has published over a dozen novels and sold almost half a million books in fourteen languages across the world. His Vampire Wars trilogy for the popular Warhammer fantasy world made the bestseller list in Germany and his novel *Primeval: Shadow of the Jaguar* was a number one bestseller in the UK. He has written for Doctor Who, Torchwood, Primeval, Stargate SG-1, Star Wars, Jurassic Park: The Lost World and Guild Wars franchises, adapted the popular British comic strip *Slaine* into a series of novels, as well as launching the new Knights of Albion series for Abaddon in the UK with the upcoming *Black Chalice*. In 2006 he coedited *Elemental: The Tsunami Relief Anthology* for Tor, which raised enough money to build and supply a school in Indonesia after the tragedies of Boxing Day 2004. His debut thriller *Silver* was released in hardcover in January 2010 and his fifty-year critical retrospective of genre television shows, *Fantastic TV*, has just been published.

The WotF workshop was a watershed moment for me. I'd been writing for a long time without much success. I remember telling someone in the days leading up to the Awards ceremony that I felt like an impostor. Looking back on the whole thing now I can see that what I was really struggling with was that I lacked a lot of the tools I needed to be a professional writer, and that more than anything was what I wanted to be.

That's what the experience gave me, the tools to succeed. What you choose to do with those tools, well, that's down to the individual, but some of the advice, and not just the "story advice," but the "business advice," is priceless. The generosity of the people involved with the Contest is amazing, and frankly humbling. It's no exaggeration to say I wouldn't be where I am today without it, and that means I wouldn't be going where I am tomorrow, either. So, in a way Writers of the Future shaped my future, and continues to shape it.

— Steven Savile

GEOFFREY GIRARD

Geoffrey Girard has appeared in several magazines and anthologies, including *Murky Depths*, *The Willows*, *Prime Codex*, *Aoife's Kiss* and *Apex Science Fiction & Horror Digest*, who serialized his tech-thriller *Cain XP11* over four issues in 2008. His Tales Of . . . series of books includes *Tales of the Jersey Devil*, *Tales of the Atlantic Pirates* and *Tales of the Eastern Indians*, and he was also hired to write a YA version of *The Iliad*. Less than a year after Writers of the Future, Geoffrey said goodbye to a decade of corporate America and has been happily teaching high-school English ever since.

Jealousy can be a great motivator. Two months before I entered Writers of the Future, I discovered online that some guy I didn't much like had been selected to appear in the previous year's anthology. I couldn't believe it! There he was, smiling in his fancy tuxedo, holding his shiny new award somewhere in Hollywood surrounded by many of the greatest writers in the history of speculative fiction. I wanted to stick a fork in my eye.

Instead, I started typing. I wrote my short story feverishly in a week and mailed it in, the first I'd submitted in years to anyone. It won.

Five years later, I've written and sold four books and fifty-plus short stories. As I keep working toward future and bigger success in my career, I can't help but think of all those I met when it was my time to smile in a fancy tux. It certainly helps that I've kept in touch with pros like Kevin J. Anderson and that a couple of the students in my group have already gone on to full-time writing careers and won some major awards. Good jealousy there, let me tell you. The kind that gets you writing each day. The fact that these very same guys have all given me advice, support and friendship during every step of their own careers only makes it sweeter. It's fun to chase beside and after others, even that first guy, and encourage each other along the way.

— Geoffrey Girard

Carl Frederick

Carl Frederick is theoretically a theoretical physicist. After a postdoc at NASA and a stint at Cornell University, he left astrophysics and his first love, quantum relativity theory (a strange first love, perhaps), in favor of high-tech industry.

He attended the Writers of the Future workshop as a published Finalist in 2002 and returned as a First Place winner in 2003. He also attended the Odyssey Writing Workshop in 2000. He is predominately a short story writer, having sold a couple of stories each to *Asimov's* and *Jim Baen's Universe*, and over thirty to *Analog*.

He fences épée, learns languages and plays the bagpipes. He lives in rural Ithaca, New York. And rural is good if you play the bagpipes. He has since returned to his aforementioned first love.

On Being a WOTF Finalist and Achieving Victory over Toenail Fungus

Through the agency of a computer glitch and a compassionate Contest Administrator, I found out two months early that I was at least a finalist in the Writers of the Future Contest. I thrilled to the thought that someone—one of the gods, surely—had read my story and concluded it was not purple pig-swill.

Over the next few weeks, I obsessed on winning. I calculated the winning odds—about forty-three percent—not great, but a heck of a lot higher than the odds of being published in say, Analog. I couldn't help but dwell on the possibility of winning. Like a mouse in a Skinner box, I pressed the key all the time, not for food pellets but for e-mail. Maybe there'd be news. I fantasized about being a "discovered" writer, and about hobnobbing with the greats at the Awards ceremony. I simply obsessed.

I had to do something. I couldn't keep obsessing over WotF. I knew it was impossible for me to just will the obsession to go away. But I figured I could transfer the behavior to another activity.

I've been a competitive athlete for many years, and over the course of padding about in locker rooms, I contracted toenail fungus. I never paid particular attention to the fungus. It didn't hurt, and it ran in the family. Eventually it engulfed six toes.

That was the plan then—to transfer my obsession from the "Writers of the Future" to the "War on Toenail Fungus." I might not win WotF, but at least I'd

2003

have nice toes. I did research and discovered it could be cured, but one had to be obsessive about it. Perfect! And I swear as Heisenberg is my witness, that I did not realize for weeks that WOTF also were the initials for War On Toenail Fungus. Strange is the subconscious mind.

Then in my office a few weeks later, I saw on a writers' e-mail list that someone had just reported receiving a phone call that she'd just won Third Place in the WotF Contest. I rushed home to check my answering machine. Nothing! A wave of sadness washed over me. I waited by the phone and as the minutes flowed away, I continually recalculated my odds of winning. Even, late in the night, when my calculated odds had ebbed to five percent, I held to a slender hope. The following day, though, my loss was confirmed.

Immediately, I threw myself into a frenzy of fighting fungus. Two days later, in a paroxysm of fungal combat, I was over my disappointment, and back to my usual cheerful self.

Then I found out that a few finalist stories are also included in the WotF anthology. Again, I calculated the odds—about twenty-seven percent. Having my story included would be great. In fact, if I had the choice of being a WotF First Place winner or a published Finalist, well, I'd take First Place. But I'd take published Finalist over either Second or Third. Why? Because I'd get to be published in the anthology, and I'd still be eligible to enter future contests.

As I write this, I still don't know if my story will be included in the anthology. But I'm not obsessed about it. The toenail stratagem is working, and I guess the "first time" can never be recaptured.

But still, I've lost once and the odds say I'm likely to lose again. Assuming the worst then, would I go through it all again? Yes—in an instant. The experience has been thrilling, the WotF organization warm and supportive, and whenever I glance at my toes, I'm pleasantly reminded of WotF. And already one of my toes has been liberated from the forces of fungus.

Addendum: written years later

My story was selected to be published in the anthology.

And the following year, my Contest entry took a First Place.

— Carl Frederick

2004

For the Writers of the Future twentieth anniversary, the Awards event returned to the Beverly Hills Hotel in Beverly Hills, California. The celebration took place on Friday, August 20, 2004. The writers' and illustrators' workshops were held at the landmark Roosevelt Hotel on Hollywood Boulevard.

Chick Corea kicked off the evening's festivities with another extravagant performance. Astronaut Story Musgrave, a longtime supporter of the Contest, and actress Sofia Milos were celebrity guests at the Awards. The Writers and Illustrators of the Future received a proclamation from *Publishers Weekly* that acknowledged the Contest as "the most enduring forum to showcase new talent in the genre."

Anne McCaffrey, one of WotF's most dedicated and enthusiastic judges since 1985, received the L. Ron Hubbard Lifetime Achievement Award for Outstanding Contributions to the Arts. On the day after the event, McCaffrey also joined the winners for a book signing at a local bookstore, autographing copies of *Writers of the Future* Volume XX.

top The Writers and Illustrators of the Future event returns to the Beverly Hills Hotel.

top middle The pre-Awards banquet at the fabulous Crystal Ballroom in the Beverly Hills Hotel.

bottom middle and bottom Chick Corea gives a standout performance to open the evening ceremonies.

winners

L. Ron Hubbard Gold Award

"The Plastic Soul of a Note" by William T. Katz

First Quarter

1. "Kinship" by Jason Stoddard
2. "Flotsam" by Bradley P. Beaulieu
3. "The Weapons of the Lord Are Not Carnal"
 by Andrew Tisbert

Second Quarter

1. "The Plastic Soul of a Note" by William T. Katz
2. "Bottomless" by Luc Reid
3. "Cancilleri's Law" by Gabriel F. W. Koch
 (Lawrence Schliessmann)

Third Quarter

1. "Sunrunners" by Matthew Champine
2. "Shipwoman" by Roxanne Hutton
3. "Last Days of the Madhi" by Tom Pendergrass

Fourth Quarter

1. "The Key" by Blair MacGregor
2. "Sleep Sweetly, Junie Carter" by Joy Remy
3. "Monkey See, Monkey Deduce" by Jonathan Laden

Published Finalists

"Asleep in the Forest of the Tall Cats" by Kenneth Brady

"In Memory" by Eric James Stone

"Conversation with a Mechanical Horse" by Floris M. Kleijne

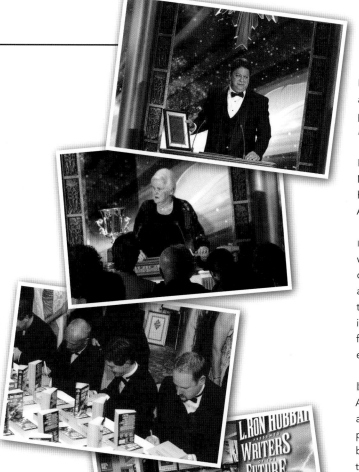

top WotF receives a celebratory proclamation from *Publishers Weekly*.

top middle Anne McCaffrey receives her Lifetime Achievement Award.

middle Writer winners autograph copies of the anthology at the reception immediately following the event.

bottom middle Anne McCaffrey and writer winners participated in a book signing on the day after the Awards event.

bottom Writer and Illustrator winners, 2004.

winner spotlights

BRADLEY P. BEAULIEU

Bradley P. Beaulieu is a SF writer who figured he'd better get serious about writing before he found himself on the wrong side of a lifelong career in software. His story, "In the Eyes of the Empress' Cat," was voted a Notable Story of 2006 by the Million Writers Award. Other stories have appeared in *Realms of Fantasy*, *Orson Scott Card's Intergalactic Medicine Show* and several DAW anthologies. He lives in Racine, Wisconsin, where he enjoys cooking spicy dishes and hiding out on the weekends with his family.

The Contest meant a lot to me. It was one of the few venues where I felt like I was competing on an even playing field with the rest of the submissions. At the same time, it felt like I was entering a contest where the competition was extremely fierce. So to have won was a great accomplishment for me, a distinct milestone in my writing career. The Awards week was an experience I will never forget. The generosity of L. Ron Hubbard, the Contest and the staff was very heartwarming. The writing workshop is something that still has and will always have a distinct bearing on my career. It was a piece of the foundation that I was already building and that I now continue to expand upon. I felt as if I had gone through a rite of passage by the time the week had ended.

I look upon the Contest as something vital in the speculative fiction world. It is a beacon for new writers, something that pushes them to aim high, and propels them to greater heights once they've won. It is something I will always be grateful for.

— Bradley P. Beaulieu

LAWRENCE SCHLIESSMANN

Born, raised and educated in New York, Lawrence Schliessmann (who wrote his prizewinning story under the pen name Gabriel F. W. Koch) has published both science fiction and horror short stories and is the author of the Marlowe Black Mysteries series, *Templar's Fire, A Gothic Vampire Novel* and the upcoming Foster Ryton science fiction saga. He is an EzineArticles.com Platinum author and a 2009 winner of National Novel Writing Month.

Now living in coastal South Carolina, Larry and his wife Ruth are the proud parents of two daughters, Clarissa and Aseia, and are under the direct influence of three domineering cats.

"*As a bookstore owner and a writer, I am very aware of how difficult it can be for a new author to get that first important break. Through research, I learned that L. Ron Hubbard started the Writers of the Future Contest in 1984 as a vehicle to assist new and aspiring writers enter the world of successfully published authors.*

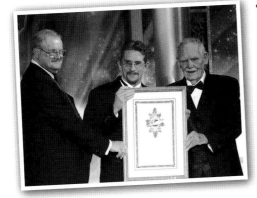

Of course writing skill is required, as is persistence. I entered five times over the years. Each time, I entered without great expectations and was surprised that I was one of the winners, and astonished at how hard the people at Galaxy Press worked to promote my work thereafter.

This Contest is a must for anyone, writer or illustrator, who loves working creatively in science fiction.

— Lawrence Schliessmann

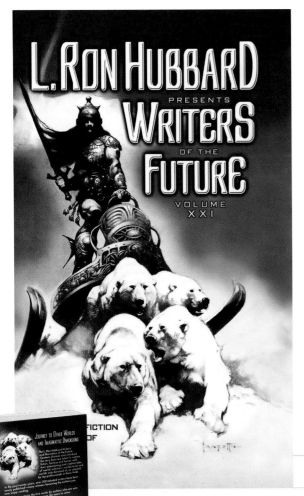

Cover painting by
Frank Frazetta

The Science Fiction Museum in Seattle, Washington was the site for the twenty-first annual Awards ceremony on Friday, August 19, 2005. Prior to the event, winners, judges and their guests were given a private tour of the museum, then enjoyed a banquet held in the Space Needle. After the ceremonies, the Science Fiction Museum hosted a large reception and book signing for the winners to autograph the newly released *L. Ron Hubbard Presents Writers of the Future* Volume XXI.

The workshops were held at the futuristic Seattle Public Library, and the casual barbecue mixer for winners and judges took place at the Fisherman's Wharf.

2005

top The 2005 pre-Awards banquet was held atop the Space Needle in Seattle.

middle top Dr. Jerry Pournelle and Larry Niven look out at Seattle from the Space Needle's observation deck.

middle Winners, judges, and guests enjoy a high-altitude banquet in the Space Needle.

middle bottom The Science Fiction Museum provided a spectacular venue for the 2005 ceremonies.

bottom The Writers of the Future winners and judges, 2005

winners

L. Ron Hubbard Gold Award

"In the Flue" by John Schoffstall

First Quarter

1. "My Daughter, the Martian" by Sidra M. S. Vitale
2. "Betrayer of Trees" by Eric James Stone
3. "Last Dance at the Sergeant Majors' Ball" by Cat Sparks

Second Quarter

1. "In the Flue" by John Schoffstall
2. "The Story of His Life" by David W. Goldman
3. "Needle Child" by M. T. Reiten

Third Quarter

1. "Mars Hath No Fury Like a Pixel Double-Crossed"
 by Stephen R. Stanley
2. "Blackberry Witch" by Scott M. Roberts
3. "The Keeper Alone" by Michael Livingston

Fourth Quarter

1. "Meeting the Sculptor" by Floris M. Kleijne
2. "Green Angel" by Sean A. Tinsley
3. "Into the Blank Where Life Is Hurled"
 by Ken Scholes

Published Finalists

"Annus Mirabilis" by Mike Rimar
"The Firebird" by Andrew Gudgel
"Deadglass" by Lon Prater

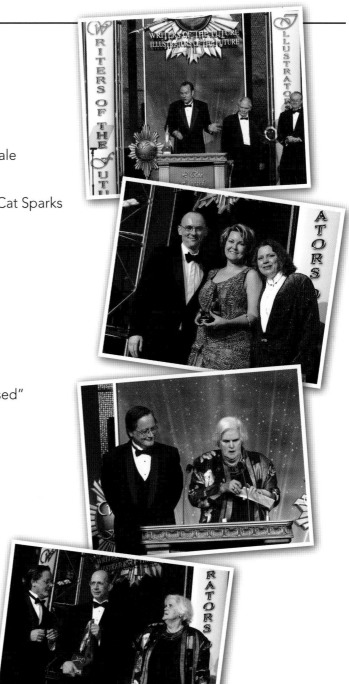

top Floris M. Kleijne from the Netherlands, a published Finalist in 2004 and now a winner in 2005, delivers his Awards speech.

top middle Sean Williams and K. D. Wentworth congratulate Australian winner Cat Sparks.

bottom middle Anne McCaffrey opens the envelope to announce the winner of the Gold Award.

bottom Tim Powers and Anne McCaffrey congratulate Gold Award winner John Schoffstall.

winner spotlights

KEN SCHOLES

Ken Scholes grew up in a trailer outside a smallish logging town not far from the base of Mount Rainier in the Pacific Northwest, and became interested in SF at a young age through books, TV and role-playing games. He decided to be a writer at age thirteen and started his own rejection slip collection by age fifteen. After working years as a sailor, soldier, preacher, musician, label gun repairman, retail manager and nonprofit director, he sold his first story to *Talebones Magazine* in 2000 and won the Writers of the Future Contest in 2004. The year after attending the WotF workshop, he sold a five-book series, The Psalms of Isaak, to Tor Books. The first two volumes, *Lamentation* and *Canticle*, have been released to widespread critical acclaim.

Scholes lives near Portland, Oregon, with his wife Jen West Scholes and their twin daughters Elizabeth Kathleen and Rachel Ann.

I credit the Writers of the Future Contest as an important part of my career launch, and I highly recommend it to everyone who wants to establish themselves in the field of science fiction and fantasy. For me, the connections with other writers (both peers and pros much further down the road) combined with the workshop and the pro-level publication, have been invaluable as a launchpad. After my Contest win, editors started to take notice, asking me when I'd have a novel for them to look at. And my second pro-level short story sale, just months after the workshop, eventually turned into a first novel and a five-book contract with Tor. I think the confidence and skill gained from Writers of the Future played a big role in that.

— Ken Scholes

right Ken Scholes with the illustrator for his WotF story, Gold Award winner, Erik Valdez y Alanis.

ERIC JAMES STONE

Eric James Stone was a published Finalist in 2004 and returned as a winner in 2005. His day job is as a Web developer for an Internet company. He has also won the Phobos Fiction Contest for his fiction and has had many short stories published in major magazines and anthologies. One of his stories was selected for the 2010 volume of *The Year's Best Science Fiction*.

I am one of the lucky writers who got a double dose of Writers of the Future: I was a published Finalist in Volume XX, then a winner in Volume XXI. Knowing that such great authors as the WotF judges felt my stories were worth publishing encouraged me to write more and submit more. "In Memory" in Volume XX was my first published story. Since then, over twenty of my short stories have been published in professional venues such as Analog, Orson Scott Card's InterGalactic Medicine Show, *the anthologies* Blood Lite 1 *and* 2, *and even* The Year's Best Science Fiction. *Some of my stories have been translated into Russian, Hebrew and Polish. And it all started with Writers of the Future.*

Attending the Writers of the Future workshop (twice) really taught me a lot about writing stories—and about managing my writing career. I know I would not have had nearly as much success if not for the invaluable advice of Tim Powers, K. D. Wentworth, Kevin J. Anderson, Rebecca Moesta and many others who generously shared their knowledge at the workshops. Also, the friendships I made, both with other contestants and with judges, have lasted long after the workshops were over.

— Eric James Stone

Cover painting by
Stephen Hickman

2006

The San Diego Aerospace Museum in San Diego, California was the site of the twenty-second annual Awards ceremony, held on Friday, August 18, 2006. Before the beginning of the event, winners, judges and their guests were given a special behind-the-scenes tour of the museum.

Celebrity presenters at the ceremony included actress Marisol Nichols and astronaut Colonel Rick Searfoss. Larry Niven and Dr. Jerry Pournelle received matching silver trophies for the L. Ron Hubbard Lifetime Achievement Award for Outstanding Contributions to the Arts.

After the conclusion of the ceremonies, the Aerospace Museum hosted a celebratory book signing for winners to autograph their newly released copies of Volume XXII. The following day, winners and many of the judges gathered for an outdoor signing at Mysterious Galaxy bookstore in San Diego, California.

top Sean Williams introduces the next winner.

middle top WotF judge Kevin J. Anderson, astronaut guest Colonel Rick Searfoss, and actress Marisol Nichols.

middle bottom Brian Herbert presents an award.

bottom Writer and Illustrator winners and the judges for 2006.

winners

L. Ron Hubbard Gold Award

"Life on the Voodoo Driving Range" by Brandon Sigrist

First Quarter

1. "Games on the Children's Ward" by Michail Velichansky
2. "Evolution's End" by Lee Beavington
3. "Balancer" by Richard Kerslake

Second Quarter

1. "The Sword from the Sea" by Blake Hutchins
2. "The Red Envelope" by David Sakmyster
3. "On the Mount" by David John Baker

Third Quarter

1. "Schroedinger's Hummingbird" by Diana Rowland
2. "Broken Stones" by Judith Tabron
3. "At the Gate of God" by Joseph Jordan

Fourth Quarter

1. "Life on the Voodoo Driving Range" by Brandon Sigrist
2. "Tongues" by Brian Rappatta
3. "The Bone Fisher's Apprentice" by Sarah Totton

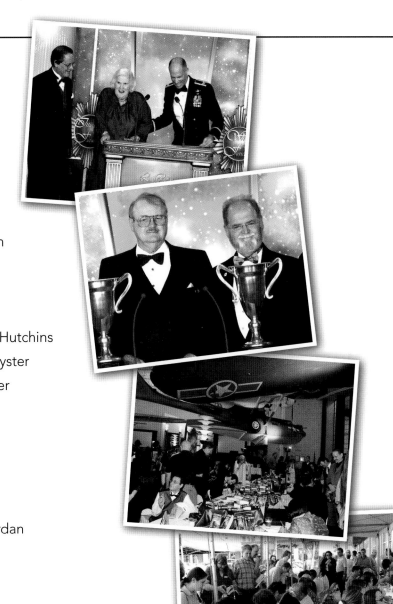

top Tim Powers, Anne McCaffrey and Colonel Rick Searfoss.

top middle Dr. Jerry Pournelle and Larry Niven with their Lifetime Achievement Awards.

bottom middle The book-signing reception at the San Diego Aerospace Museum.

bottom On the day after the event, Mysterious Galaxy bookstore in San Diego hosted a large signing for WotF winners and judges.

winner spotlights

Diana Rowland

Diana Rowland has lived her entire life below the Mason-Dixon line, uses "y'all" for second-person-plural, and otherwise has no southern accent (in her opinion). She attended college at Georgia Tech where she earned a BS in applied mathematics, and after graduation forgot everything about higher math as quickly as possible.

She has worked as a bartender, a blackjack dealer, a pit boss, a street cop, a detective, a computer forensics specialist, a crime scene investigator and a morgue assistant, which means that she's seen more than her share of what humans can do to each other and to themselves. She won the marksmanship award in her police academy class, has a black belt in hapkido, has handled numerous dead bodies in various states of decomposition and can't rollerblade to save her life.

She presently lives in south Louisiana with her husband and her daughter, where she is deeply grateful for the existence of air conditioning. Her first two urban fantasy/police procedurals, *Mark of the Demon* and *Blood of the Demon*, were released by Bantam Dell. She has also sold six more novels to DAW.

It was my very first on-my-own, honest-to-god book signing. There I was at a small table near the front of my local Barnes & Noble. Carefully displayed on the table in front of me were twenty-four copies of L. Ron Hubbard Presents Writers of the Future XXII.

A story I had written was in that book. If you looked in the table of contents there was a listing for "Schroedinger's Hummingbird" by Diana Rowland, and if you turned to the indicated page you could even read the story that had earned me not only some respectable prize money, but a weeklong workshop with the best and brightest names of science fiction and fantasy. Only a few months earlier I'd been listening to and learning from the likes of Tim Powers, K. D. Wentworth, Anne McCaffrey, Kevin J. Anderson, Larry Niven, Dr. Jerry Pournelle and David Brin. For a week, I and eleven other winning writers had been gifted with the rare opportunity to interact with these luminaries of the field and learn from their wealth of experiences. For that incredible week, we'd been treated like established

professionals, and were reminded over and over that we were professional writers. We'd been published. It was up to us to keep that momentum going.

And now I was back in my hometown, the copies of the anthology arranged in an eye-catching display, and me with my pen at the ready.

An older gentleman entered the store and wandered over to the table. I gave him a bright, hopeful smile as he picked up a copy of the book and peered at the cover. My grip on the pen tightened as interest seemed to light his eyes. He shifted his gaze from the cover to me, gave me a friendly smile and said . . .

"Are you L. Ron Hubbard?"

Somehow I managed to restrain myself from thunking my head down onto the table. I kept the smile on my face, and carefully and kindly explained who L. Ron Hubbard was and described the legacy he'd left behind that had allowed me such an opportunity. And after the man bought the book and I signed it for him, I couldn't help but think, "Love ya, Ron, but the next book I sign is going to have my name on the cover!"

It wasn't until many months later, after I was more than halfway through the book that would become Mark of the Demon, *that I realized that there'd been no question in my mind as to whether I would ever have a book with my name on it. The workshop and the support of the other authors had been so inspiring that "I am a writer and I will write books" was quite firmly planted in my head.*

About nine months later, I found an agent who loved Mark of the Demon. *Six months later, it and a sequel sold to Bantam. A couple of years after that my agent and I sold six more books to DAW. There was no doubt in anyone's mind that I was a writer.*

But my proudest moment came on June 27, 2009. I was at that same table in that same Barnes & Noble, with copies of Mark of the Demon *carefully displayed in front of me. A middle-aged woman walked into the store, picked up a book, and then looked at me.*

"Are you Diana Rowland?" she asked.

I smiled proudly. "Why, yes. Yes, I am."

— Diana Rowland

David Sakmyster

David Sakmyster is the award-winning author of over two dozen short stories and two novels, including *The Pharos Objective*, the first book in a series about remote viewers and psychic archaeologists searching for ancient mystical artifacts. In 2009, Dragon Moon Press published his epic historical fantasy tale, *Silver and Gold*.

Five years after being a winner in the Contest, I still feel the commanding presence of that award, resting on my bookshelf beside my computer (and underneath the framed illustration for my winning story "The Red Envelope"). The day I got that phone call letting me know I'd won served as a validation of my dreams and I've continually looked back on that and the whole week spent in San Diego as a strong nod of confidence (and a kick in the pants when I start to doubt myself).

Since then, I've published ten more stories and written five novels, including an historical fantasy epic and part one of a trilogy about psychic archaeologists pursuing the world's greatest ancient mysteries. Spending a week in San Diego with Tim Powers, K. D. Wentworth and a huge cast of my favorite authors, learning secrets of the trade, not only gave me the confidence to pursue writing as a career but instilled in me the unquenchable enthusiasm to go after it. I've signed with an agent, launched a website and a newsletter, and applied invaluable marketing advice to succeeding at book signings and interviews.

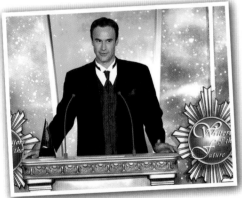

And finally, I was inspired during my week spent with the other Writers of the Future to branch out into screenwriting. A fellow winner had spoken one night about the craft of screenwriting and inspired me first to adapt my winning story into a screenplay, and then—when that went on to win a few awards in screenwriting contests—I wound up writing three more screenplays, and now I have a manager in Hollywood shopping them around to several interested production companies. All in all, the Writers of the Future Contest launched my career into several amazing trajectories, and I'm enjoying them all.

— David Sakmyster

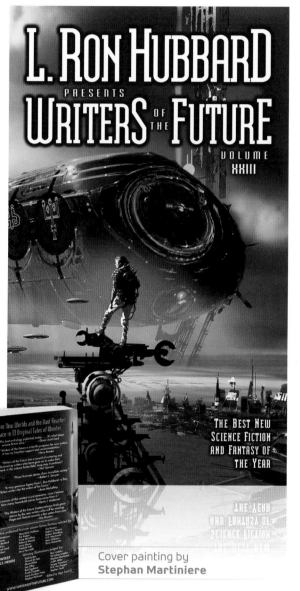

Cover painting by
Stephan Martiniere

The California Institute of Technology in Pasadena, California is a fitting venue for a science fiction awards event, since Albert Einstein had an office there. Before the 2007 ceremonies, the winners, judges and their guests participated in an extensive tour of the Jet Propulsion Laboratory robotics lab and the Mars Science Laboratory Project, where they were treated to demonstrations of new space-probe prototypes, Mars rovers and advances in robotics.

The twenty-third annual Awards ceremony was held on Friday, August 24, 2007 in the beautiful outdoor setting of the Caltech Athenaeum. Actresses Lee Purcell and Carina Ricco were celebrity presenters. Charles N. Brown of *Locus* magazine received the L. Ron Hubbard Lifetime Achievement Award for Outstanding Contributions to the Arts. Following the ceremony, a large reception and book signing for the winners took place inside the Caltech Athenaeum.

top The outdoor Caltech Athenaeum venue for the 2007 Writers and Illustrators of the Future Awards.

middle Actress Wendy Carter and award-winning audiobook narrator Scott Brick at the pre-Awards banquet.

bottom *Locus* publisher Charles N. Brown receives his Lifetime Achievement Award.

2007

winners

L. Ron Hubbard Gold Award

"Saturn in G Minor" by Stephen Kotowych

First Quarter

1. "The Frozen Sky" by Jeff Carlson
2. "The Stone Cipher" by Tony Pi
3. "The Phlogiston Age" by Corey Brown

Second Quarter

1. "Ripping Carovella" by Kim Zimring
2. "Primetime" by Douglas Texter
3. "Our Last Words" by Damon Kaswell

Third Quarter

1. "Saturn in G Minor" by Stephen Kotowych
2. "Obsidian Shards" by Aliette de Bodard
3. "Pilgrimage" by Karl Bunker

Fourth Quarter

1. "The Sun God at Dawn, Rising from a Lotus Blossom"
 by Andrea Kail
2. "The Gas Drinkers" by Edward Sevcik
3. "Mask Glass Magic" by John Burridge

Published Finalist

"By the Waters of the Ganga"
by Stephen Gaskell

top Andrea Kail receives her First Place Award.

top middle Tim Powers and actress Lee Purcell with Gold Award winner Stephen Kotowych.

bottom middle The traditional book-signing reception after the Awards ceremony.

bottom The Writers and Illustrators of the Future winners and judges, 2007.

winner spotlights

JEFF CARLSON

Jeff Carlson is the international bestselling author of the SF thriller trilogy, *Plague Year, Plague War, Plague Zone.* To date, his work has been translated into fourteen languages. *Plague Year* has also been optioned for film. He lives with his wife and sons in California and is currently at work on a new stand-alone thriller.

In the twenty-five-year history of the Contest, I'm the only winner to have gone into the writing workshop and Awards ceremony with a novel already in stores. Why am I bragging? Because I like to think I learned more than anyone else from Powers and Kathy—a.k.a. Tim Powers and K. D. Wentworth for those of you who haven't had the pleasure of surviving this literary boot camp.

In August 2007, I flew into Pasadena feeling pretty smug with myself. Plague Year was one of Ace/Penguin's lead titles that same month, so I figured I knew everything.

Not so.

Powers and Kathy are very good at what they do, and the intense, nonstop workshop comes loaded with writerly tools and challenges. Did I mention it's entirely free? The Writers of the Future Contest doesn't just throw piles of money, trophies and those gorgeous anthologies at its winners. You're also treated like royalty with airfare, hotel, a banquet and VIP tours of installations like JPL or the Kennedy Space Center, not to mention the professional contacts and friendships forged in the fire of this weeklong gala event. Wow.

I credit the skills I learned during WotF for carrying me to other top short fiction markets such as Asimov's and the anthology Fast Forward 2. My second novel, written after the workshop, was a finalist for the Philip K. Dick Memorial Award and the Plague Year series has gone on to become international bestsellers.

It's hard to say enough about how unique and powerful this Contest can be for any writer who's ready to take the next step.

— Jeff Carlson

225

ALIETTE DE BODARD

French by birth, Aliette de Bodard chose to write in English—her second language—after a two-year stint in London. Though she was trained as an engineer (graduating from Ecole Polytechnique, one of France's most prestigious colleges), she has always been fascinated by history and mythology. She was a John W. Campbell Award finalist, and her short fiction has appeared in *Realms of Fantasy*, *Interzone* and *Fantasy*; her work has also been selected for *The Year's Best Science Fiction*.

Her novels *Servant of the Underworld* and *Harbinger of the Storm* (expanded from her WotF-winning story "Obsidian Shards") are published by an imprint of HarperCollins.

Writers of the Future was in many ways a watershed for me. I had heard of it through Orson Scott Card's How to Write Science Fiction and Fantasy, *and the prospect of a trip to the US, as well as a chance to be taught by some of the great SF writers I admired, were a powerful enticement for me to submit. I entered my very first short fiction piece in the Contest in 2004, and submitted every quarter until I placed in the second quarter of 2006. The quarterly deadlines encouraged me to write a continuous flow of short fiction, which in turn helped me improve my writing to the point where it was finally publishable in a professional market.*

The WotF workshop was also a landmark, which taught me many of the things I needed to start plotting a novel—and, as a side effect, netted me a crash course in professional

networking, which I put to good use in the following years. More than anything, WotF was what put me on the map: my novelette got an honorable mention in Gardner Dozois' The Year's Best Science Fiction *and was favorably reviewed in many places. As my first professional sale, it also allowed me to join SFWA—a long-standing dream of mine which allowed me to connect with further writers. And, finally, it was the enthusiasm of some of my fellow WotF winners that convinced me that my winning story "Obsidian Shards" had the potential to become a novel:* Servant of the Underworld, *the first in a series of three, published with Angry Robot/HarperCollins. So, all in all, I would say WotF played a pivotal role in my career.*

— Aliette de Bodard

STEPHEN KOTOWYCH

In addition to winning the WotF Gold Award, Stephen Kotowych has been a finalist for Canada's top SF prize, the Prix Aurora Award. He has a master's in the history of science and technology from the University of Toronto, which not only looks impressive hanging on his wall, it also provides good fodder for his fiction. He has been published in the anthologies *Tesseracts Eleven* and *Under Cover of Darkness*.

Before I won the Writers of the Future, I wanted to be a writer. After, I needed to be.

Every time I sit down to write, I think of the lessons I learned during that incredible week, and what winning the Contest has already meant for me: book signings, conventions, interviews. Being a Writers of the Future Gold Award winner is an incredible credential to have, and has already helped me get introduced to agents and editors, helped get my stories translated and published in Finnish, Russian, Spanish and Greek, and even helped get me nominated for the Prix Aurora Award, Canada's highest honor in SF writing.

Yet despite all this, because my win came only three years ago I think the biggest impact of Writers of the Future is yet to come. I don't know if this is a common feeling amongst winners of the Contest, but in some sense I feel like my award was an indication that things—big things!—are expected of me in my writing career.

Winning Writers of the Future is, to me, something you live up to: You win because you show talent and promise, but that's when the really hard work starts, to show that you truly deserved the accolades. The Contest has a fabulous track record of finding and nurturing the next generation of great SF writers, and I like to see my win as the judges saying they expect that level of success and performance from me, too. It helps keep me motivated. I hope other winners see the Contest that way: not as an end, but rather as a fabulous beginning.

— Stephen Kotowych

TONY PI

Tony Pi was born in Taipei, Taiwan, but moved to Canada when he was eight. He enjoys reading, gaming and writing. He is a member of the Science Fiction and Fantasy Writers of America, SF Canada, Crime Writers of Canada and the Codex Writers' Group. He holds a PhD in linguistics, and his areas of expertise are semantics and sociolinguistics. He currently works in the Cinema Studies Institute at Innis College in the University of Toronto. His short fiction has appeared in numerous anthologies and magazines.

The true rewards of Writers of the Future aren't the trophies or the money, but those intangibles that stay with you even years after: the wisdom of our instructors; friendships forged during the workshop; and the fellowship of judges and winners past and present. Not only do they teach you how to write a better story, but also how to build a professional career around your passion for writing.

My sale to L. Ron Hubbard Presents Writers of the Future Volume XXIII undoubtedly opened the way to my nominations for the John W. Campbell Award for Best New Writer and the Prix Aurora Award, and I am truly grateful. I hope aspiring writers will learn as much as I did from the winning stories and the judges' illuminating advice in each volume.

— Tony Pi

L.RON HUBBARD

PRESENTS

WRITERS

OF THE

FUTURE

VOLUME
XXIV

THE BEST NEW
SCIENCE FICTION
AND FANTASY OF
THE YEAR

"THE BEST ANTHOLOGY PUBLISHED TODAY....
IT'S WHAT KEEPS SCIENCE FICTION ALIVE."
—ORSON SCOTT CARD

Cover painting by
Stephan Martiniere

The Writers and Illustrators of the Future returned to Author Services, Inc., in Hollywood, California for the twenty-fourth annual Awards. The ceremony was held on Friday, August 15, 2008. Aleta Jackson, cofounder of XCOR Aerospace, gave a rousing guest speech about the possibilities of private suborbital flights and space tourism. Dr. Sandra Thomas (NAACP representative for southern California) and actress Elisabeth Moss were guest presenters.

This year also marked an unusual first: 2005 writer winner Stephen R. Stanley became a 2008 Illustrators of the Future winner, the first person ever to win both Contests.

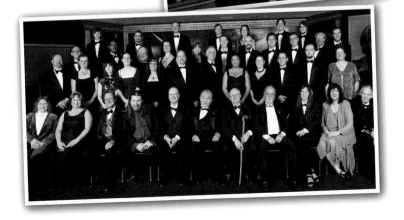

top Amelia Beamer and Charles N. Brown of *Locus* magazine arrive at the event.

middle top Aleta Jackson of XCOR Aerospace talks about the possibilities of commercial space flight.

middle bottom Second Place winner Sonia Helbig with judge Robert J. Sawyer.

bottom Writer and Illustrator winners and judges.

2008

winners

L. Ron Hubbard Gold Award

"Bitter Dreams" by Ian McHugh

First Quarter

1. "Hangar Queen" by Patrick Lundrigan
2. "Epiphany" by Laura Bradley Rede
3. "A War Bird in the Belly of the Mouse"
 by David Parish-Whittaker

Second Quarter

1. "Circuit" by J. D. EveryHope
2. "Simulacrum's Children" by Sarah L. Edwards
3. "Snakes and Ladders" by Paula R. Stiles

Third Quarter

1. "Bitter Dreams" by Ian McHugh
2. "The Girl Who Whispered Beauty"
 by Al Bogdan
3. "The Bird Reader's Granddaughter"
 by Kim A. Gillett

Fourth Quarter

1. "Cruciger" by Erin Cashier
2. "Crown of Thorns" by Sonia Helbig
3. "Taking a Mile" by J. Kathleen Cheney

Published Finalist

"A Man in the Moon" by
Dr. Philip Edward Kaldon

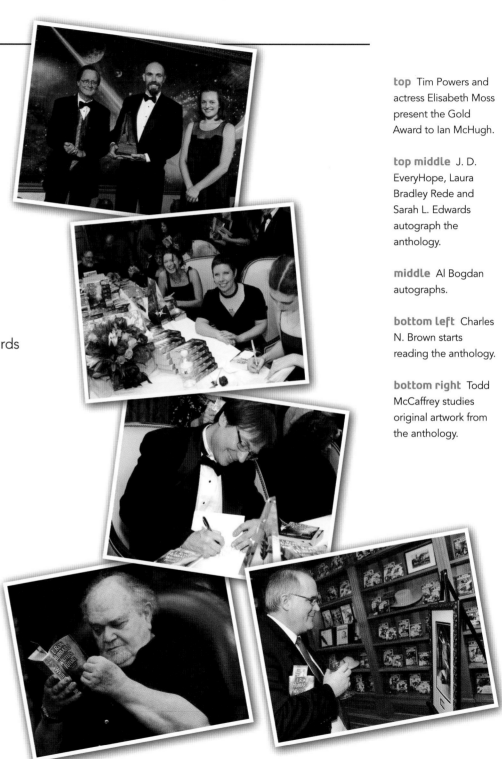

top Tim Powers and actress Elisabeth Moss present the Gold Award to Ian McHugh.

top middle J. D. EveryHope, Laura Bradley Rede and Sarah L. Edwards autograph the anthology.

middle Al Bogdan autographs.

bottom left Charles N. Brown starts reading the anthology.

bottom right Todd McCaffrey studies original artwork from the anthology.

winner spotlights

J. KATHLEEN CHENEY

J. Kathleen Cheney has sold her fiction work to *Jim Baen's Universe*, *Fantasy Magazine*, and the anthology *Alembical 2*, which consists of three original novellas; the other two are written by fellow WotF winners Tony Pi (2007) and David D. Levine (2002). The story she wrote in twenty-four hours during the WotF workshop recently sold to *Beneath Ceaseless Skies*.

Born and raised in El Paso, Texas, J. Kathleen Cheney's parents actually were rocket scientists (they worked at White Sands Missile Range). After graduating with degrees in English and Marketing, she worked as a menswear buyer for retail department store chains before changing careers to become a teacher.

In 2005, she decided to take a sabbatical from the academic world to focus on writing. J. Kathleen has twice attended the summer Writer's Workshop at the Center for the Study of Science Fiction under the tutelage of James Gunn.

When not writing, she likes to don a mask and get sweaty fencing, both foil and saber, or put on her Wellingtons and get her hands dirty in the garden. Quieter hobbies include quilting and taking care of her husband and dog.

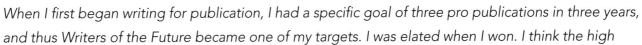

When I first began writing for publication, I had a specific goal of three pro publications in three years, and thus Writers of the Future became one of my targets. I was elated when I won. I think the high point of the experience for me was actually the workshop. Our instructors, Tim Powers and K. D. Wentworth, were knowledgeable, helpful and most importantly, friendly. All of the authors and judges with whom we met that week—too many to name here—were shining examples of what we all wanted to be farther down the line in our careers. It was an inspiring experience, and the writers of WotF XXIV came out of it with new friends and allies for our careers ahead.

Since then, I've had success with short fiction sales. I have sold novella length fiction and hope to soon sell a novel or two. If nothing else, the workshop taught us that hard work and persistence were the keys to success in this field. And that's what we're all striving for.

— J. Kathleen Cheney

PAULA R. STILES

Paula R. Stiles is an American who's traveled all over the place, including working for the Peace Corps for two years in Cameroon. Until recently, she was in Scotland finishing a PhD on the Knights Templars in Spain, which she completed in 2004. She has also published articles on everything from paleolithic art and bog bodies to Islamic and Jewish history to Canadian television. She wrote her master's thesis on popular legends about the Templars.

"When I submitted to Writers of the Future for what turned out to be the final time, I really had no expectations. I first submitted to either the first or second Contest, ever, back in the '80s when I was very young and suffered from an inability to finish most of the stories I started. The last time I tried (c. 1990), I decided that WotF was a bridge too far for me, that I would never be one of those "rising stars" on their roster, and I would just have to find another way to make my vague dreams of becoming a science fiction writer come true.

Time passed. I did other things, like Peace Corps and grad school, got a PhD in medieval history in Scotland. When I went off to the UK in '99, I told myself it was time to get cracking on the getting-published side of things (Peace Corps' goal had been the writing side). By 2003, I had published two stories and by 2007, had finally made my first pro sale.

By the time I came around to subbing again to WotF, I already had two pro sales and wasn't sure if I even still qualified for the Contest at that point. I sent "Snakes and Ladders" in with the idea that it was a very long story, WotF was one of the few markets that took novelettes, and I needed someplace for it to cool its heels while other, less-challenging markets opened up for it.

Imagine my surprise when I came home one day and there was a message on my answering machine. I was a Finalist. Naturally, this changed my attitude quite a bit toward the Contest and my thoughts on my chances of winning (though they made me more anxious than anything). I figured that, with my luck, I would end up just missing the final three. Needless to say, I didn't.

How has the win affected my career? At first, it felt like just another sale, albeit a very big sale. Some have asked me how I feel about coming in third in my quarter. I tell them it's a dirty job, but somebody's gotta do it and I'm happy to volunteer. As time has passed, I feel that more strongly, especially as I've had to comfort friends who "only" got to the semifinalist stage and I've urged them to try again. Third Place is a win and I'm not going to be a sore winner about getting on the podium just because of the color of my medal.

Since then, it's been odd. Some people are impressed by the fact I got into WotF. But often more significant are the folks who are suddenly aware of who I am and glad to meet me. Goals and markets that previously seemed impossible or nebulous are suddenly all too practical. I feel a part of the science fiction community now. Maybe not a really famous one, but one with a profile. And I have to admit, that feels pretty cool.

— Paula R. Stiles

DR. PHILIP EDWARD KALDON

Dr. Philip Edward Kaldon was born in western New York state and has since lived in the lake-effect snow belts of four of the five Great Lakes. Educated at Northwestern University with a BA in integrated science (everything) and grad school at Michigan Tech with an MS in physics and a PhD in applied physics, Dr. Phil currently teaches physics at Western Michigan University in Kalamazoo by day, and aspires to write The Great Science Fiction Romantic Epic in the wee hours of the night. His WotF story was his first pro sale, soon followed by "The Brother on the Shelf" in *Analog*. Dr. Phil is still submitting to the Contest and hopes to retire a winner before his eligibility runs out. (By his count, he has submitted thirty-two times to the Contest!)

What does the Contest mean to me? It's generated nearly half of my sixty completed stories, driven by that quarterly deadline and the very generous 17,000-word count. It's allowed me to explore the twenty-ninth century, where about half of my stories take place, but also to play with other concepts and ideas as I see fit. It has, without question, made me a better writer and given me the confidence to submit my stories to the best-paid commercial markets. I've met so many other WotF entrants—and having been to the WotF workshop and published in Volume XXIV, I have been introduced to so many pro writers and have met so many writers who have also achieved success with WotF, that I can say that Writers of the Future has been at least as important as the six-week boot-camp experience of attending the Clarion workshop. And a side benefit of having attended the WotF workshop was getting a chance to meet the artists of the Illustrators of the Future Contest.

Finally, my hat is off to those who do the heavy lifting at the Contest—K. D. Wentworth and Tim Powers and all the judges, plus all the people at Author Services and Galaxy Press who have worked hard to make this first twenty-five years of the Writers of the Future happen.

— Dr. Philip Edward Kaldon

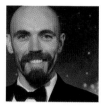

IAN MCHUGH

Ian McHugh is a graduate of the Clarion West writers' workshop, a Gold Award winner in the Writers of the Future Contest and a winner at Australia's Aurealis Awards. He lives in Canberra, Australia. Most of his published short fiction can be found free to read online.

I think I said at the Awards ceremony that there's a tradition in the SF community of writers giving a hand up to the next generation, and that WotF is the most striking and generous example of that tradition that I'm aware of. Aside from the prize money and publication, the whole experience was a blast: Free flights from Australia to the States, where I was able to take a side trip to Worldcon and meet a bunch of friends I hadn't seen in two years. Making new friends at WotF among the year's other winners. The WotF workshop with Tim and K. D. and the other judges. Hanging out with the judges and former prizewinners. Getting punked by Jerry Pournelle. Walking the red carpet on Hollywood Boulevard. Getting my face on an electronic billboard in Times Square.

I'm not sure I can comment yet on what material effect the prize has had on my writing career—too much else has got in the way since, to the extent that my writing pretty much stalled for the second half of 2009 while I crawled into my cave to sort myself out. But a few things have come from the winning story, some of which could yet lead to wonderful magical things.

The story got me a grant from artsACT, my local arts council, to write a novel set in the same fantasy Australia, for which I completed a very bloated and disjointed first draft and then crawled off to a meditation retreat for a fortnight to rehabilitate my mushy brain. The story was also a finalist for Best Horror Short Story at Australia's Aurealis Awards and made the shorter list of Honorable Mentions in Ellen Datlow's Best Horror of the Year 1. Since then, I've won an Aurealis Award for Best Fantasy Short Story, for a story also set in the same fantasy world (and coincidentally written on the flights to and from WotF), and I've qualified for SFWA membership.

I'm back on the writing wagon now, and I've drafted the first half of a comic script based on my WotF story, which I've been working on in fits and starts with Bob Hall, who illustrated the story in the Writers of the Future anthology. My first short fiction sale for 2010 was for a third story set in the same world (of five written and several more plotted), and finally in 2010, I have a grant to turn my WotF story into a film script.

— Ian McHugh

Cover painting by Stephan Martiniere

The twenty-fifth anniversary of the Writers of the Future Contest—a landmark, commemorating a quarter century of helping new writers. The Awards ceremony was held on Saturday, August 29, 2009 at the Blossom Room of the Hotel Roosevelt in the heart of Tinseltown: the same room that hosted the very first Academy Awards. The Writers and Illustrators of the Future workshops were also held in Hollywood at Author Services, Inc.

The event began with a lavish and spectacular interpretive dance symbolizing the creative spirit. Guest speakers included Dr. Harry Kloor, about his new animated film *Quantum Quest,* and Don Hartsell, commissioner and managing director of the World Air League, about the World Airship Race 2011, a worldwide zeppelin race. (And this year's Gold Award winners were invited to join one of the zeppelins on the journey!)

Celebrity presenters included actors Dion Graham, Marisol Nichols, Sofia Milos and John Francis Daley.

The Awards ceremonies were also streamed live around the world over the Internet.

top The Writers and Ilustrators of the Future return to the Roosevelt Hotel for the twenty-fifth anniversary celebration.

middle Crowds gather outside the Blossom Room before the event begins.

bottom Actor John Francis Daley and judge Rebecca Moesta with winner Heather McDougal.

2009

winners

L. Ron Hubbard Gold Award

"Garden of Tian Zi" by Emery Huang

First Quarter

1. "Gone Black" by Matthew S. Rotundo
2. "The Farthest Born" by Gary Kloster
3. "The Assignment of Runner ETI"
 by Fiona Lehn

Second Quarter

1. "The Shadow Man" by Donald Mead
2. "Risqueman" by Mike Wood
3. "Life in Steam" by Grá Linnaea

Third Quarter

1. "After the Final Sunset, Again"
 by Jordan Lapp
2. "The Reflection of Memory"
 by C. L. Holland
3. "Gray Queen Homecoming"
 by Schon M. Zwakman

Fourth Quarter

1. "Garden of Tian Zi" by Emery Huang
2. "The Candy Store" by Heather McDougal
3. "The Dizzy Bridge" by
 Krista Hoeppner Leahy

top and top middle The twenty-fifth anniversary Awards ceremony opened with a colorful interpretive dance performance.

middle The reception and signing after the Awards ceremony.

bottom middle Nina Kiriki Hoffman explains the subtleties of autographing to Donald Mead.

bottom The Writers and Illustrators of the Future winners and judges, 2009.

winner spotlights

EMERY HUANG

As a child, Emery Huang had little understanding of the difference between fiction and nonfiction, and stories filled him with a sense of wonder. Though the passage of time has disabused his mind of such fanciful notions, his heart still believes.

As a writer, and now Gold Award winner, Emery's dream is to finish a series that places China's rich dynastic background firmly on the map of American fantasy literature. After his appearance in the twenty-fifth Writers of the Future anthology, Emery has also sold a short story to the anthology *The Dragon and the Stars* (where his work appears beside fellow WotF winners Melissa Yuan-Innes and Tony Pi). He has recently opened a restaurant, Baohaus, in Manhattan.

The Writers of the Future Contest has been, without doubt, one of the most important milestones in my career. I first attempted to write fiction as a junior in college and it was one of the hardest challenges

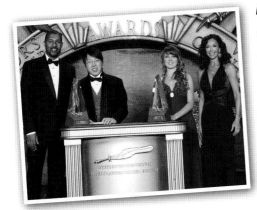

I'd ever faced in my life. But I stuck with it for a year and a half, and soon enough it was one of the most enjoyable times in my life. Then it dawned on me that I wanted to be good enough at this writing thing to one day make it a career. That desire led me to the yawning abyss that lay between an amateur writer and a professional.

I really don't know what I would have done at that point if the Writers of the Future Contest didn't exist. I guess I could have submitted some work to the Big Three. But the Big Three are scary. They're full of grizzled veterans who've survived that leap across the abyss. I mean, I'm sure plenty of them did it without WotF's help, but for me? For me, WotF was like a diaphanous bridge limning the abyss,

above (center) Gold Award winners Emery Huang (writer) and Oleksandra Barysheva (illustrator) with presenters Dion Graham and Sofia Milos.

showing me that, however tenuous, there was a way across as long as I had the grit and courage to take a chance. And after all was said and done, I made it across no worse for the wear.

In fact, shortly after the Contest, I sold a story to DAW Books' anthology, The Dragon and the Stars, *a collection of F&SF stories based on Chinese culture.*

— Emery Huang

MIKE WOOD

Mike Wood was a winner of the first Jim Baen Memorial competition and his work has appeared in *The Best of Jim Baen's Universe II*, *Murky Depths* and *Jupiter* magazine. Mike lives in the UK.

Winning my place at the Writers of the Future Awards was the single most important thing that has happened to me as a writer. It gave me the confidence to move on from being an enthusiastic amateur to being a writer with a structured and businesslike plan for achieving the goals I want to reach.

In the few months since the Awards ceremony in August 2009, I have received positive and encouraging feedback from the editors I have submitted work to, and I know that further success is only a matter of "when" rather than "maybe."

— Mike Wood

C. L. HOLLAND

C. L. Holland is a British fantasy writer. As well as *Writers of the Future* Volume XXV, her works have appeared in publications such as the *Ruins Metropolis* anthology, *Bards and Sages Quarterly*, *Alternative Coordinates* and *Every Day Fiction*.

A year is barely any time to judge progress in the world of publishing, but winning Writers of the Future has already opened a few doors for me: editors have invited me to submit to their publications, or allowed me to bypass the slush pile. And yet, I can't help wondering how many now judge my work by a higher standard than they would otherwise. My friends and family certainly do—now they expect me to succeed, where before writing was often seen as an eccentric hobby. Six in ten winners do, after all.

Winning has changed my expectations too. I now submit more to professional markets, and have taken up my boyfriend's challenge to write a novel in a year. I don't know where winning the Contest will take me in the future, but I intend to make the most of the opportunities it provides.

— C. L. Holland

above C. L. Holland with the illustrator for her WotF story, Gold Award winner Oleksandra Barysheva.

DONALD MEAD

Donald Mead grew up surrounded by the cornfields of central Illinois. He attended Illinois Wesleyan University for his bachelor's degree in political science, and Illinois State University for his master's degree in criminal justice. He currently works in the payroll department of Illinois State University.

He began writing in the early 1990s, deciding to hone his craft with short stories before moving to a novel project. He had some minor successes before his First Place finish in Writers of the Future. Two stories were published in *The Magazine of Fantasy & Science Fiction*, both of which made the preliminary ballot for the British Fantasy Award, and one was reprinted in *The Year's Best Fantasy and Horror*, edited by Ellen Datlow. He was also a finalist for the International Aeon Award in 2009.

I was at a writers' retreat in Chattanooga, Tennessee with a number of other budding authors when I received the word that I'd gotten First Place for my quarter in Writers of the Future. I ran around giving the other writers high-fives until I calmed down enough to tell them what had happened. Our host, a well-regarded author, brought out a bottle of champagne to celebrate. It was one of the most glorious moments of my writerly life.

The workshop brought together some of the most legendary names in writing including Kevin J. Anderson, Doug Beason, Rebecca Moesta, Jerry Pournelle, Tim Powers, Robert Sawyer and so many others it's impossible to list them all. Not only did they talk about writing strategies and the industry in a formal setting, but they were available informally at the hotel and at meals to talk to us individually. They were quite literally at our beck and call. And they enjoyed themselves too—that's what really impressed me. Writers of the Future is something they really believe in.

Whenever I speak on panels or talk to writers, I always suggest Writers of the Future as the premiere contest in our genre.

— Donald Mead

239

MATTHEW S. ROTUNDO

Matthew S. Rotundo has also published stories in *Jim Baen's Universe* and *Orson Scott Card's Intergalactic Medicine Show.* He is a 1998 graduate of the Odyssey Writing Workshop. Matt plays guitar and has been known to sing karaoke. He and his wife live in Omaha, Nebraska.

Winning the Writers of the Future Contest has been a whirlwind experience for me. The publicity from the award has led to numerous interviews and more congratulatory messages—many from professional writers and editors—than I can count. The Contest is truly one of the best things that can happen to an aspiring writer of science fiction/fantasy.

Since winning the contest, I have published stories in Jim Baen's Universe *and* Orson Scott Card's Intergalactic Medicine Show, *among others. I have also started writing movie reviews for* Fantasy Magazine, *and was even interviewed for the documentary film* The People vs. George Lucas. *I'm excited to see what the future brings, and deeply grateful to everyone at Galaxy Press and Author Services for all they've done.*

— Matthew S. Rotundo

GARY KLOSTER

Gary Kloster's winning story was his fifth entry in the Contest, if you count the two he sent in as a teenager (which he'd really prefer you didn't). Since his win, he has been published in *Jim Baen's Universe, Fantasy Magazine* and *Warrior Wisewoman 3.*

When the Writers of the Future Contest first began, I was a teen. An avid SF reader, I came across the first volume, read it and thought to myself, maybe. . . . At the time, I had considered writing as a possible career, along with president, astronaut and mad scientist. But it was idle speculation, mostly because I was clueless. I had no idea about how to make up a manuscript, where to send it, or what to expect. In that book though, these mysteries were explained. And unlike the processes involved for my other career paths, they weren't really that hard. So I gave it a try, wrote up a couple of stories and sent them in. Unfortunately, the stories were awful. But I got back some nice, encouraging rejection letters.

Over twenty years later, I'd come to the conclusion that the president, astronaut, mad scientist things

following pages In its first twenty-five years, winners of the Writers of the Future Contest have published more than 700 novels and 3,000 short stories. Here is a sampling of books published by WotF winners.

weren't going to work out. So I went back to writing. Being a bit smarter, and working a lot harder, I wrote some new stories. Stories that I thought weren't quite so awful as those first two, so I started looking for markets. And I found the Contest, still going strong. So I sent the stories, collected a few much more encouraging rejections, and then, finally, an acceptance.

Starting writing isn't easy. Especially in the beginning, when it seems to consist entirely of blank screens, grammar conundrums, Xeroxed rejections and a vast sense of cluelessness. The Writers of the Future Contest goes a long way to helping a new writer deal with some of that . . . well, maybe not the blank screens and grammar, but it gives you a place to start. Write a story. Make it about so long. Send it in. Repeat. Because that's the secret to getting started in writing. Especially the repeat part.

Writing's not easy, but it can be done. And the Writers of the Future helps you do it.

Too bad there's not an equivalent for becoming a mad scientist.

— Gary Kloster

the trophy

The impressive pyramidal trophy was first introduced at the 1985 ceremonies: a silver quill and a star embedded in transparent Lucite.

Beautiful and impressive, the Writers of the Future trophy poses many challenges to create. Each trophy must be carefully set in stages. First the base is made and injected with color. Then the sterling silver star and plume are eased onto the Lucite, and then the transparent top is poured, with careful adjustments made to keep the silver in place. Finally, the whole trophy is hand cut into the distinctive pyramidal shape.

Each one is individually made, and so no two are exactly alike. Even the silver star-and-plume ornaments are handcrafted by a silversmith, without a mold.

In a sense, the individuality of the award is fitting, as the works of the new authors are individual and unique as well.

"Science fiction does *not* come

after the fact of a scientific discovery

or development.

It is the herald of possibility."

— L. Ron Hubbard

epilogue:
the herald of possibility

For many years, creating a time capsule was a tradition at the Writers and Illustrators of the Future Awards. Judges, winners, celebrity presenters, scientists and other distinguished guests wrote down their predictions and thoughts, which were sealed away as a legacy for future readers. The first of these time capsules will be opened in 2012.

But the Contest itself provides a far more significant legacy for future generations of readers. By finding, nurturing and training the best new creative talent each year, by inspiring them and giving them the tools they need to turn their ideas and their imaginations into actual careers, WotF provides the seeds for the future of SF. For twenty-five years winners have gone on to make their mark on the genre, entertaining and engaging millions of readers around the world. Some of the works are wild adventures, some are incredible flights of fancy, while others are heart-wrenching or provocative.

No other contest in the history of science fiction, fantasy or horror has had such an impact or exerted so much influence on the practitioners of the field. No other contest has lasted so long, has helped so many new writers (and distributed so much prize money!).

Each year the numbers of submissions increase. Aspiring writers from all around the globe enter the Contest. Some of them win, some of them become successful writers afterward, and some even carry on the tradition and become judges themselves, paying forward for the generations to come.

Just wait until you see the Writers of the Future discoveries over the next twenty-five years.

the appendix

acknowledgments

The Writers and Illustrators of the Future Contests are truly massive and complex undertakings—from managing the submissions to coordinating with the judges, interacting with the winners, administering the workshop, staging the Awards event, producing the annual anthology and arranging the book signings. Over twenty-five years, countless people have given their time, their ideas and their energy to make the Contest into a world-class showcase for new creative talent.

Foremost, we thank L. Ron Hubbard for having the foresight to create and endow the Writers and Illustrators of the Future Contests.

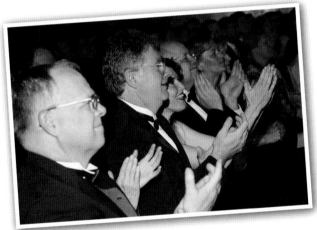

A special round of thanks goes to:

Algis Budrys, Dave Wolverton, Tim Powers and K. D. Wentworth who have spearheaded the annual workshop and helped shape the Contest into what it is today.

All of the judges and guest speakers who have devoted time and expertise, sharing their knowledge with the next generation of writers to help them become peers instead of students.

The tens of thousands of contestants who have entered, and continued entering, because they provide the raw material that keeps the Contest alive.

The supportive staff at Author Services, Inc. and Galaxy Press, who do such an excellent job of running the Contest from start to finish, year after year.

image credits

All images used with permission from the following [for book covers, after each book title and except as otherwise noted, in this order, is the name of the publisher and any cover artist credit given in the book or from the publisher]:

Pages 12 & 13: Mission Earth covers: © 2007 Cliff Nielsen; *Unknown* and *Astounding Science Fiction* copyright © by Street & Smith Publications, Inc. Reprinted with permission of Penny Publications, LLC; *Top-Notch Magazine, Western Story Magazine* are © and ™ Condé Nast Publications and are used with their permission; © 1935, 1936 Metropolitan Magazines, Inc.; © 1949 Standard Magazines, Inc.; © 1948 Better Publications, Inc. Reprinted with permission of Hachette Filipacchi Media; *Argosy Magazine, Dime Adventure, Adventure Magazine, Detective Fiction Weekly* are © 1935, 1936, 1937 Argosy Communications, Inc. All rights reserved. Reprinted with permission from Argosy Communications, Inc. **22:** b. *Sound* © 1994 Frank Frazetta; c. Andrew Tucker; d. *Homecoming* © 2009 Stephan Martiniere; **28:** *Sound* © 1994 Frank Frazetta; **33:** *A Fighting Man of Mars* © 1997 Frank Frazetta; **34:** Orson Scott Card photo by Bob Henderson, Henderson Photography; **35:** *Cosmonaut* © 2008 Stephan Martiniere; **36:** Kevin J. Anderson, Eric Flint & Dave Wolverton photo by Steven L. Sears; **39:** *Silver Warrior* © 1972 Frank Frazetta; **40:** *New World* © 1972 Frank Frazetta; **45:** *Homecoming* © 2009 Stephan Martiniere; **50:** *The Galleon* © 1973 Frank Frazetta; **53:** *Jupiter Station* © 1984 Frank Kelly Freas; **56:** *Cosmonaut* © 2007 Stephan Martiniere; **60:** © 1999 Galaxy Press, LLC; **73-75:** photos of Sag Harbor by Ralph Pugliese, Jr.; **76:** © Shutterstock; **80-81:** Rocket Garden: Kennedy Space Center Visitor Complex; **83:** photos center and lower right are © Shutterstock; **84:** upper left corner: NASA/Kim Shiflett; center photo: Kennedy Space Center Visitor Complex; **85:** NASA © Kings Lane Images/Photographers Direct; **95:** j. *Sound* © 1994 Frank Frazetta; k. *Green Hills of Earth* © 1995 Frank Kelly Freas; l. *To The Future* © 1996 Bob Eggleton; m. *A Fighting Man of Mars* © 1997 Frank Frazetta; n. *Island City in Blue* © 1998 Paul Lehr; o. © 1999 Galaxy Press, LLC; p. © 2000 Galaxy Press, LLC; q. *Jupiter Station* © 1984 Frank Kelly Freas; r. *New World* © 1972 Frank Frazetta; s. *The Galleon* © 1973 Frank Frazetta; t. Andrew Tucker; u. *Silver Warrior* © 1972 Frank Frazetta; v. *The Once and Future King* © 2006 Stephen Hickman; w. *Cosmonaut* © 2007 Stephan Martiniere; x. *Cosmonaut* © 2008 Stephan Martiniere; y. *Homecoming* © 2009 Stephan Martiniere; **96:** credits for each of these covers are under individual author page credits; **99:** top and bottom photos: © 1985 Alan Berliner; **100:** bottom photo: courtesy of Dean Wesley Smith; **101:** Dean Wesley Smith: *The Abductors: Conspiracy,* Tor, Gary Ruddell; *Steel,* Tor, © 1997 DC Comics; *Men in Black: The Green Saliva Blues,* Bantam Books, © 1999 Columbia Pictures Industries, Inc.; *Aliens Rogue,* Spectra, © 1995 John Bolton; *The Hunted,* WaterBrook Press, Stephen Gardner & Kirk DouPonce; *Smallville: Whodunnit,* Warner Books, Don Puckey; *Spider-Man: Goblin's Revenge,* Boulevard Books, Julie Bell; **102 & 103:** David Zindell: Book covers from *Black Jade* by David Zindell, © 2005 David Zindell, art by Geoff Taylor, *War in Heaven* by David Zindell, © 1998 David Zindell, art by Mick Van Houten, both Courtesy of HarperCollins Publishers; *The Broken God,* Spectra, © 1993 Stephen Youll; *Neverness,* Spectra, © 1989 Don Dixon; *Lord of Lies,* Tor, Gordon Crabb; **104:** Nina Kiriki Hoffman: *Spirits That Walk in Shadow,* Firebird, © 2006 Daniel Dos Santos; *Catalyst,* Tachyon Publications, Ann Monn; *A Red Heart of Memories,* Ace, Tim Barrall; *A Fistful of Sky,* Ace, Judy York; *A Stir of Bones,* Firebird, Jay Cooper; Book covers from *The Silent Strength of Stones* by Nina Kiriki Hoffman, © 1995 Nina Kiriki Hoffman, art by Matt Stawicki & *The Thread That Binds the Bones* by Nina Kiriki Hoffman, © 1993 Nina Kiriki Hoffman, art by Richard Bober, both Courtesy of HarperCollins Publishers; *Child of an Ancient City,* Tor, Greg Hildebrandt; **105:** Karen Joy Fowler: *Sister Noon,* Plume, © Roger-Viollet/Liaison Agency, © Underwood Photo Archives/Superstock; *Sarah Canary,* Plume, © Johner/Photonica; *Wit's End,* G. P. Putnam Sons, © Robert Llewellyn/Jupiterimages; *The Jane Austen Book Club,* Plume, Amanda Dewey; **106:** Leonard Carpenter: *Conan the Outcast, Conan the Hero, Conan of the Red Brotherhood, Conan the Savage,* Tor, Ken Kelly; *Conan the Raider,* Tor, Boris Vallejo; *Conan the Renegade,* Tor, Kirk Reinert; *Conan Lord of the Black River,* Tor, Doug Beekman; **107:** Mary Frances Zambreno: *Voyage of the Basset: Firebird,*

Random House, James C. Christensen; *Journeyman Wizard: A Magical Mystery, A Plague of Sorcerers,* Hyperion, © 1996 Carol Heyer; *Invisible Pleasures,* American Fantasy, © Douglas Klauba; **110:** Ray Aldridge: *The Emancipator Book I: The Pharaoh Contract, Book II: The Emperor of Everything, Book III: The Orpheus Machine,* Bantam Spectra, © 1991, 1992 Paul Youll; **111:** Marina Fitch: *The Border,* Ace, Diane Fenster; *The Seventh Heart,* Ace, Rudy Muller; **111:** Robert Reed: *Beneath the Gated Sky,* Tor; *The Well of Stars,* Tor, Lee Gibbons; *The Cuckoo's Boys,* Golden Gryphon Press, Edward Miller; *Marrow,* Tor, Gary Ruddell; *Sister Alice,* Tor, Paul Youll; **112:** Howard V. Hendrix: *Better Angels,* Ace, Victor Stabin; *The Labyrinth Key,* Del Rey, © Stanislaw Fernandes; *Lightpaths, Standing Wave,* Ace, Phil Heffernan; *Spears of God,* Del Rey, © Big Dot Design; **113:** Bridget McKenna: *Fantasy & Science Fiction October/November 1993,* Mercury Press, Inc., Thomas Canty; *Dead Ahead, Caught Dead,* Berkley; **116 & 117:** Dave Wolverton: *On My Way to Paradise,* Spectra, © 1989 Steve and Paul Youll; *The Runelords: The Sum of All Men, The Runelords: Sons of the Oak,* Tor, Darrell K. Sweet; *The Golden Queen: Lords of the Seventh Swarm,* Tor, Vladimir Nenov; *Ravenspell: Of Mice and Magic,* Covenant Communications, © Howard Lyon; *The Golden Queen: Beyond the Gate,* Tor, Nicholas Jainschigg; *Path of the Hero,* Bantam Spectra, © 1993 Paul Youll; *Star Wars: The Courtship of Princess Leia,* Spectra, Drew Struzan © 1995 Lucasfilm Ltd.; **117:** Carolyn Ives Gilman: *Lewis and Clark: Across the Divide,* Smithsonian Books, Missouri Historical Society, Saint Louis; *Aliens of the Heart,* Aqueduct Press; *Halfway Human* by Carolyn Ives Gilman, © 1998 Carolyn Ives Gilman, Courtesy of HarperCollins Publishers; **118:** M. Shayne Bell: *How We Play the Game in Salt Lake and Other Stories,* iPublish.com; *Washed by a Wave of Wind: Science Fiction from the Corridor,* Signature Books; *Nicoji,* Baen, Don Clavette; **119:** J.R. Dunn: Book covers from *Days of Cain* by J.R. Dunn, © 1997 J.R. Dunn, *Full Tide of Night* by J.R. Dunn, © 1998 J.R. Dunn, both Courtesy of HarperCollins Publishers; *This Side of Judgment,* Roc, Donato; *Analog Science Fiction and Fact February 1997,* © 1997 Dell Magazines a division of Penny Publications, art by Daniel S. Jiménez; **122:** Jo Beverley: *The Secret Duke, A Lady's Secret, Chalice of Roses, The Secret Wedding, The Stanforth Secrets,* Signet & NAL; **123:** John Moore: *Slay and Rescue,* Baen, Stephen Hickman; *Bad Prince Charlie, The Unhandsome Prince, A Fate Worse Than Dragons, Heroics for Beginners,* Ace, Walter Velez; **124:** Nancy Farmer: *A Girl Named Disaster,* Puffin, © 1998 Robert Hunt; *The Ear, the Eye, and the Arm,* Puffin, © 1995 Broeck Steadman; *The Islands of the Blessed, The Sea of Trolls, The Land of the Silver Apples,* Atheneum, © 2009 Jon Foster; **125:** R. García y Robertson: Covers from *The Spiral Dance* by R. García y Robertson, © 1991 Rodrigo García y Robertson, art by Daniel Horne, *The Virgin and the Dinosaur* by R. García y Robertson, © 1996 R. García y Robertson, art by Jean Pierre Targete, *Atlantis Found* by R. García y Robertson, © 1997 Rodrigo García y Robertson, art by Jean Pierre Targete, all Courtesy of HarperCollins Publishers; *American Woman,* Forge; *The Moon Maid and Other Fantastic Adventures,* Golden Gryphon Press, Ron Walotsky; *Firebird,* Tor, Kinuko Y. Craft; *Knight Errant, Lady Robyn, White Rose,* Tor, Julie Bell; **126:** Mary Turzillo: *Your Cat & Other Space Aliens,* van Zeno Press, Geoffrey Landis; *Dragon Soup,* van Zeno Press, © 2008 Marge Simon; *Fantasy & Science Fiction February 1996,* Mercury Press, Kent Bash; *Cat Tales: Fantastic Feline Fiction,* Wildside Press; *The Ultimate Witch,* Dell, Bruce Jensen; **129:** Mark Anthony: *Beyond the Pale, The Dark Remains, Blood of Mystery, The Gates of Winter, The First Stone, The Keep of Fire,* Spectra, © 1999, 2001, 2002, 2003, 2004 Stephen Youll; *The Magicians and Mrs. Quent,* Spectra, © Phillip Heffernan; **130:** K. D. Wentworth: *Black on Black, Stars over Stars,* Baen, Patrick Turner; *The Crucible of Empire,* Baen, Bob Eggleton; *The Imperium Game,* Del Rey, Nicholas Jainschigg; *House Of Moons,* Hawk Publishing; **131:** Jamil Nasir: *The Higher Space, Quasar,* Spectra, © 1995, 1996 Bruce Jensen; *Tower of Dreams, Distance Haze,* iUniverse, John Grazier; *The Houses of Time,* Tor, Veer (man) and Getty (galaxy); **132:** Virginia Baker: *Tomorrow SF No. 24,* Unifont Company, © 1996 Kandis Elliot; *Jack Knife,* Jove, Erika Fusari; **132:** J. Steven York: *Fortress of Lies,* Roc, Ray Lundgren; *Generation X: Genogoths,* Berkley Boulevard, Julie Bell; *Age of Conan Hyborian Adventures: Heretic of Set, Age of Conan Hyborian Adventures: Venom of Luxur,* Ace, Justin Sweet; **133:** Stephen Baxter: Book covers from *Voyage* by Stephen Baxter, © 1996 Stephen Baxter, photos © NASA/FPG International & © G. Randall/FPG International, *Flux* by Stephen Baxter, © 1993 Stephen Baxter, art by Bob Eggleton, *Longtusk* by Stephen Baxter, © 1999 Stephen Baxter, *Anti-Ice* by Stephen Baxter, © 1993 Stephen Baxter, all Courtesy of HarperCollins Publishers; *Emperor,* Ace, Alan Brooks; *The Light of Other Days,* Tor, © 1999 Photodisc; *Firstborn, Manifold: Space, Transcendent,* Del Rey; **136:** James Alan Gardner: Book covers from *Commitment Hour* by James Alan Gardner, © 1998 James Alan Gardner, *Ascending* by James Alan Gardner, © 2001 James Alan Gardner, *Trapped* by James Alan Gardner, © 2002 James Alan Gardner, *Vigilant* by James Alan Gardner, © 1999 James Alan Gardner, *Gravity Wells* by James Alan Gardner, © 2005 James Alan Gardner, art by Fred Gambino, *Expendable* by James Alan Gardner, © 1997 James Alan Gardner, art by Gregory Bridges, all Courtesy of HarperCollins

Publishers; **137:** Bruce Holland Rogers: *Flaming Arrows,* IFD Publishing, © 2001 Alan M. Clark; *The Keyhole Opera,* Wheatland Press, Lara Wells; *Thirteen Ways to Water and Other Stories,* Wheatland Press, Hanovi Braddock; *Wind Over Heaven and Other Dark Tales,* Wildside Press; **138:** Scot Noel: *The Book of All Flesh,* Eden Studios, © 2001 George Vasilakos; *The Book of More Flesh,* Eden Studios, Christopher Shy © 2002 Eden Studios; **141:** Mark A. Garland: *Demon Blade,* Baen, Larry Elmore; *Dinotopia: Rescue Party,* Random House, Michael Welply © 1999 James Gurney; *Dorella, Sword of the Prophets,* Baen, Darrell K. Sweet; *Frost,* Baen, David Mattingly; **142:** Michelle L. Levigne: *10,000 Suns, Picture This, The Dreamer's Loom,* Amber Quill Press, © 2004, 2005, 2006 Trace Edward Zaber; *Shatter Scatter,* Mundania Press, © 2009 Ana Winson; *Wolves on the West Side,* Mundania Press, © 2007 Trace Edward Zaber; **143:** Valerie J. Freireich: *Becoming Human, Testament,* Roc, John Jude Palencar; *Impostor,* Roc, Michael Herring; *The Beacon,* Roc; *Tomorrow SF No. #13,* Unifont Company, © 1994 Paul Lehr; **143:** Michael H. Payne: *Asimov's Science Fiction August 1997,* © 1997 Dell Magazines a division of Penny Publications, art by Kinuko Y. Craft; *The Blood Jaguar,* Tor, Julie Bell; **144:** James C. Glass: *Empress of Light,* Baen, Richard Martin; *Shanji,* Baen, Darrell K. Sweet; *Toth,* Borgo Press; *Visions,* Borgo Press, © 2007 James C. Glass; *Imaginings of a Dark Mind,* Borgo Press, © Corey Ford/Fotolia; **147:** Michael Paul Meltzer: *Mission to Jupiter: A History of the Galileo Project,* NASA; **148:** Stephen Woodworth: *From Black Rooms, In Golden Blood, Through Violet Eyes,* Bantam Dell, Tom Hallman; *With Red Hands,* Bantam Dell, © 2005 Tom Hallman; **149:** Nick DiChario: *A Small Remarkable Life,* Red Deer Press, Karen Thomas Petherick; *Valley of Day-Glo,* Red Deer Press, courtesy NASA/JPL–CalTech; **150:** Mark Budz: *Clade, Crache,* Spectra, © Stephen Youll; *Till Human Voices Wake Us,* Spectra, Shasti O'Leary Soudant; *Idolon,* Spectra, Allen Spiegel; **151:** Astrid Julian: *Fantasy & Science Fiction May 1996,* Mercury Press, Bob Eggleton; *Xanadu 3,* Tor, Tony Roberts; **154:** photo of Stoney Compton by Delmar Burham; Stoney Compton: *Russian Amerika,* Baen, Kurt Miller; **155:** Sean Williams: *Books of the Cataclysm: The Crooked Letter,* Voyager, Greg Bridges; *Evergence: The Prodigal Sun,* Ace, Bob Warner; *The Resurrected Man,* PYR, John Picacio; *Cenotaxis,* MonkeyBrain Books, © 2007 Sparth; *Star Wars: The Force Unleashed,* Del Rey, Petrol Advertising in conjunction with LucasArts; **156:** Eric Flint: *1632, Mother of Demons,* Baen, Larry Elmore; *1812: The Rivers of War,* Del Rey; *Belisarius I: Thunder at Dawn,* Baen, Kurt Miller; *The Crucible of Empire,* Baen, Bob Eggleton; **157:** Elizabeth E. Wein: *A Coalition of Lions, The Sunbird,* Firebird, © 2003, 2004 Greg Spalenka; *The Empty Kingdom, The Lion Hunter,* Viking, © 2007, 2008 Cliff Nielsen; *The Winter Prince,* Firebird, © Greg Spalenka; **158:** Lisa Smedman: *The Lucifer Deck,* Roc, Carl Gallian; *The Forever Drug,* Roc, Peter Peebles; *The Apparition Trail,* Tesseract Books, James Beveridge; *Shadowrun: Psychotrope, Shadowrun: Blood Sport,* Roc; **161:** Susan J. Kroupa: *Beyond the Last Star,* SFF Net, Steve Ratzlaff; Book cover from *Bruce Coville's Shapeshifters* compiled and edited by Bruce Coville, © 1999 General Licensing Company, Inc., art by Ernie Colón © 1999 General Licensing Company, Inc., Courtesy of HarperCollins Publishers; **162:** Austin Bruce Hallock: *Sky Full of Dreams,* Elevon Books; **165:** Melissa Lee Shaw: Book covers from *Silver Birch, Blood Moon* edited by Ellen Datlow and Terri Windling, © 1999 Ellen Datlow and Terri Windling, art by Tom Canty, *Sirens and Other Daemon Lovers* edited by Ellen Datlow and Terri Windling, © 1998 Ellen Datlow and Terri Windling, both Courtesy of HarperCollins Publishers; **166:** Julia and Brook West: *The Shimmering Door* edited by Katharine Kerr, © 1996 Katharine Kerr and Martin H. Greenberg, FPG Int./Paul Avis, Courtesy of HarperCollins Publishers; *Enchanted Forests,* DAW, Jean-Francois Podevin, used with permission of DAW Books; *Marion Zimmer Bradley's Sword and Sorceress XXIV* edited by Elisabeth Waters, Norilana Books, © 2009 Ahyicodae; **168:** Susan Urbanek Linville: *The Price of Stones,* Viking-Penguin; **171:** photo of Syne Mitchell by Bobbie Climer; Syne Mitchell: *The Changeling Plague, End in Fire, The Deathless: The Last Mortal Man,* Roc; *Technogenesis,* Roc, Ray Lundgren; **174:** Ken Rand: *Pax Dakota* by Ken Rand (May 2008 Five Star), jacket illustration by Alan M. Clark, jacket design by Christopher Wait/ENC Graphic Services; *The Golems of Laramie County,* Yard Dog Press, David Deen; *Fairy BrewHaHa at the Lucky Nickel Saloon* by Ken Rand (March 2005 Five Star), jacket illustration by Paul Groendes, jacket design by Christopher Wait/ENC Graphic Services; **175:** John Brown: *Servant of a Dark God,* Tor, Raymond Swanland; **176:** Sara Backer: *American Fuji,* Berkley, Royce M. Becker; **180:** Amy Sterling Casil: *U.S. Warplanes: The B-1 Lancer, Buzz Aldrin: The Pilot of the First Moon Landing,* Rosen Publishing; *Imago,* Wildside Press; *Without Absolution,* Wildside Press, Amy Sterling Casil; **182:** Ron Collins: *Future Wars,* DAW, Gregory Bridges, used with permission of DAW Books; **185:** photo of Jim C. Hines by Craig Hebert; Jim C. Hines: *Heroes in Training,* DAW; *The Mermaid's Madness,* DAW, Scott Fischer; *Goblin Hero, Goblin Quest, Goblin War,* DAW, Mel Grant; Used with permission of DAW Books; **186:** Scott Nicholson: *The Harvest, The Home,* Pinnacle Books, Bruce Emmett; *The Farm, The Red Church,* Pinnacle Books, Richard Newton; *The Skull Ring, Drummer Boy,* Haunted Computer Books; **189:** Tobias S. Buckell: *Halo: The Cole Protocol,* Tor,

chrono

Chronological Listing of Winners and Published Finalists by Year

1985

Leonard Carpenter
L. E. Carroll
Randell Crump
Karen Joy Fowler
Michael Green
Ira Herman
Nina Kiriki Hoffman
Norma Hutman
Jor Jennings
A. J. Mayhew
Michael D. Miller
Dennis J. Pimple
Victor L. Rosemund
Dean Wesley Smith
Mary Frances Zambreno
David Zindell

1986

Ray Aldridge
Don Baumgart
Laura E. Campbell
Camilla Decarnin
Marina Fitch
Jon Gustafson
Howard V. Hendrix
Sansoucy Kathenor
Bridget McKenna
Jerry Meredith

Marianne O. Nielsen
Kenneth Schulze
D. E. Smirl
Jay Sullivan
Robert Touzalin (Robert Reed)
Parris ja Young

1987

M. Shayne Bell
R. V. Branham
L. E. Carroll
J. R. Dunn
Christopher Ewart
Carolyn Ives Gilman
Eric M. Heideman
Paula May
Mary Catherine McDaniel
Jean Reitz
Martha Soukup
Tawn Stokes
Lori Ann White
Dave Wolverton

1988

Jo Beverley
Flonet Biltgen
Paul Edwards
Larry England

Nancy Farmer
Michael Green
Mark D. Haw
Astrid Julian
Rayson Lorrey
P. H. MacEwen
Jane Mailander
Dennis E. Minor
John Moore
R. Garcia y Robertson (Rod Garcia)
Mary A. Turzillo
Richard Urdiales

1989

Mark Anthony
Virginia Baker
Stephen M. Baxter
Dan'l Danehy-Oakes
Stephen C. Fisher
C. W. Johnson
Steve Martindale
Marc Matz
Paula May
Jamil Nasir
Gary Shockley
Eolake Stobblehouse
K. D. Wentworth
Alan Wexelblat
J. Steven York

1990

James Gleason Bishop
David Carr
David Ira Cleary
Charles D. Eckert
James Gardner
Michael I. Landweber
Jo Etta Ledgerwood
Pete D. Manison
Stephen Milligan
Scot Noel
John W. Randal
Bruce Holland Rogers
Michael L. Scanlon
Jason Shankel
Annis Shepherd
James Verran
Sharon Wahl
Matthew Wills

1991

Michael C. Berch
Öjvind Bernander
William Esrac
Valerie J. Freireich
Mark Andrew Garland
James C. Glass
David Hast
Michelle L. Levigne
Michael H. Payne
Barry H. Reynolds
Don Satterlee
Merritt Severson
Allen J. M. Smith
Terri Trimble
Ross Westergaard

1992

Christine Beckert
Gene Bostwick
Mark Budz
Brian Burt
Nicholas A. DiChario
James S. Dorr
Bronwynn Elko
Larry Ferrill
Astrid Julian
Kevin Kirk
Michael Paul Meltzer
C. Maria Plieger
Wendy Rathbone
M. C. Sumner
Mike E. Swope
Sam Wilson
Stephen Woodworth

1993

Stoney Compton
Kathleen Dalton-Woodbury
John Richard DeRose
Tom Drennan
Steve Duff
Eric Flint
Vaughn Heppner
D. A. Houdek
Douglas Jole
Karawynn Long
Pete D. Manison
Lisa Maxwell
David Phalen
Charles M. Saplak
Lisa Smedman
Elizabeth E. Wein
Sean Williams

1994

Alan Barclay
Lauren Fitzgerald
Ron Ginzler
Dan Gollub
Bruce Hallock
Sheila Hartney
James Gladu Jordan
Susan Kroupa
Audrey Lawson
D. E. Lofgran
Andrew W. Mackie
Mark Schimming
W. Eric Schult
C. Ellis Staehlin

1995

William J. Austin
Shira Daemon
Ann Miller Jordan
Susan Urbanek Linville
Gordon R. Menzies
Grant Avery Morgan
J. F. Peterson
Brian Plante
Steve Rissberger
Elisa Romero-McCullough
Melissa Lee Shaw
Beverly Suarez-Beard
Julia H. West
Brook West

1996

Russell William Asplund
S. M. Azmus
Scott Everett Bronson

Jerry Craven
Darren Clark Cummings
Richard Flood
Roge Gregory
Arlene C. Harris
M. W. Keiper
Fruma Klass
Edwina Mayer
Syne Mitchell
Carrie Pollack
Callan Primer
E. Robertson Rose
Sue Storm

1997

Lee Allred
Sara Backer
Morgan Burke
Cati Coe
David L. Felts
Bo Griffin (John Brown)
Kyle David Jelle
Janet Martin
Ken Rand
S. Seaport
Alan Smale
Heidi Stallman
Malcolm Twigg

1998

Scott M. Azmus
Jayme Lynn Blaschke
Amy Sterling Casil
Ron Collins
Stefano Donati
Chris Flamm
Richard Flood
Tim Jansen

Maureen Jensen
Ladonna King
David Masters
Steven Mohan, Jr.
Carla Montgomery
Scott Nicholson
J. C. Schmidt
T. M. Spell
Brian Wightman

1999

Amy Sterling Casil
Ron Collins
Manfred Gabriel
David W. Hill
Jim Hines
G. Scott Huggins
Gregory Janks
Nicole Montgomery
Scott Nicholson
W. G. Rowland
Don Solosan
Franklin Thatcher

2000

Dan Barlow
Paul D. Batteiger
Ilsa J. Bick
William Brown
Tobias S. Buckell
Dan Dysan
Michael J. Jasper
Paul E. Martens
Gary Murphy
Jeff Rutherford
Mark Siegel
Leslie Claire Walker
Melissa J. Yuan-Innes

2001

Anna D. Allen
Janet Barron
A. C. Bray
Tony Daley
Marguerite Devers Green
Everett S. Jacobs
Bob Johnston
Philip Lees
Michele Letica
David Lowe
Kelly David McCullough
Tim Myers
Steven C. Raine
Robert B. Schofield
Greg Siewert
Meredith Simmons
J. Simon
Eric M. Witchey

2002

Aimee C. Amodio
Lee Battersby
Joel Best
Tom Brennan
Jae Brim
Woody O. Carsky-Wilson
Carl Frederick
Susan Fry
Ari Goelman
Dylan Otto Krider
Seppo Kurki
David D. Levine
Drew Morby
Nnedi Okorafor
Ray Roberts
Patrick Rothfuss
Leon J. West

2003

Steve Bein
Joel Best
Brandon Butler
Matthew Candelaria
Michael Churchman
Myke Cole
Robert J Defendi
Carl Frederick
Geoffrey Girard
Ian Keane
Jay Lake
Ken Liu
Luc Reid
Steven Savile

2004

Bradley P. Beaulieu
Kenneth Brady
Matthew Champine
Roxanne Hutton
William T. Katz
Floris M. Kleijne
Gabriel F. W. Koch
 (Lawrence Schliessmann)
Jonathan Laden
Blair MacGregor
Tom Pendergrass
Luc Reid
Joy Remy
Jason Stoddard
Eric James Stone
Andrew Tisbert

2005

David W. Goldman
Andrew Gudgel

Floris M. Kleijne
Michael Livingston
Lon Prater
M. T. Reiten
Mike Rimar
Scott M. Roberts
John Schoffstall
Ken Scholes
Cat Sparks
Stephen R. Stanley
Eric James Stone
Sean A. Tinsley
Sidra M. S. Vitale

2006

David John Baker
Lee Beavington
Blake Hutchins
Joseph Jordan
Richard Kerslake
Brian Rappatta
Diana Rowland
David Sakmyster
Brandon Sigrist
Judith Tabron
Sarah Totton
Michail Velichansky

2007

Corey Brown
Karl Bunker
John Burridge
Jeff Carlson
Aliette de Bodard
Stephen Gaskell
Andrea Kail
Damon Kaswell
Stephen Kotowych

Tony Pi
Edward Sevcik
Douglas Texter
Kim Zimring

2008

Al Bogdan
Erin Cashier
J. Kathleen Cheney
Sarah L. Edwards
J. D. EveryHope
Kim A. Gillett
Sonia Helbig
Dr. Philip Edward Kaldon
Patrick Lundrigan
Ian McHugh
David Parish-Whittaker
Laura Bradley Rede
Paula R. Stiles

2009

C. L. Holland
Emery Huang
Gary Kloster
Jordan Lapp
Krista Hoeppner Leahy
Fiona Lehn
Grá Linnaea
Heather McDougal
Donald Mead
Matthew S. Rotundo
Mike Wood
Schon M. Zwakman

alpha

Alphabetical Listing of Winners and Published Finalists

A • B • C

Aldridge, Ray, 1986
Allen, Anna D., 2001
Allred, Lee, 1997
Amodio, Aimee C., 2002
Anthony, Mark, 1989
Asplund, Russell William, 1996
Austin, William J., 1995
Azmus, Scott M., 1996, 1998
Backer, Sara, 1997
Baker, David John, 2006
Baker, Virginia, 1989
Barclay, Alan, 1994
Barlow, Dan, 2000
Barron, Janet, 2001
Batteiger, Paul D., 2000
Battersby, Lee, 2002
Baumgart, Don, 1986
Baxter, Stephen M., 1989
Beaulieu, Bradley P., 2004
Beavington, Lee, 2006
Beckert, Christine, 1992
Bein, Steve, 2003
Bell, M. Shayne, 1987
Berch, Michael C., 1991
Bernander, Öjvind, 1991
Best, Joel, 2002, 2003
Beverley, Jo, 1988
Bick, Ilsa J., 2000
Biltgen, Flonet, 1988

Bishop, James Gleason, 1990
Blaschke, Jayme Lynn, 1998
Bogdan, Al, 2008
Bostwick, Gene, 1992
Brady, Kenneth, 2004
Branham, R. V., 1987
Bray, A. C., 2001
Brennan, Tom, 2002
Brim, Jae, 2002
Bronson, Scott Everett, 1996
Brown, Corey, 2007
Brown, William, 2000
Buckell, Tobias S. 2000
Budz, Mark, 1992
Bunker, Karl, 2007
Burke, Morgan, 1997
Burridge, John, 2007
Burt, Brian, 1992
Butler, Brandon, 2003
Campbell, Laura E., 1986
Candelaria, Matthew, 2003
Carlson, Jeff, 2007
Carpenter, Leonard, 1985
Carr, David, 1990
Carroll, L. E., 1985, 1987
Carsky-Wilson, Woody O., 2002
Cashier, Erin, 2008
Casil, Amy Sterling, 1998, 1999
Champine, Matthew, 2004
Cheney, J. Kathleen, 2008

Churchman, Michael, 2003
Cleary, David Ira, 1990
Coe, Cati, 1997
Cole, Myke, 2003
Collins, Ron, 1998, 1999
Compton, Stoney, 1993
Craven, Jerry, 1996
Crump, Randell, 1985
Cummings, Darren Clark, 1996

D • E • F

Daemon, Shira, 1995
Daley, Tony, 2001
Dalton-Woodbury, Kathleen, 1993
Danehy-Oakes, Dan'l, 1989
de Bodard, Aliette, 2007
Decarnin, Camilla, 1986
Defendi, Robert J, 2003
DeRose, John Richard, 1993
DiChario, Nicholas A., 1992
Donati, Stefano, 1998
Dorr, James S., 1992
Drennan, Tom, 1993
Duff, Steve, 1993
Dunn, J. R., 1987
Dysan, Dan, 2000
Eckert, Charles D., 1990
Edwards, Paul, 1988
Edwards, Sarah L., 2008

Elko, Bronwynn, 1992
England, Larry, 1988
Esrac, William, 1991
EveryHope, J. D., 2008
Ewart, Christopher, 1987
Farmer, Nancy, 1988
Felts, David L., 1997
Ferrill, Larry, 1992
Fisher, Stephen C., 1989
Fitch, Marina, 1986
Fitzgerald, Lauren, 1994
Flamm, Chris, 1998
Flint, Eric, 1993
Flood, Richard, 1996, 1998
Fowler, Karen Joy, 1985
Frederick, Carl, 2002, 2003
Freireich, Valerie J., 1991
Fry, Susan, 2002

G • H • I

Gabriel, Manfred, 1999
Gardner, James, 1990
Garland, Mark Andrew, 1991
Gaskell, Stephen, 2007
Gillett, Kim A., 2008
Gilman, Carolyn Ives, 1987
Ginzler, Ron, 1994
Girard, Geoffrey, 2003
Glass, James C., 1991
Goelman, Ari, 2002
Goldman, David W., 2005
Gollub, Dan, 1994
Green, Marguerite Devers, 2001
Green, Michael, 1985, 1988
Gregory, Roge, 1996
Griffin, Bo (John Brown), 1997
Gudgel, Andrew, 2005
Gustafson, Jon, 1986

Hallock, Bruce, 1994
Harris, Arlene C., 1996
Hartney, Sheila, 1994
Hast, David, 1991
Haw, Mark D., 1988
Heideman, Eric M., 1987
Helbig, Sonia, 2008
Hendrix, Howard V., 1986
Heppner, Vaughn, 1993
Herman, Ira, 1985
Hill, David W., 1999
Hines, Jim, 1999
Hoffman, Nina Kiriki, 1985
Holland, C. L., 2009
Houdek, D. A., 1993
Huang, Emery, 2009
Huggins, G. Scott, 1999
Hutchins, Blake, 2006
Hutman, Norma, 1985
Hutton, Roxanne, 2004

J • K • L

Jacobs, Everett S., 2001
Janks, Gregory, 1999
Jansen, Tim, 1998
Jasper, Michael J., 2000
Jelle, Kyle David, 1997
Jennings, Jor, 1985
Jensen, Maureen, 1998
Johnson, C. W., 1989
Johnston, Bob, 2001
Jole, Douglas, 1993
Jordan, Ann Miller, 1995
Jordan, James Gladu, 1994
Jordan, Joseph, 2006
Julian, Astrid, 1988, 1992
Kail, Andrea, 2007
Kaldon, Dr. Philip Edward, 2008

Kaswell, Damon, 2007
Kathenor, Sansoucy, 1986
Katz, William T., 2004
Keane, Ian, 2003
Keiper, M. W., 1996
Kerslake, Richard, 2006
King, Ladonna, 1998
Kirk, Kevin, 1992
Klass, Fruma, 1996
Kleijne, Floris M., 2004, 2005
Kloster, Gary, 2009
Koch, Gabriel F. W. (Lawrence Schliessmann), 2004
Kotowych, Stephen, 2007
Krider, Dylan Otto, 2002
Kroupa, Susan, 1994
Kurki, Seppo, 2002
Laden, Jonathan, 2004
Lake, Jay, 2003
Landweber, Michael I., 1990
Lapp, Jordan, 2009
Lawson, Audrey, 1994
Leahy, Krista Hoeppner, 2009
Ledgerwood, Jo Etta, 1990
Lees, Philip, 2001
Lehn, Fiona, 2009
Letica, Michele, 2001
Levigne, Michelle L., 1991
Levine, David D., 2002
Linnaea, Grá, 2009
Linville, Susan Urbanek, 1995
Liu, Ken, 2003
Livingston, Michael, 2005
Lofgran, D. E., 1994
Long, Karawynn, 1993
Lorrey, Rayson, 1988
Lowe, David, 2001
Lundrigan, Patrick, 2008

M • N • O

MacEwen, P. H., 1988
MacGregor, Blair, 2004
Mackie, Andrew W., 1994
Mailander, Jane, 1988
Manison, Pete D., 1990, 1993
Martens, Paul E., 2000
Martin, Janet, 1997
Martindale, Steve, 1989
Masters, David, 1998
Matz, Marc, 1989
Maxwell, Lisa, 1993
May, Paula, 1987, 1989
Mayer, Edwina, 1996
Mayhew, A. J., 1985
McCullough, Kelly David, 2001
McDaniel, Mary Catherine, 1987
McDougal, Heather, 2009
McHugh, Ian, 2008
McKenna, Bridget, 1986
Mead, Donald, 2009
Meltzer, Michael Paul, 1992
Menzies, Gordon R., 1995
Meredith Jerry, 1986
Miller, Michael D., 1985
Milligan, Stephen, 1990
Minor, Dennis E., 1988
Mitchell, Syne, 1996
Mohan, Jr., Steven, 1998
Montgomery, Carla, 1998
Montgomery, Nicole, 1999
Moore, John, 1988
Morby, Drew, 2002
Morgan, Grant Avery, 1995
Murphy, Gary, 2000
Myers, Tim, 2001
Nasir, Jamil, 1989

Nicholson, Scott, 1998, 1999
Nielsen, Marianne O., 1986
Noel, Scot, 1990
Okorafor, Nnedi, 2002

P • Q • R

Parish-Whittaker, David, 2008
Payne, Michael H., 1991
Pendergrass, Tom, 2004
Peterson, J. F., 1995
Phalen, David ,1993
Pi, Tony, 2007
Pimple, Dennis J., 1985
Plante, Brian, 1995
Plieger, C. Maria, 1992
Pollack, Carrie, 1996
Prater, Lon, 2005
Primer, Callan, 1996
Raine, Steven C., 2001
Rand, Ken, 1997
Randal, John W., 1990
Rappatta, Brian, 2006
Rathbone, Wendy, 1992
Rede, Laura Bradley, 2008
Reid, Luc, 2003, 2004
Reiten, M. T., 2005
Reitz, Jean, 1987
Remy, Joy, 2004
Reynolds, Barry H., 1991
Rimar, Mike, 2005
Rissberger, Steve, 1995
Roberts, Ray, 2002
Roberts, Scott M., 2005
Robertson, R. Garcia y (Rod Garcia), 1988
Rogers, Bruce Holland, 1990
Romero-McCullough, Elisa, 1995
Rose, E. Robertson, 1996

Rosemund, Victor L., 1985
Rothfuss, Patrick, 2002
Rotundo, Matthew S., 2009
Rowland, Diana, 2006
Rowland, W. G., 1999
Rutherford, Jeff, 2000

S • T • U

Sakmyster, David, 2006
Saplak, Charles M., 1993
Satterlee, Don, 1991
Savile, Steven, 2003
Scanlon, Michael L., 1990
Schimming, Mark, 1994
Schmidt, J. C., 1998
Schoffstall, John, 2005
Schofield, Robert B., 2001
Scholes, Ken, 2005
Schult, W. Eric, 1994
Schulze, Kenneth, 1986
Seaport, S., 1997
Sevcik, Edward, 2007
Severson, Merritt, 1991
Shankel, Jason, 1990
Shaw, Melissa Lee, 1995
Shepherd, Annis, 1990
Shockley, Gary, 1989
Siegel, Mark, 2000
Siewert, Greg, 2001
Sigrist, Brandon, 2006
Simmons, Meredith, 2001
Simon, J., 2001
Smale, Alan, 1997
Smedman, Lisa, 1993
Smirl, D. E., 1986
Smith, Allen J. M., 1991
Smith, Dean Wesley, 1985
Solosan, Don, 1999
Soukup, Martha, 1987

Sparks, Cat, 2005
Spell, T. M., 1998
Staehlin, C. Ellis, 1994
Stallman, Heidi, 1997
Stanley, Stephen R., 2005
Stiles, Paula R., 2008
Stobblehouse, Eolake, 1989
Stoddard, Jason, 2004
Stokes, Tawn, 1987
Stone, Eric James, 2004, 2005
Storm, Sue, 1996
Suarez-Beard, Beverly, 1995
Sullivan, Jay, 1986
Sumner, M. C., 1992
Swope, Mike E., 1992
Tabron, Judith, 2006
Texter, Douglas, 2007
Thatcher, Franklin, 1999
Tinsley, Sean A., 2005
Tisbert, Andrew, 2004
Totton, Sarah, 2006
Touzalin, Robert (Robert Reed), 1986
Trimble, Terri, 1991
Turzillo, Mary A., 1988
Twigg, Malcolm, 1997
Urdiales, Richard, 1988

V·W·X·Y·Z

Velichansky, Michail, 2006
Verran, James, 1990
Vitale, Sidra M. S., 2005
Wahl, Sharon, 1990
Walker, Leslie Claire, 2000
Wein, Elizabeth E., 1993
Wentworth, K. D., 1989
West, Brook, 1995
West, Julia H., 1995
West, Leon J., 2002

Westergaard, Ross, 1991
Wexelblat, Alan, 1989
White, Lori Ann, 1987
Wightman, Brian, 1998
Williams, Sean, 1993
Wills, Matthew, 1990
Wilson, Sam, 1992
Witchey, Eric M., 2001
Wolverton, Dave, 1987
Wood, Mike, 2009
Woodworth, Stephen, 1992
York, J. Steven, 1989
Young, Parris ja, 1986
Yuan-Innes, Melissa J., 2000
Zambreno, Mary Frances, 1985
Zimring, Kim, 2007
Zindell, David, 1985
Zwakman, Schon M., 2009

alpha

writers of the future contest rules

1. No entry fee is required, and all rights in the story remain the property of the author. All types of science fiction, fantasy and dark fantasy are welcome.

2. By submitting to the Contest, the entrant agrees to abide by all Contest rules.

3. All entries must be original works, in English. Plagiarism, which includes the use of third-party poetry, song lyrics, characters or another person's universe, without written permission, will result in disqualification. Excessive violence or sex, determined by the judges, will result in disqualification. Entries may not have been previously published in professional media.

4. To be eligible, entries must be works of prose, up to 17,000 words in length. We regret we cannot consider poetry, or works intended for children.

5. The Contest is open only to those who have not professionally published a novel or short novel, or more than one novelette, or more than three short stories, in any medium. Professional publication is deemed to be payment of at least five cents per word, and at least 5,000 copies, or 5,000 hits.

6. Entries submitted hardcopy must be typewritten or a computer printout in black ink on white paper, printed only on the front of the paper, double-spaced, with numbered pages. All other formats will be disqualified. Each entry must have a cover page with the title of the work, the author's legal name, a pen name if applicable, address, telephone number, email address and an approximate word count. Every subsequent page must carry the title and a page number, but the author's name must be deleted to facilitate fair, anonymous judging.

 Entries submitted electronically must be double-spaced and must include the title and page number on each page, but not the author's name. Electronic submissions will separately include the author's legal name, pen name if applicable, address, telephone number, email address and approximate word count.

7. Manuscripts will be returned after judging only if the author has provided return postage on a self-addressed envelope.

8. We accept only entries for which no delivery signature is required by us to receive them.

9. There shall be three cash prizes in each quarter: a First Prize of $1,000, a Second Prize of $750, and a Third Prize of $500, in US dollars. In addition, at the end of the year the four First Place winners will have their entries rejudged, and a Grand Prize winner shall be determined and receive an additional $5,000. All winners will also receive trophies.

10. The Contest has four quarters, beginning on October 1, January 1, April 1 and July 1. The year will end on September 30. To be eligible for judging in its quarter, an entry must be postmarked or received electronically no later than midnight on the last day of the quarter. Late entries will be included in the following quarter and the Contest Administration will so notify the entrant.

11. Each entrant may submit only one manuscript per quarter. Winners are ineligible to make further entries in the Contest.

12. All entries for each quarter are final. No revisions are accepted.

13. Entries will be judged by professional authors. The decisions of the judges are entirely their own, and are final.

14. Winners in each quarter will be individually notified of the results by phone, mail or email.

15. This Contest is void where prohibited by law.

16. To send your entry electronically, go to www.writersofthefuture.com and follow the instructions.

 To send your entry hardcopy, mail it to:
 L. Ron Hubbard's Writers of the Future Contest
 PO Box 1630
 Los Angeles, California 90078

17. Visit the website for any contest rules updates at www.writersofthefuture.com.

Index

index